Watercolour

for the **Absolute Beginner**

Alwyn Crawsh... ...ark & Trevor Waugh

This edition first published in hardback in 2004,
this paperback edition published in 2006
by Collins, an imprint of
HarperCollins Publishers Ltd
77-85 Fulham Palace Road
London
W6 8JB

The Collins website address is:
www.collins.co.uk

Collins is a registered trademark of
HarperCollins Publishers Ltd

Compilation edition first published in paperback in 2003
by Collins, exclusively for WH Smith

First published by Collins as:
You Can Paint Watercolour 2000
You Can Paint People in Watercolour 2002
You Can Paint Animals in Watercolour 2002

Original works edited by Isobel Smales and designed by Penny Dawes.
Photography: Howard Gimber, George Taylor and Nigel Cheffers-Heard
Compilation edition edited by Heather Thomas
Production of compilation edition by SP Creative Design Ltd

ISBN-10 0 00 723606 9
ISBN-13 978 0 00 723606 0

Colour reproduction by Colourscan, Singapore
Printed and bound by Imago, Singapore

CONTENTS

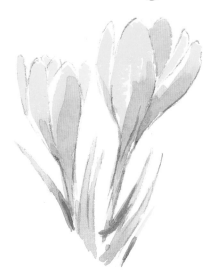

THE ARTISTS

Alwyn Crawshaw

ALWYN CRAWSHAW has been an inspiration to millions of amateur painters and has made seven very popular TV series on painting for Channel 4, which have been shown worldwide. He is author of over 20 books on art instruction, all published by Collins, and runs popular painting holidays and courses. He is a regular contributor to *Leisure Painter* magazine, Founder of the Society of Amateur Artists, President of the National Acrylic Painters Association, a member of the Society of Equestrian Artists and the British Watercolour Society, and a Fellow of the Royal Society of Arts. He is listed in the current edition of *Who's Who in Art*, and the *Marquis Who's Who in the World*.

Sharon Finmark

SHARON FINMARK specializes in life painting in watercolour, pastels and acrylics. She was Artist-in-Residence for BBC Radio 4's *Today* programme in 2001 and has worked backstage at the National Theatre and with The Royal Shakespeare Company, sketching actors such as Robert Lindsay, Ian Holm and Barbara Flynn. Her sketch of Robert Lindsay was shortlisted for the prestigious Garrick Milne Prize. She is a visiting lecturer in art at a range of colleges, and has written a number of books as well as being a regular contributor to *The Artist* magazine.

Trevor Waugh

TREVOR WAUGH studied at the Slade School of Fine Art in London and is now an established popular painter who runs very successful painting workshops and holidays. In recent years he has travelled extensively to the USA, the Middle East, Morocco, Egypt, France, Italy, Spain and Turkey, painting, running watercolour classes and exhibiting his work. Apart from his original watercolours, Trevor Waugh's work is also known to a wide market through his greetings cards, prints and other merchandise. He has published a number of successful painting books.

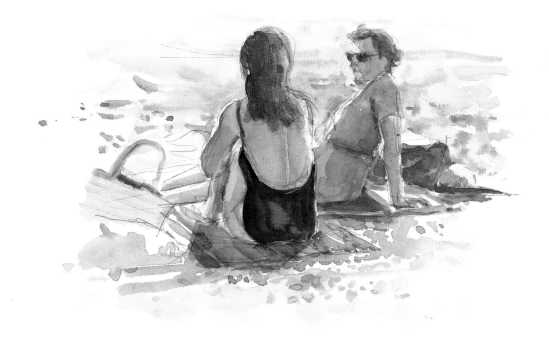

INTRODUCTION

This book is an instruction book for absolute beginners, aiming to help you produce realistic paintings. It describes the materials you will need and shows you the basic watercolour techniques. You can develop your skills by copying the exercises and demonstrations which are broken down into simple stages.

Part One features a wide range of subject matter, from still lifes to landscapes, as Alwyn Crawshaw shows you how to master some basic watercolour techniques and how to mix colours. In the following sections on painting people and animals, additional techniques are introduced which are specific to those subjects.

Hickling Church 28 x 40 cm (11 x 16 in)
Alwyn Crawshaw

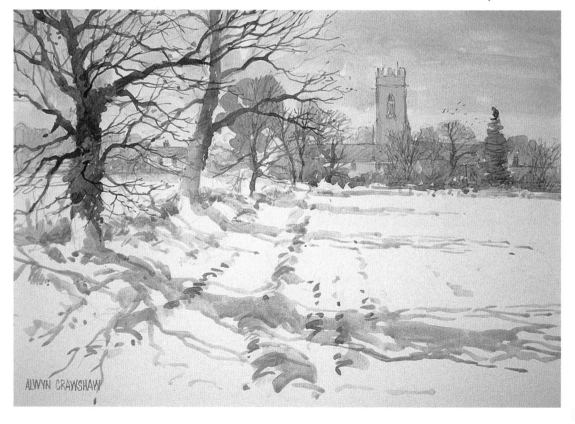

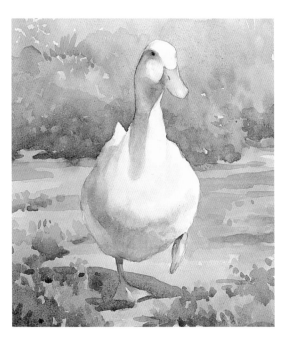

Running duck *25 x 20 cm (10 x 8 in)*
Trevor Waugh

This will boost your confidence and inspire you to paint some of your own favourite subjects.

In Part Two, Sharon Finmark explains how you can produce realistic figures – everything from getting the proportions right to mixing convincing skin colours. After showing you how to paint single figures, she demonstrates how to paint people in groups, moving around and in different settings. You can practise the step-by-step examples until you have gained the confidence to tackle subjects of your choice.

Trevor Waugh, in the final section of this book, takes you through the simple rudiments of animal painting, which will help you to develop your blossoming watercolour skills. Use the section on basic shapes as a general reference for the animals you want to paint. By the time you have finished the book, you will be well equipped to draw and paint all your favourite animals.

Throughout this book there are detailed demonstrations featuring a variety of subjects. Do not be put off by the complexity of the finished pictures: they are merely the end results of a number of more simple stages. Just work your way through them, stage by stage, without leaving any out, and you will see how they combine to develop your painting.

Even if you are a complete beginner who has never lifted a pencil or paintbrush before, you can produce watercolour paintings you can be proud of – so have fun and be inspired!

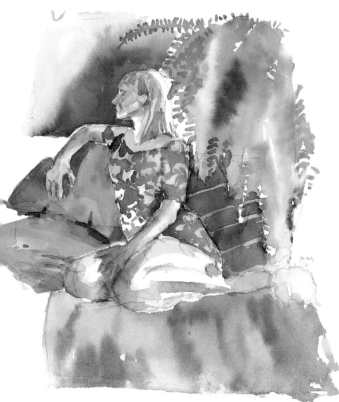

Lucy relaxing on the sofa
Sharon Finmark

MATERIALS

As a beginner you do not need to buy a wide range of expensive art materials. The fewer you have, the fewer you have to master. As you gain experience and confidence, you will want to change or extend your range of brushes, paper, colours, etc. It is good to want to progress and experiment, and watercolour is a wonderful medium for exploring. But at the beginning, let's keep it simple! Here are some basic guidelines on what you will need.

Paints
It is usually better to use 'pans' rather than tubes of paint as you can control the amount of paint you put on your brush more easily, but tubes of colour are useful in the studio. There are two qualities of paint: Students' and Artists'. Artists' quality is superior but the Students' watercolours are very good for beginners, and less expensive.

Colours
Some useful colours to have in your palette include: Yellow Ochre, Raw Sienna, Burnt Sienna, Burnt Umber, Warm Sepia, Cobalt Blue, French Ultramarine, Coeruleum, Cadmium Yellow and Cadmium Yellow Pale, Lemon Yellow, Naples Yellow, Cadmium Orange, Cadmium Red, Alizarin Crimson, Permanent Rose, Hooker's Green, Emerald Green, Viridian, Payne's Grey, Black and a watercolour white.

Brushes
Sable hair brushes are best but they are also the most expensive as they are made from real sable fur. There are also excellent synthetic brushes on the market that cost much less than sable, as well as synthetic-sable mixes. You will need a No.10 as your big brush, a smaller No.6 for detail, and a rigger No.2 for thin lines.

Pans and tubes of watercolour.

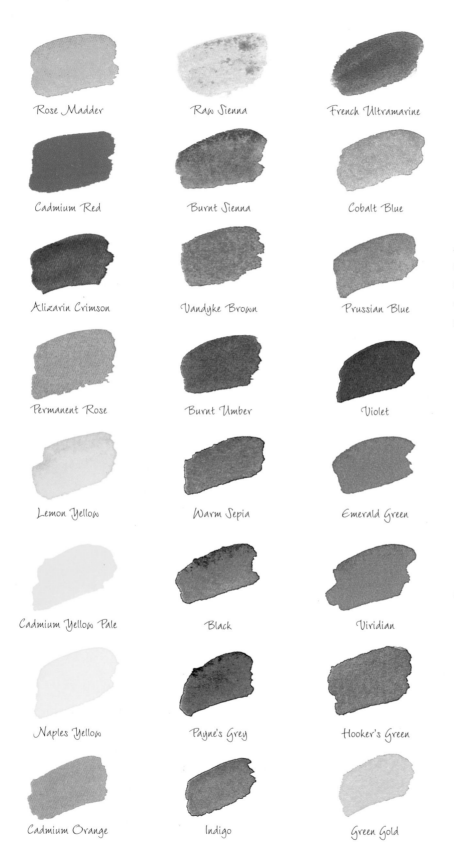

Rose Madder

Raw Sienna

French Ultramarine

Cadmium Red

Burnt Sienna

Cobalt Blue

Alizarin Crimson

Vandyke Brown

Prussian Blue

Permanent Rose

Burnt Umber

Violet

Lemon Yellow

Warm Sepia

Emerald Green

Cadmium Yellow Pale

Black

Viridian

Naples Yellow

Payne's Grey

Hooker's Green

Cadmium Orange

Indigo

Green Gold

Here are some of the colours that are used within the exercises and demonstrations in this book.

Materials 9

Paper

There are many different papers in pads or blocks which are available from all good art shops. To start off, you will need an A4 cartridge pad for pencil sketching and an A4 pad or block of watercolour paper, such as Bockingford, Langton or Saunders Waterford, for painting. These papers are all inexpensive and of excellent quality, and they are available in a range of different sized pads.

There are different weights and thicknesses of paper, ranging from 150 gsm (72 lb) up to 850 gsm (400 lb). It's best to use 300 gsm or over as any paper less than this may need stretching on a board to prevent it buckling when wet. This is particularly important if you want to work quite wet (see page 16).

There are rough and smooth-surfaced (hot-pressed) papers with which you can experiment as you become more proficient. Paper with a rough surface has a pronounced texture and is suitable for bold, vigorous brushwork. The not surfaces have less texture and are ideal for beginners, whereas a hot-pressed surface is very smooth indeed with minimal texture. Before you try this paper, you will need to know how to handle your watercolour. If you use the paint very wet, it can easily run.

Even experienced artists can find it awe-inspiring to sit in front of a large, blank piece of paper, brush poised, so work small initially, no larger than about 25 x 38 cm (10 x 15 in).

A selection of watercolour papers.

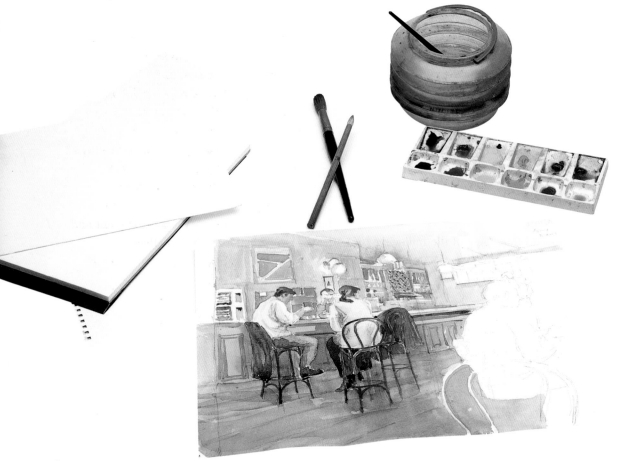

Some of the extra items that you will find useful.

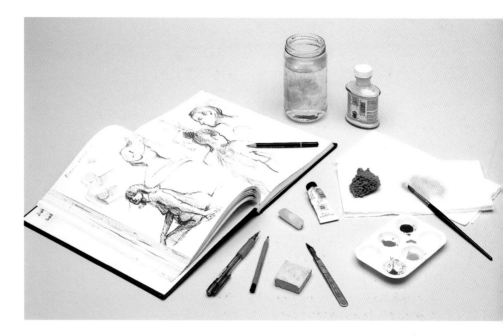

Graphite pencils
You will need three grades, HB, 2B and 4B, to give varying degrees of softness in sketching (the higher the number, the softer the pencil) and for adding tone.

Erasers
A soft putty eraser is useful for rubbing off the pencil lines when you have finished painting. However, it will not lift off too much of the colour or damage the paper.

Extra equipment
You will also find that some of the following items of equipment can be very useful.
White gouache This is a thick white paint, supplied in tubes, which may be used when an area of white is needed.
Masking fluid This is applied and allowed to dry before watercolour is added over the top. It can be rubbed off once the watercolour is dry to reveal the original white paper underneath.
A jam jar This, or another container, can be used to keep your water in.

A plastic palette This will give you space to mix your paint.
Kitchen roll This may be used to blot excess water from your brushes and for lifting out areas of wet paint or mistakes.
A natural sponge This may be used damp for taking out mistakes that have dried.
A lightweight drawing board This is useful for supporting your paper. Masking tape may be used to secure the paper to the board.
A candle This will add texture to your paintings. If you paint over areas where you have applied wax, the wax repels the paint and leaves highlights or a dappled effect.
A craft knife This is used for scratching out highlights, and is useful when painting hair.
A small back pack This is useful if you are planning to travel with your paints.
A small stool This is handy for outdoor work. You can buy a lightweight folding one.
Bulldog clips These are useful for securing paper but an elastic band can be used instead.
Masking tape Buy a roll of this for fixing loose sheets of watercolour paper to your board.

GETTING STARTED IN WATERCOLOUR

Alwyn Crawshaw

'I can't paint, I'm not an artist.' People frequently say this to me, and I always reply, 'Have you tried?'. Usually the answer is 'No', or 'Yes, I have tried but I'm no good'. I then ask, 'But have you been taught how to paint?' and the answer is always 'No'. Well, painting is just like any other art or trade; you have to learn in order to progress. You do not expect to be able to play the piano without having lessons, and so it is with painting. I have been teaching painting for over 35 years, and have drawn on all my experience to write this section of the book, which will introduce the complete beginner to the wonderful world of watercolour painting.

Watercolour is a very popular medium; it lends itself to painting a wide range of subjects. It also has the great advantage that it requires no complicated equipment, making it ideal for a beginner. And even when you are painting outdoors, your basic essentials are a pencil, a box of paints, a brush, paper and water.

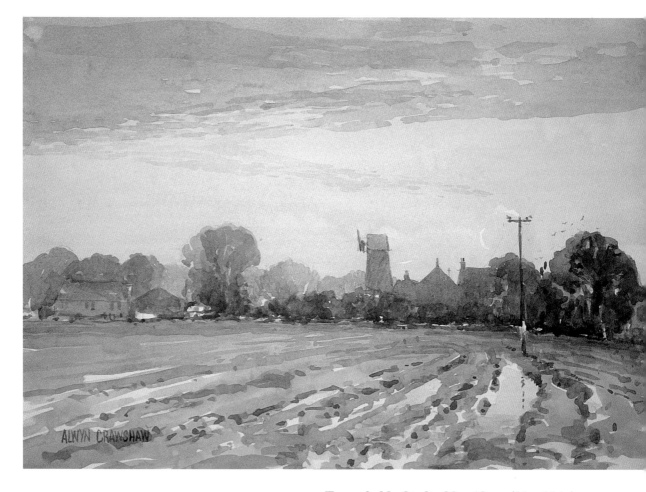

Towards My Studio 28 x 40 cm (11 x 16 in)
Cartridge drawing paper

My aim is to get you started and then to inspire you to greater heights, so I have kept the instructions very simple. I show you enough basic traditional watercolour techniques to give you a good grounding. It is important to practise these basic techniques before you try any 'proper' paintings. Try to curb your enthusiasm to rush through the book before mastering the basics! Get some paper and doodle with your brushes and paints. See what happens when you add water, or add wet paint onto wet paint, or try to paint a thin line.

Learning can be challenging and rewarding, and it is just as enjoyable as producing a masterpiece. Every time you mix a colour or paint a brush stroke you have learned a little more and gained some experience. The more experience you have, the more confident you will be and the more you will want to paint. If you follow the book carefully and practise the exercises with a feeling of excitement and enthusiasm, you will be well on the way to being a watercolour artist. Above all, it is important to enjoy your painting.

TECHNIQUES

There are many ways of applying paint to paper and creating effects. I am sure that you will find some of your own, as you progress. But if you practise the very important basic techniques described on the next few pages, they will show you how your brush, the paper and the paint behave. Most importantly, you will have started on the road to watercolour painting.

Flat wash

The most fundamental technique is the wash. It is the traditional way of applying paint over a large or small area on your paper. The golden rule is to have your paint very watery, so that it runs down and spreads on the paper. The flat wash is the first to practise.

Load your large brush with watery paint. Starting at the top left-hand side of the paper, take the brush along in a definite stroke. At the end, lift the brush off the paper and start another stroke, running it into the bottom of the first wet stroke. Continue in this way, adding more watery paint to your brush as and when you need it.

Graded wash

This wash is used when you want the colour to get gradually paler. This technique (like all washes) can be worked small.

Graded colour wash

This wash gradually changes colour from top to bottom. I use this technique a great deal for painting skies.

Work exactly the same way as for the flat wash, but gradually add water to the colour mix in your palette to make it paler as you work down the wash.

Work the same way as for the flat wash but add different colours to the first mixed colour in your palette as you work down. Keep your paint watery.

Wet-on-wet

This is a very exciting watercolour technique. Putting wet colour on to wet colour can give you some of watercolour's 'happy accidents'. These are areas of a painting where you did not control the visual result, but it looks great. Experience will teach you how to create and control some happy accidents.

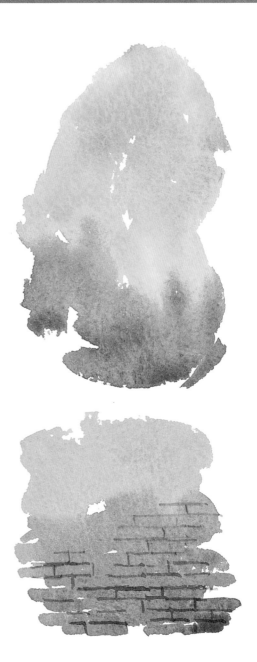

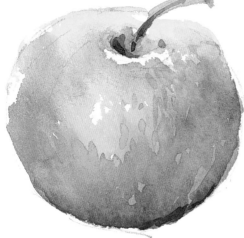

Start with yellow and then add green and, finally, red. The colours will all blend. When it's dry, add some stronger red to show the markings on the apple.

Let the paint run its own way, changing the colours as you work. When it's dry, you can suggest bricks with a rigger brush. This technique is ideal for painting buildings.

Wet-on-dry

This is the way to build up a painting. Remember that if the background paint is wet it merges, but if it is dry you get sharp edges.

Soft edges

There are times when you need to paint a soft edge and not a sharp one. You will find that during a painting you use this technique a lot.

Paint a wash in any colour and let it dry. With different colours paint on top of the dry colour. To paint a thin line, use less water on your brush, or it will spread.

Use water for the first stroke, then continue with paint. Also try the reverse; paint a wash and finish with water. This technique needs plenty of practice.

Dry brush

As the name of this technique implies, when you dry brush, the brush has less paint and water and is dragged along hitting and missing the paper and leaving flecks unpainted. It also becomes a natural stroke as you run out of paint on the brush. The rougher the surface of the paper, the more exaggerated the effect will be. When you practise this, try dabbing the brush on a tissue or some blotting paper to remove the excess paint.

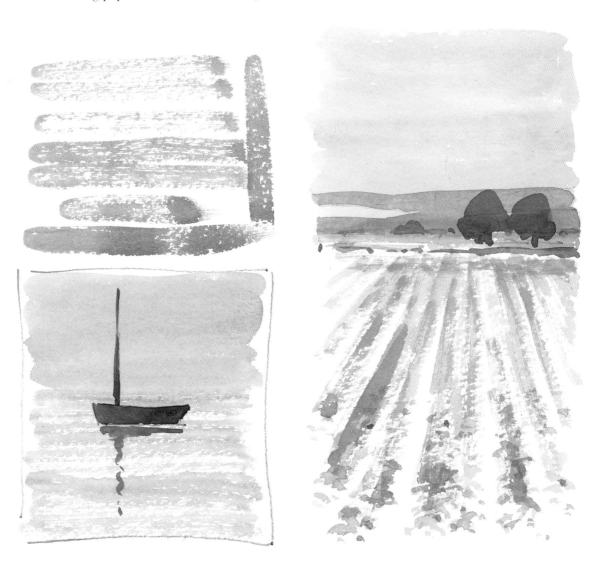

This technique is perfect for sunlit water. Drag the brush in horizontal strokes across the paper. Keep the strokes level, or the water will appear to run downhill!

Drag the brush towards you from the edge of the field. Make the technique more pronounced in the foreground. When dry, add some blobs of darker colour to this area.

Lifting out

Lifting out is when you remove an area of paint.
It can be used to take off an excess of colour
(either there by accident or design), or as part of
the painting's work plan. You will never be able
to lift out and leave pure white
paper. There will usually be a
slight stain, depending on
the colour of the paint.
Some papers lift out
better than others.

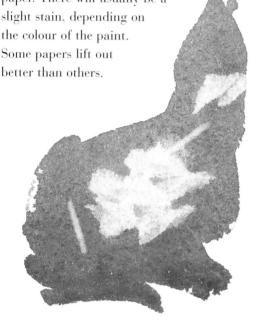

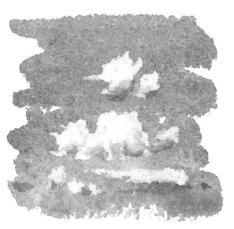

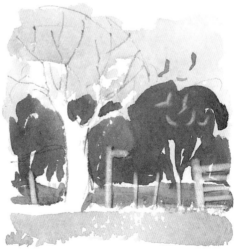

*Paint an area of blue (top) and while the
paint is wet, sponge out areas with a screwed
up soft tissue to represent clouds (above). This
is very simple, but extremely effective.*

*With a wet brush, drag the area to be removed
over and over again, then blot with tissue (top).
Note that the tree trunk (white paper) is much
whiter than the fence and gate I lifted out (above).*

EASY COLOUR MIXING

All the colours that you will need can be mixed using the three primary colours: red, yellow and blue. There are obviously different shades of red, yellow and blue which means that you can mix a wide range of different colours.

Starter palette

When you begin painting in watercolour I recommend that you start with the basic starter palette illustrated below, which will enable you to mix almost any colour you need. These are the colours I use. In fact, for most of my painting I use only Alizarin Crimson, Yellow Ochre and French Ultramarine to mix my colours, but I do use a green when I am painting landscapes. Throughout the book, where I discuss colour mixes, I list the colours in the sequence that you should mix them.

To make colours lighter you need to use more water in your mix (see bottom row below). In order to make the colours darker you add more paint (pigment), or less water.

Basic starter palette

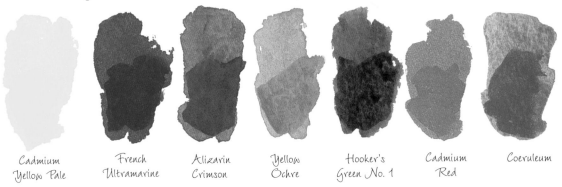

| Cadmium | French | Alizarin | Yellow | Hooker's | Cadmium | Coeruleum |
| Yellow Pale | Ultramarine | Crimson | Ochre | Green No. 1 | Red | |

Basic colours with added water

The golden rule

The most important rule to remember when mixing a colour is to put the predominant colour of the mix into your palette first (with water) and add smaller amounts of other colours to it. For example, if you wanted to mix a reddy-orange, you would put the predominant colour – red – into your palette and then add yellow to it. If you started off with yellow, you would have to mix a lot of red into it to 'overpower' the yellow and make a 'reddy'-orange. You would use a lot more paint, mix more than you need, lose time and get very frustrated. So always keep to the golden rule – the predominant colour first.

Predominant colour first

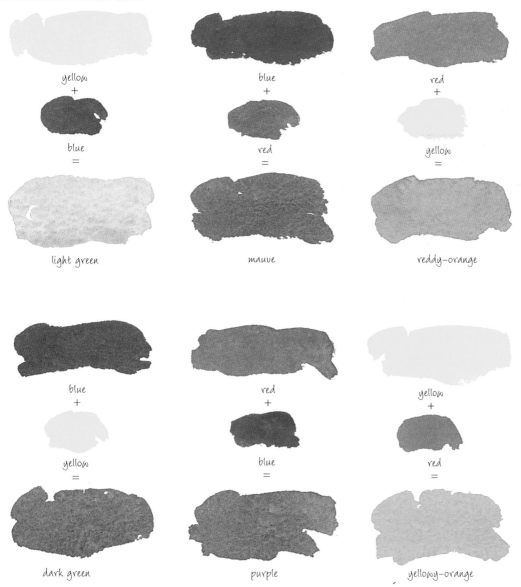

yellow
+
blue
=
light green

blue
+
red
=
mauve

red
+
yellow
=
reddy-orange

blue
+
yellow
=
dark green

red
+
blue
=
purple

yellow
+
red
=
yellowy-orange

Mixing only three colours

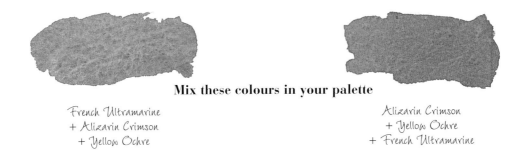

Mix these colours in your palette

French Ultramarine
+ Alizarin Crimson
+ Yellow Ochre

Alizarin Crimson
+ Yellow Ochre
+ French Ultramarine

Then add the other colours below to the above colour mix in the palette, and test the colour.

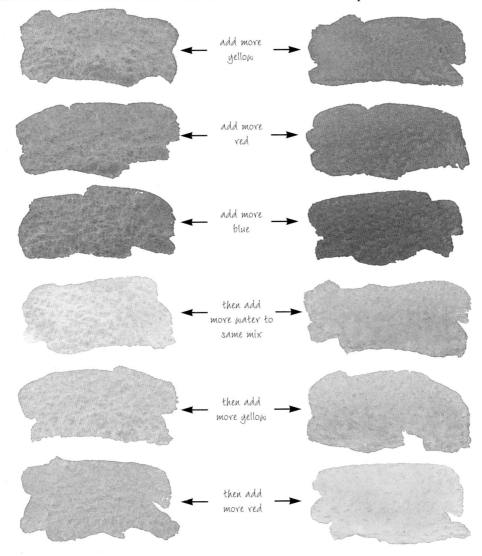

← add more
yellow →

← add more
red →

← add more
blue →

← then add
more water to
same mix →

← then add
more yellow →

← then add
more red →

More colour mixing

Hooker's Green No. 1
+ Alizarin Crimson

Now try adding the colours below to the above mix

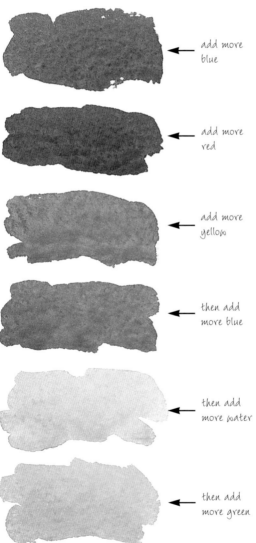

← add more blue

← add more red

← add more yellow

← then add more blue

← then add more water

← then add more green

Remember that adding water is like adding white – it makes the colours paler

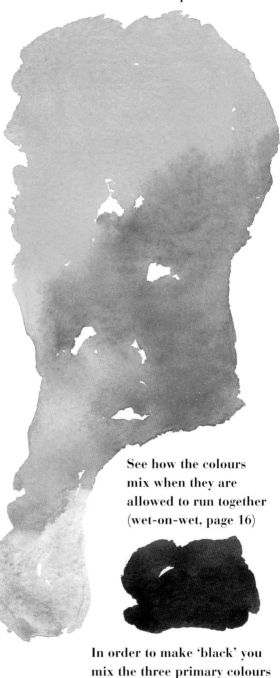

See how the colours mix when they are allowed to run together (wet-on-wet, page 16)

In order to make 'black' you mix the three primary colours with a small amount of water

MAKING OBJECTS LOOK 3D

This is perhaps the most important lesson to master. If you don't have contrast, your picture will be flat, with no recognizable shape or form. Look at the paintings below. The objects only become real when you add shadows. Remember that light against dark will always show shape and form and make an object look three dimensional.

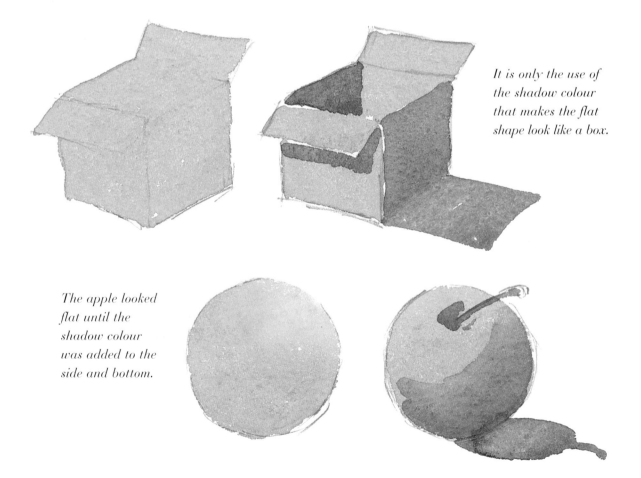

A mix of French Ultramarine, Alizarin Crimson and a touch of Yellow Ochre will give you a good general shadow colour.

It is only the use of the shadow colour that makes the flat shape look like a box.

The apple looked flat until the shadow colour was added to the side and bottom.

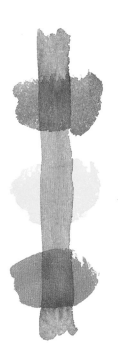

Because watercolour is transparent, the shadow colour (the vertical line) allows the underneath colour to show through – but darker.

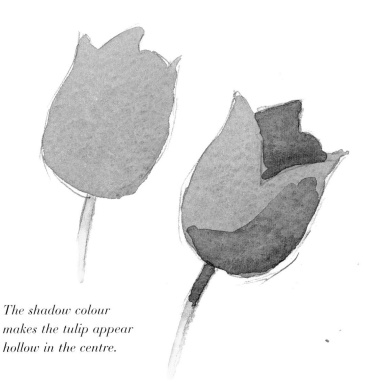

The shadow colour makes the tulip appear hollow in the centre.

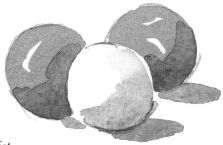

Notice how the white ball doesn't exist without the shadow. Also, the little highlight of white paper left on each ball makes them look shiny and spherical.

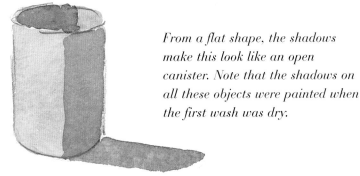

From a flat shape, the shadows make this look like an open canister. Note that the shadows on all these objects were painted when the first wash was dry.

FRUIT

The great thing about painting fruit is that you usually have some in the house! You can make a picture out of just one apple or a whole basket of fruit. In fact, fruit is an ideal subject on which to practise techniques and colour mixing.

Peach

Like most fruit, a peach can have many colours. These range from bright yellow to deep reddy-purple. They are warm colours and are very powerful and exciting. When you are starting out, don't try to capture the velvet texture of the skin. Concentrate on the shape and form.

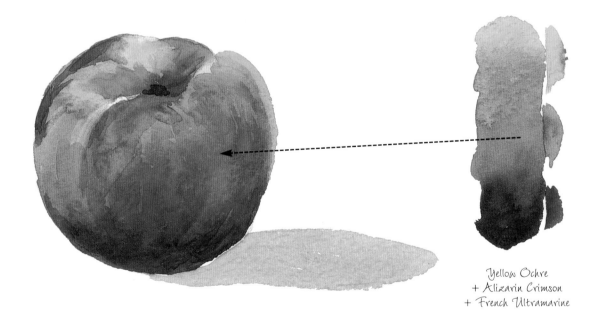

*Yellow Ochre
+ Alizarin Crimson
+ French Ultramarine*

When I painted this peach I wanted to show how to make it sit on the ground. This was done in two ways. The first was by painting a very dark area at the bottom of the peach.

This made it appear to be a round object, but it still looked as if it was 'floating' on the page. Adding the shadow made the peach sit on the ground.

Colourful cherries

Like peaches, cherries also have vibrant colours. They are very simple to draw and there are not large areas to cover with paint. This is a good example of how small you can paint a wash. Although the wash used on the cherry is very small in comparison to, say, a wash on a sky, the technique is the same.

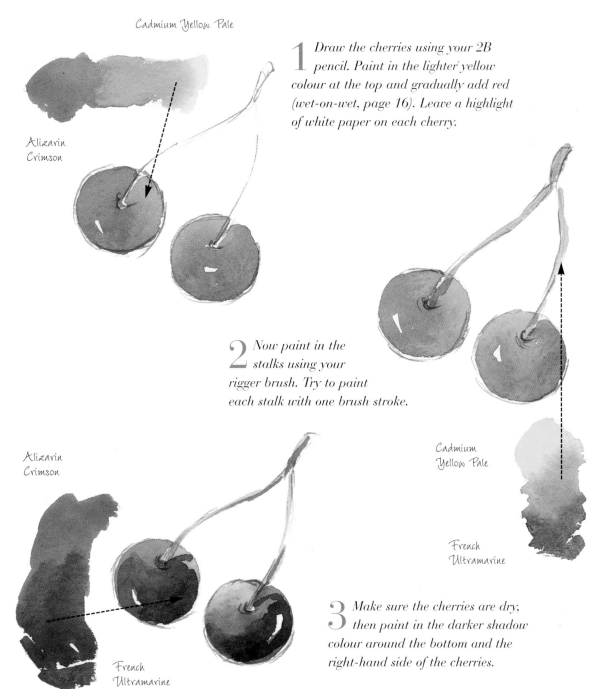

Cadmium Yellow Pale

Alizarin Crimson

1 *Draw the cherries using your 2B pencil. Paint in the lighter yellow colour at the top and gradually add red (wet-on-wet, page 16). Leave a highlight of white paper on each cherry.*

2 *Now paint in the stalks using your rigger brush. Try to paint each stalk with one brush stroke.*

Alizarin Crimson

Cadmium Yellow Pale

French Ultramarine

3 *Make sure the cherries are dry, then paint in the darker shadow colour around the bottom and the right-hand side of the cherries.*

French Ultramarine

Banana

This is another fruit that is not complicated to draw. When you have had a go at copying mine, try painting a banana from life. You might find the drawing more difficult, but copying this one will have given you more confidence.

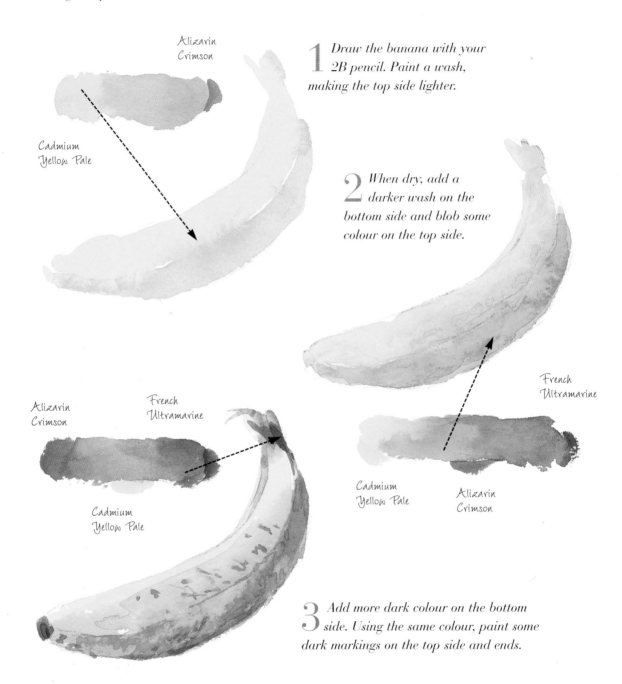

Alizarin Crimson

Cadmium Yellow Pale

1 *Draw the banana with your 2B pencil. Paint a wash, making the top side lighter.*

2 *When dry, add a darker wash on the bottom side and blob some colour on the top side.*

French Ultramarine

Alizarin Crimson

French Ultramarine

Cadmium Yellow Pale

Cadmium Yellow Pale

Alizarin Crimson

3 *Add more dark colour on the bottom side. Using the same colour, paint some dark markings on the top side and ends.*

Juicy grapes

These appear to be the most difficult of the fruit to paint, but if you look carefully, it's only like painting a lot of cherries, although different shapes and colours. Study them carefully before you start. Notice how in the finished stage light against dark and dark against light play an important part in making the grapes look 3D (page 24).

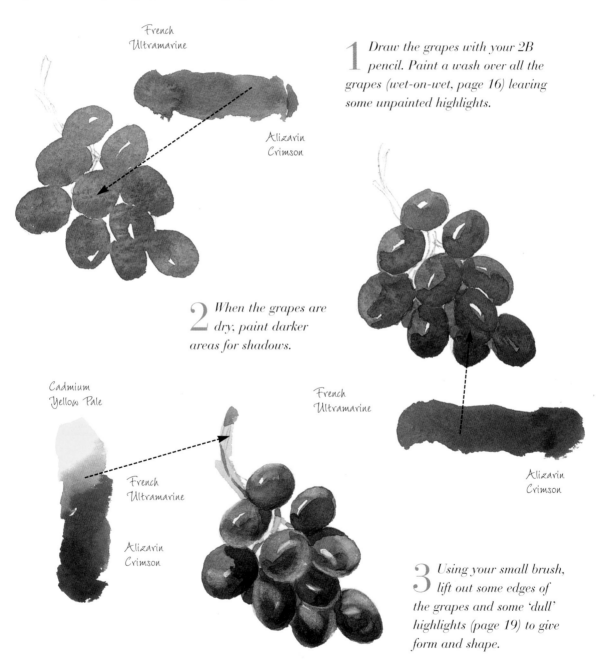

French Ultramarine

Alizarin Crimson

1 Draw the grapes with your 2B pencil. Paint a wash over all the grapes (wet-on-wet, page 16) leaving some unpainted highlights.

2 When the grapes are dry, paint darker areas for shadows.

Cadmium Yellow Pale

French Ultramarine

French Ultramarine

Alizarin Crimson

Alizarin Crimson

3 Using your small brush, lift out some edges of the grapes and some 'dull' highlights (page 19) to give form and shape.

DEMONSTRATION ◼ FRUIT

 AT A GLANCE...

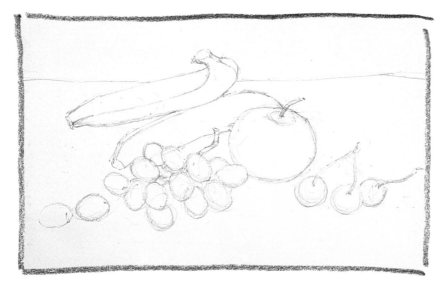

1 *Draw the fruit with your 2B pencil. Be positive with the pencil. It doesn't matter if the pencil lines still show through when the painting is finished. Start by drawing the first banana and work down to the grapes and cherries.*

2 *Using your small brush, paint the first wash on the bananas. Make the top side of the first banana lighter and the bottom side darker. This gives it form and dimension. Keep the painting simple at this stage.*

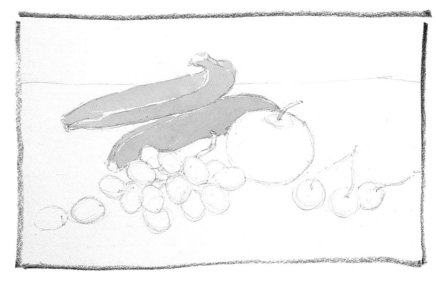

The palette

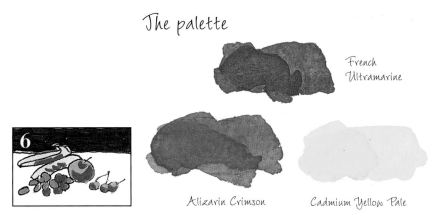

French
Ultramarine

Alizarin Crimson

Cadmium Yellow Pale

3 *With the same brush, paint in the apple. Work your wash wet-on-wet (page 16), changing the colours as you work your way down the apple. Leave some unpainted highlights. Now paint the cherries in the same way, also leaving some highlights.*

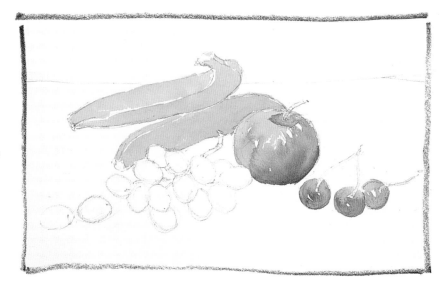

4 *Continue with the first wash on the grapes. Do not worry at this stage if the fruit does not look 'strong' enough. This is only the first wash and it is the next stage that will give strength and character to the fruit.*

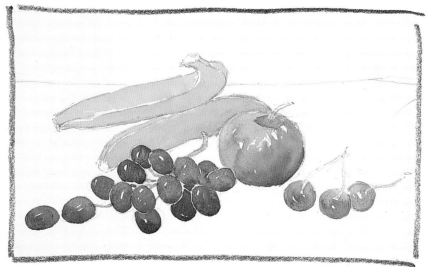

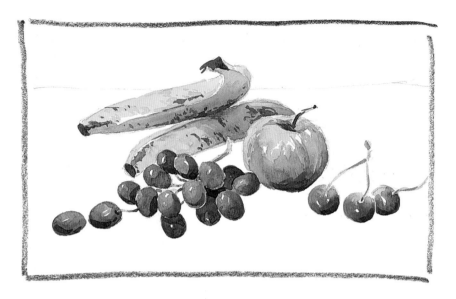

5 Paint in darker shadow areas on all the fruit and make sure they are dark enough to make the fruit appear 'round'. Remember to follow the shape of the fruit with your brush strokes. Next paint the dark markings on the bananas and the stalks on the other fruit.

Detail: The dark markings on the bananas are simple brush strokes, which follow the contour of the banana. The top of the apple comes away from the banana because the apple is light against the dark shadow of the banana.

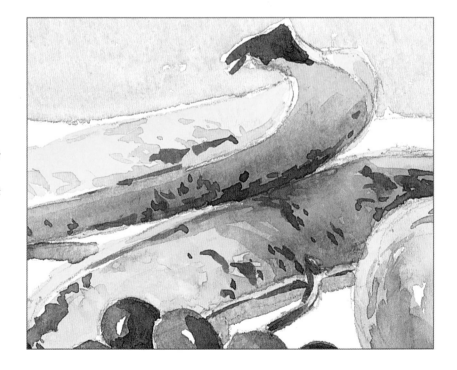

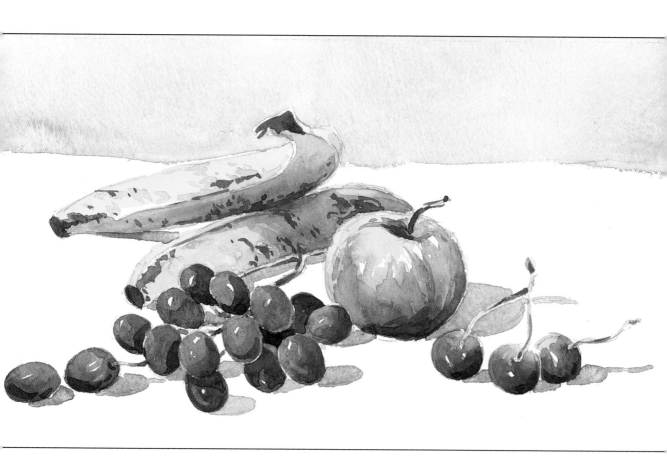

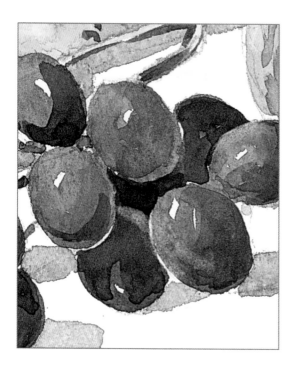

6 **Finished picture**: *Bockingford watercolour paper, 19 x 30 cm (7½ x 12 in). Using your big brush, paint in the background colour. Now mix a shadow colour with your small brush and paint in the shadows cast on the table. This makes the fruit 'sit' and not 'float' on the paper. Finally, add any darks (accents) that you feel will help your painting.*

Detail: *Two grapes have their shape defined by lifting out their edges with a brush.*

Getting started in watercolour 33

VEGETABLES

Like fruit, this is a subject that you can practise painting indoors to learn the techniques and the magic of watercolour under controlled conditions. This is important at the beginning, when you want as little interruption to your concentration as possible. There's enough to think about with the painting!

Green pepper

A pepper can look like a ceramic ornament, because of its smooth, shiny, bulbous shape and its very bright colouring. A pepper is a challenge to paint, so try painting the other simpler vegetables on the next pages first, then have a go at copying mine.

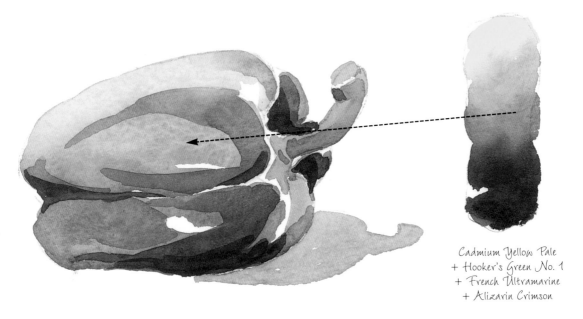

Cadmium Yellow Pale
+ Hooker's Green No. 1
+ French Ultramarine
+ Alizarin Crimson

The most important part of this painting was to capture the reflected shapes and shadows. I looked at the pepper very carefully to see 'shapes' of colour and tone (light against dark).

I began by using a wet-on-wet technique (page 16). When the wash was dry, I painted darker shapes on top. Note the white paper which I left for highlights.

Carrot

A carrot is easy to draw and nor is it complicated to paint. Its main colour is orange, but you will still use the three primary colours to mix from. To paint the carrot, you should use a graded colour wash technique (page 15).

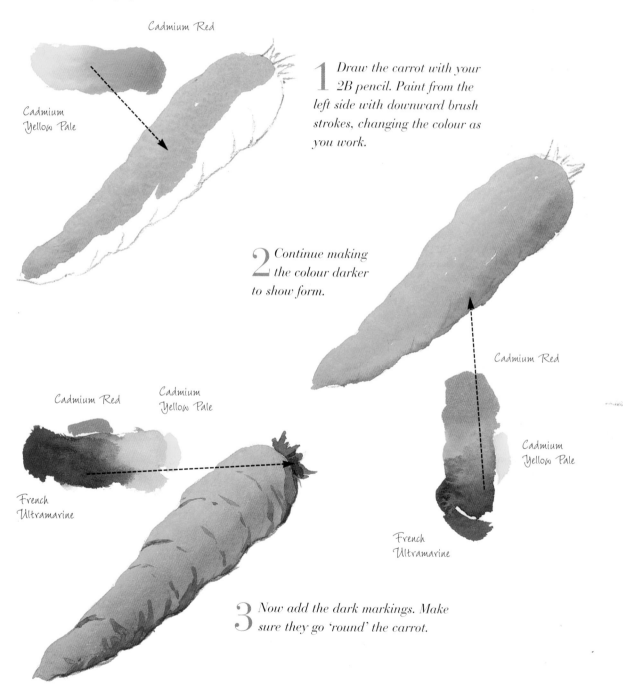

Cadmium Red

Cadmium Yellow Pale

1 Draw the carrot with your 2B pencil. Paint from the left side with downward brush strokes, changing the colour as you work.

2 Continue making the colour darker to show form.

Cadmium Red

Cadmium Yellow Pale

Cadmium Red Cadmium Yellow Pale

French Ultramarine

French Ultramarine

3 Now add the dark markings. Make sure they go 'round' the carrot.

Radishes

Radishes are very much like cherries and grapes to paint except they have extra drawing on the top and bottom. If you look at vegetables and fruit with an artistic eye, many of them are very similar in shape and are relatively easy to draw.

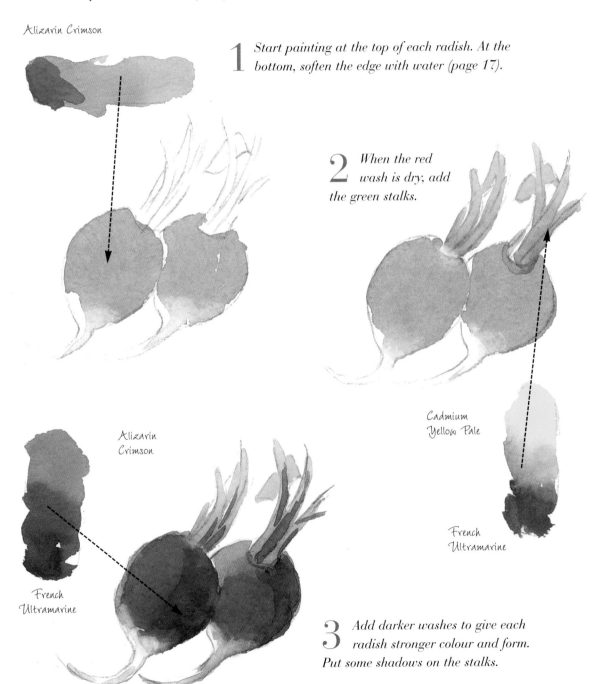

Alizarin Crimson

1 Start painting at the top of each radish. At the bottom, soften the edge with water (page 17).

2 When the red wash is dry, add the green stalks.

Cadmium
Yellow Pale

Alizarin
Crimson

French
Ultramarine

French
Ultramarine

3 Add darker washes to give each radish stronger colour and form. Put some shadows on the stalks.

Onion

By now, if you have been practising, you will be very familiar with making objects look round in shape. The onion is another round vegetable. It lends itself very well to watercolour, because the skin is suggested with thin transparent washes.

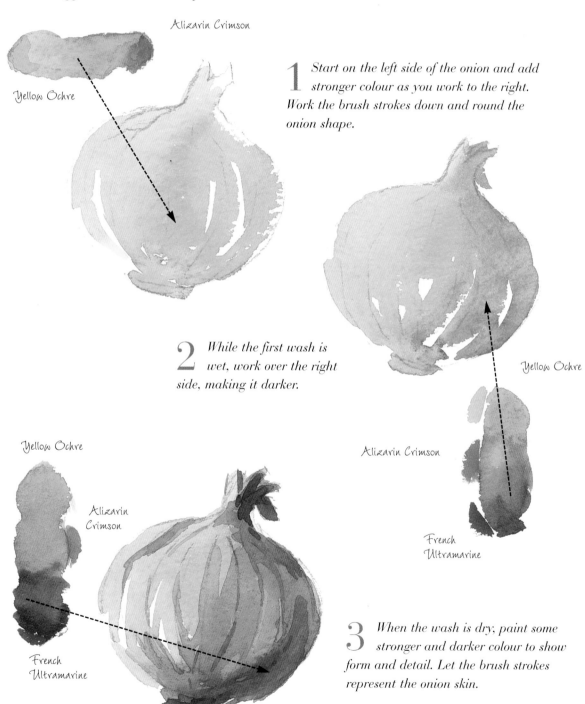

Alizarin Crimson

Yellow Ochre

1 *Start on the left side of the onion and add stronger colour as you work to the right. Work the brush strokes down and round the onion shape.*

2 *While the first wash is wet, work over the right side, making it darker.*

Yellow Ochre

Alizarin Crimson

French Ultramarine

Yellow Ochre

Alizarin Crimson

French Ultramarine

3 *When the wash is dry, paint some stronger and darker colour to show form and detail. Let the brush strokes represent the onion skin.*

FLOWERS

This is another subject that can be painted indoors. After copying these flowers, you could try painting some in your garden. In general, the shapes are a little more complicated than the fruit and vegetables, but if you have been practising, you shouldn't have any problems.

Daisy

I think that the daisy is one of the most positive flower shapes to paint. The petals can vary in size and position. and it is relatively simple to draw. Because the petals are white. in watercolour they can be left as unpainted paper with simple shadows painted on them.

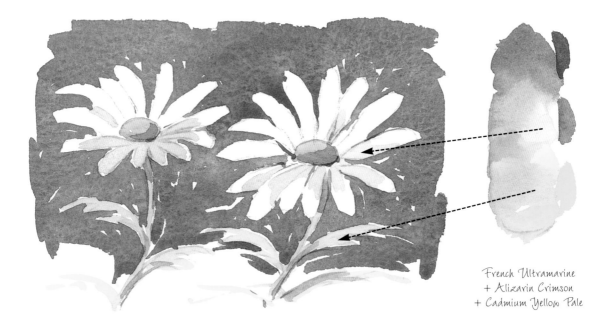

French Ultramarine
+ Alizarin Crimson
+ Cadmium Yellow Pale

The most important part of this painting was the blue sky background. This was done as a flat wash, but with the brush going in all directions to paint up to the petals. Remember that the secret of a good wash is to make sure your paint is very watery.

Crocus

There are some wonderful crocus colours to paint. Crocuses are only small flowers, but when they come up in early spring they really make you feel as if winter has gone. Because of their colour, the yellow ones remind me most of spring.

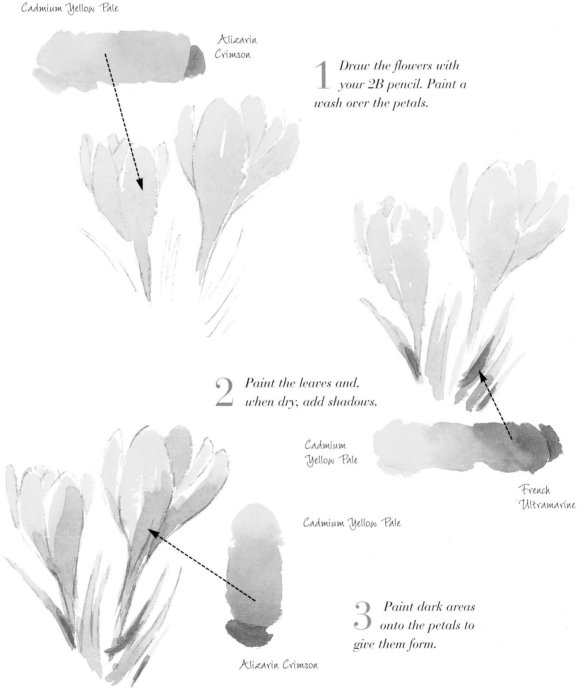

Cadmium Yellow Pale

Alizarin Crimson

1 Draw the flowers with your 2B pencil. Paint a wash over the petals.

2 Paint the leaves and, when dry, add shadows.

Cadmium Yellow Pale

Cadmium Yellow Pale

French Ultramarine

3 Paint dark areas onto the petals to give them form.

Alizarin Crimson

Fuchsia

If you like strong colour, the fuchsia couldn't be a better flower to paint. With its vibrant red and mauve, it is not a subject for the faint-hearted! Have a go with strong colour and enjoy it.

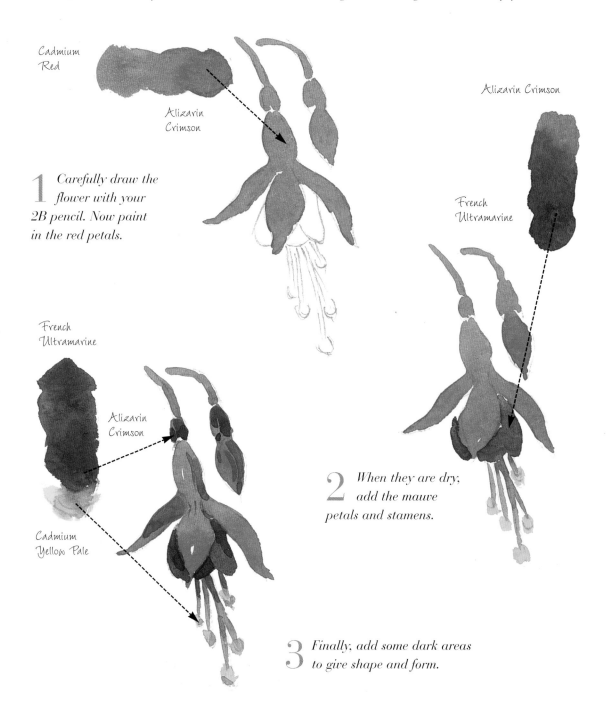

Cadmium Red

Alizarin Crimson

Alizarin Crimson

French Ultramarine

1 Carefully draw the flower with your 2B pencil. Now paint in the red petals.

French Ultramarine

Alizarin Crimson

Cadmium Yellow Pale

2 When they are dry, add the mauve petals and stamens.

3 Finally, add some dark areas to give shape and form.

Snowdrop

Painting a snowdrop is like painting a crocus upside-down. Because it is white like the daisy, it needs a dark background to help show its shape. With the daisy I painted the background first, but I have painted it last with the snowdrop.

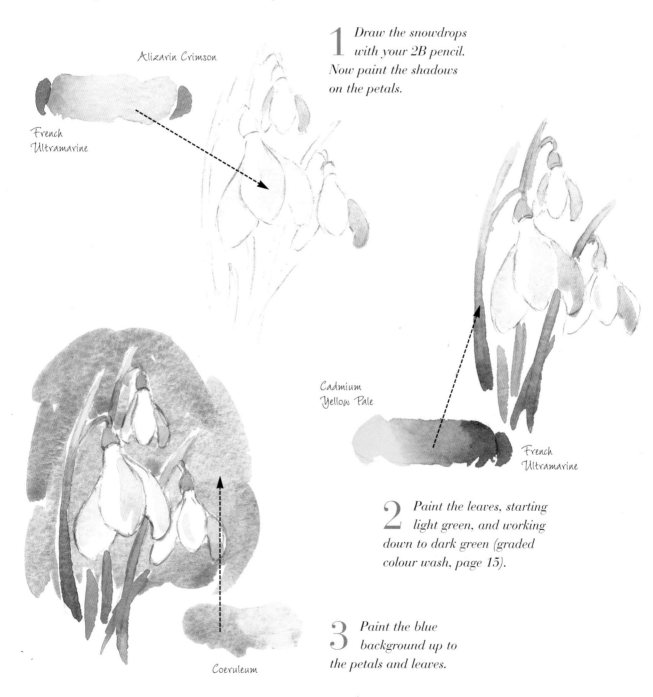

Alizarin Crimson

French Ultramarine

1 *Draw the snowdrops with your 2B pencil. Now paint the shadows on the petals.*

Cadmium Yellow Pale

French Ultramarine

2 *Paint the leaves, starting light green, and working down to dark green (graded colour wash, page 15).*

Coeruleum

3 *Paint the blue background up to the petals and leaves.*

SKIES

Skies are very inspirational. They set the mood for a landscape painting. You can look at them almost any time, from outside or through a window, so they are a subject with which you are very familiar. However, in order to paint them, you need to observe them more closely.

Heavy clouds

When you practise skies, always suggest the land as I have done in the painting below. This gives scale to your sky. Notice how the clouds, painted very simply, get smaller and narrower to the horizon, and the darker clouds are nearer to you. This gives the impression of distance.

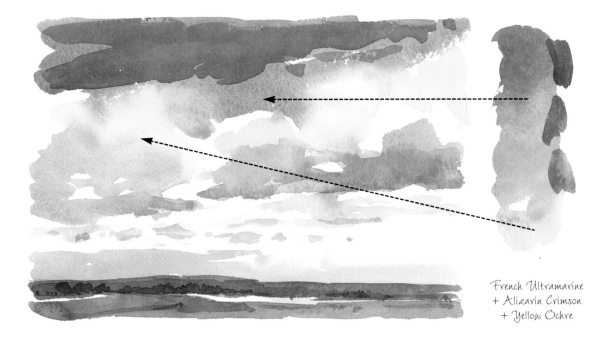

*French Ultramarine
+ Alizarin Crimson
+ Yellow Ochre*

I painted the blue sky first and while it was wet, painted the clouds (wet-on-wet, page 16). I allowed some clouds to run and merge with the *sky. When the paint was dry, I painted darker shadows on the clouds, and the very heavy dark cloud at the top over the original blue sky.*

Sunset

A sunset in any landscape painting runs the risk of looking a little 'over the top'. This is simply because a real sunset is often very vivid with its vibrant colours and strong shapes. The answer, until you get more experience, is to tone down the colours.

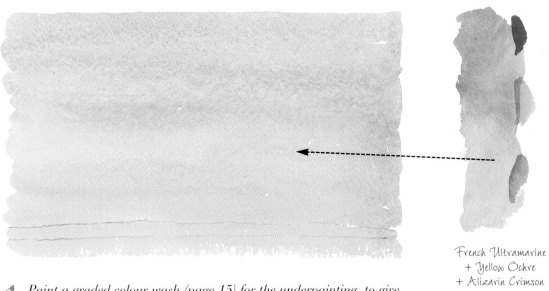

French Ultramarine
+ Yellow Ochre
+ Alizarin Crimson

1 *Paint a graded colour wash (page 15) for the underpainting, to give an all-over background colour.*

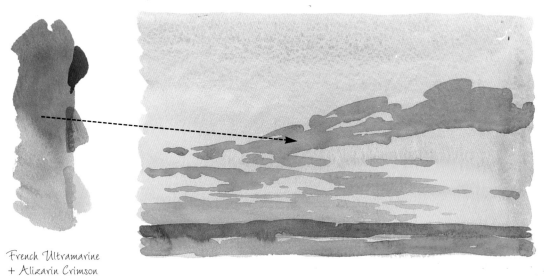

French Ultramarine
+ Alizarin Crimson
+ Yellow Ochre

2 *When the first wash is dry, paint in the clouds using positive and confident brush strokes, making them narrower nearer to the horizon (wet-on-dry, page 17).*

Soft clouds

The heavy cloudy sky (page 42) was painted with a lot of crisp edges. This sky is painted with soft edges (page 17). The clouds are further away and not overhead. There isn't a lot of definition in the clouds, which helps to make them look as if they are a long way off.

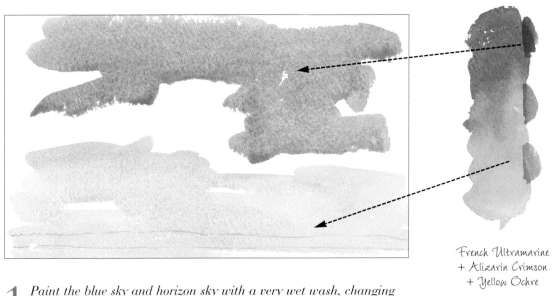

French Ultramarine + Alizarin Crimson + Yellow Ochre

1 *Paint the blue sky and horizon sky with a very wet wash, changing the colour as you paint (wet-on-wet, page 16).*

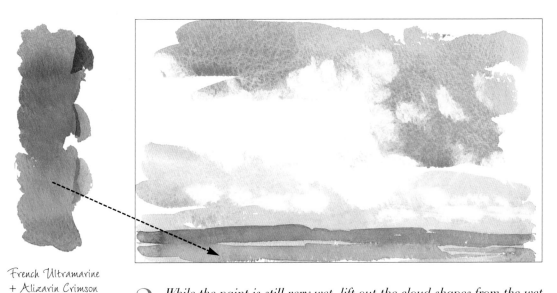

French Ultramarine + Alizarin Crimson + Yellow Ochre

2 *While the paint is still very wet, lift out the cloud shapes from the wet background sky with a screwed-up soft tissue (lifting out, page 19). When dry, suggest the land.*

Rainy sky

This type of sky always looks dramatic in a painting. As you are painting wet-on-wet, there will be happy accidents, but you can also get unhappy ones. So if it doesn't work it's not your fault! Try experimenting with other colours for the sky – for example, sunset colours.

Yellow Ochre

1 *Paint a wash from the left, with diagonal downward brush strokes working to the right. Leave a white (paper) area to represent sunlight.*

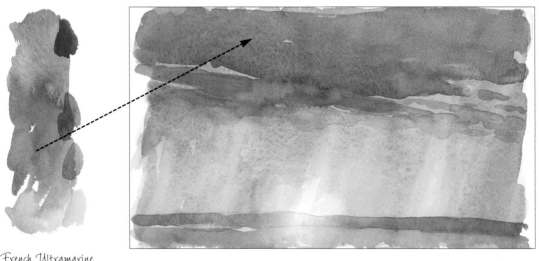

*French Ultramarine
+ Alizarin Crimson
+ Yellow Ochre
+ Cadmium Yellow Pale*

2 *Now paint the land. When this is dry, paint a wash over the whole sky and land. When dry, paint the dark clouds at the top and blend in to the 'rain' effect. Lift out sunlit areas with a brush (page 19).*

EXERCISE Paint a sky

When you paint this exercise, the first three stages are done while the paint is wet. So you can't be interrupted while you are painting these stages. Have your coffee when you finish! Use this picture as a guide only – it's impossible to copy mine exactly.

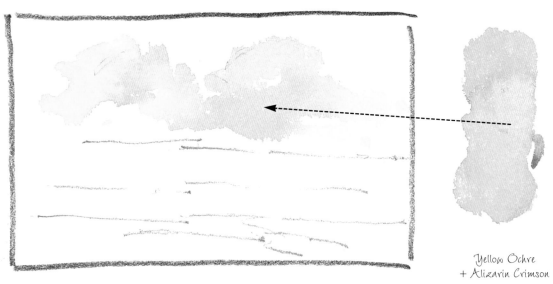

Yellow Ochre
+ Alizarin Crimson

1 *Draw the main features with your 2B pencil. Then paint the main cloud formation (wet-on-wet, page 16).*

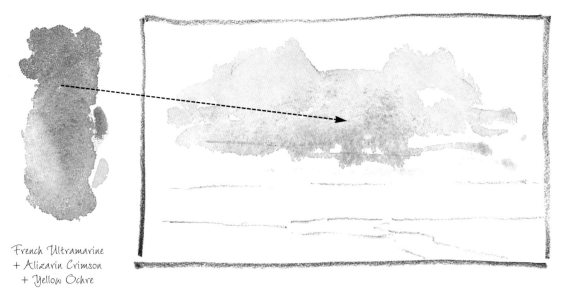

French Ultramarine
+ Alizarin Crimson
+ Yellow Ochre

2 *Add shadow colour to the clouds (page 24). Put your brush into the yellow and paint down.*

The palette

French Ultramarine　　Alizarin Crimson　　Yellow Ochre　　Hooker's Green No. 1

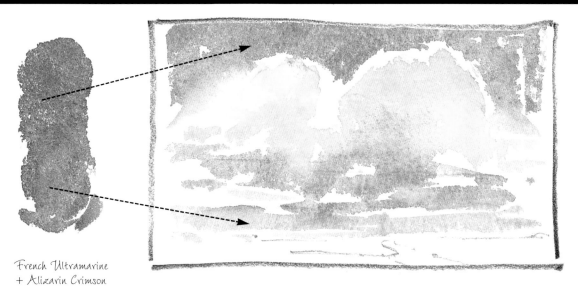

French Ultramarine
+ Alizarin Crimson

3　*Paint in the blue sky above and below the main clouds. Leave white
paper edges and in some places let the blue merge into the clouds.*

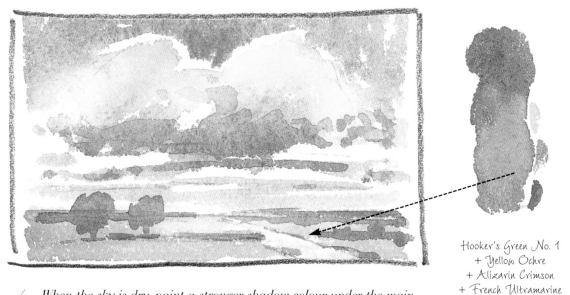

Hooker's Green No. 1
+ Yellow Ochre
+ Alizarin Crimson
+ French Ultramarine

4　*When the sky is dry, paint a stronger shadow colour under the main
clouds. Then paint the land.*

TREES

Trees are one of my favourite subjects. There are plenty of different shapes and sizes to work from, and of course they change their look and colouring during the four seasons. When you are painting trees, always keep them simple, and remember that, like a vivid sunset, a full autumn colouring can look over the top, so try to tone the colours down!

Winter willow

Willows have a very distinctive shape and cannot be mistaken for any other tree. They grow in wet areas by or near rivers and lakes. If you are working from your imagination, don't paint willows on hills – they would look wrong!

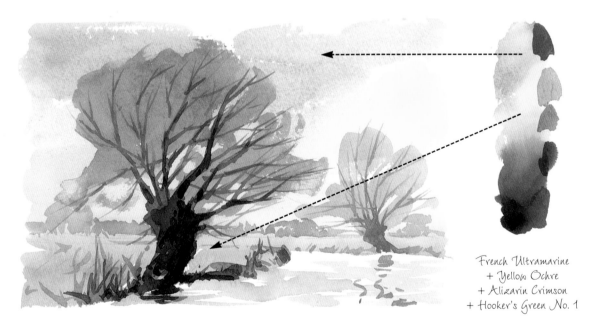

French Ultramarine
+ Yellow Ochre
+ Alizarin Crimson
+ Hooker's Green No. 1

I painted the trees on the background once it was dry. The further tree is painted in just two washes; the trunk and branches first, then a wash for the overall shape. The foreground tree was done the same way but with more work on the trunk. Note how I have put them near water.

48 Getting started in watercolour

Winter tree

It is a good idea to start by drawing winter trees. You then see all the branches, and the way the tree forms its shape.

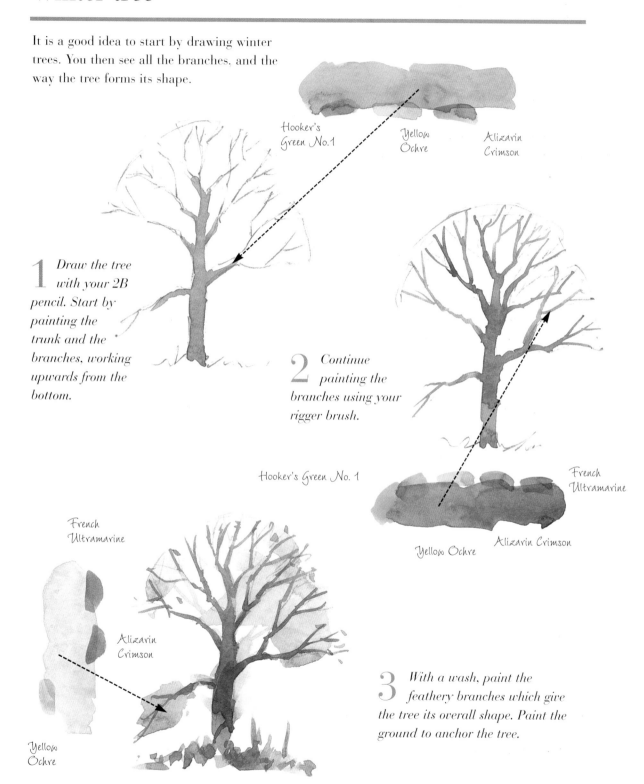

Hooker's Green No.1

Yellow Ochre

Alizarin Crimson

1 *Draw the tree with your 2B pencil. Start by painting the trunk and the branches, working upwards from the bottom.*

2 *Continue painting the branches using your rigger brush.*

Hooker's Green No. 1

French Ultramarine

Yellow Ochre

Alizarin Crimson

French Ultramarine

Alizarin Crimson

Yellow Ochre

3 *With a wash, paint the feathery branches which give the tree its overall shape. Paint the ground to anchor the tree.*

Sketching trees

When you are outdoors with your pencil and sketchbook, make sketches of trees or any parts of trees that interest you. Make notes at the side or on the back of the paper. If you have your paints, then add some colour. These pages give you an idea of what to look for.

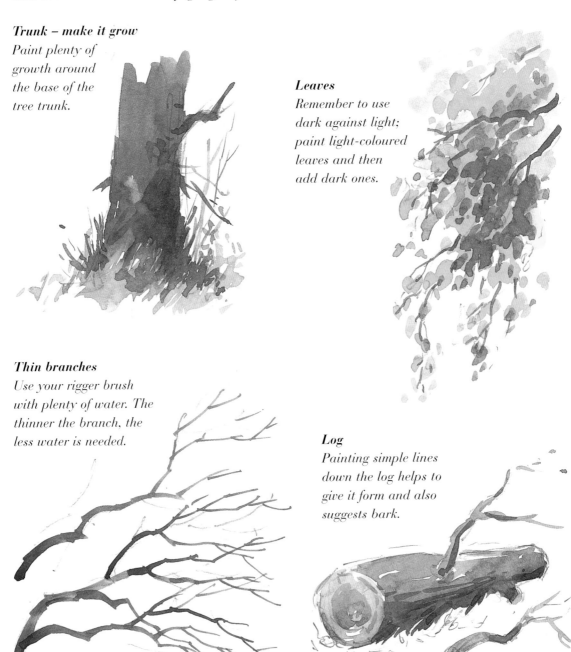

Trunk – make it grow
Paint plenty of growth around the base of the tree trunk.

Leaves
Remember to use dark against light; paint light-coloured leaves and then add dark ones.

Thin branches
Use your rigger brush with plenty of water. The thinner the branch, the less water is needed.

Log
Painting simple lines down the log helps to give it form and also suggests bark.

Fir tree silhouette
This can be very
effective.

Close-up branch
Draw some close-up
branches with your
2B pencil. Then
add some colour.

Distant autumn trees
A very simple suggestion
of distant trees. Paint
them using your small
brush with one wash.

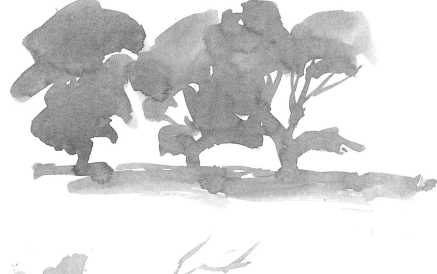

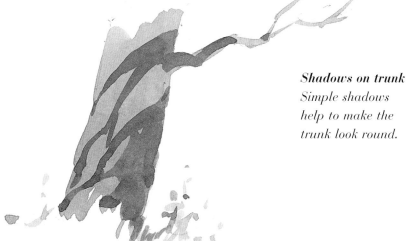

Shadows on trunk
Simple shadows
help to make the
trunk look round.

Paint a summer tree

Don't overwork a tree in leaf. Make sure you leave some sky showing through the leaves in places and show some branches, or the tree will look too solid. Until you have experience, don't paint trees too close-up; paint them in the middle distance like the one below.

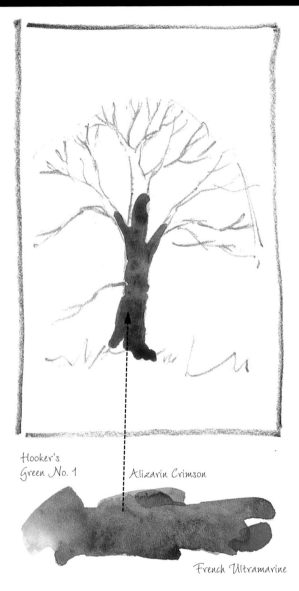

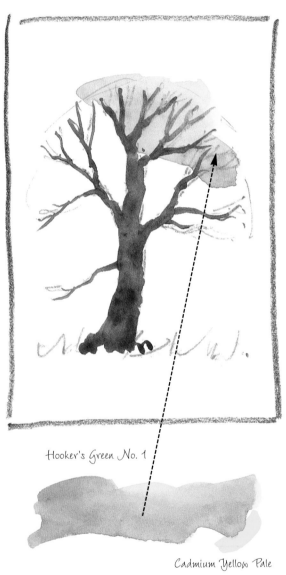

Hooker's
Green No. 1

Alizarin Crimson

French Ultramarine

Hooker's Green No. 1

Cadmium Yellow Pale

1 *Draw in with your 2B pencil. Start painting the trunk working from the bottom upwards, like the winter tree (page 49).*

2 *Continue with the small branches using your rigger brush. Then start painting a wash of green from the top.*

The palette

Hooker's Green No. 1

Alizarin Crimson

French Ultramarine

Cadmium Yellow Pale

Alizarin Crimson

Hooker's Green No. 1

Hooker's Green No. 1

Alizarin Crimson

Cadmium Yellow Pale

3 *Continue with the green wash using free brush strokes. Let the brush strokes dictate the shapes.*

4 *Using the same brush stroke, paint in the darker foliage. Go over the trunk, then paint the ground. The fence posts suggest scale.*

DISTANCE AND FOREGROUND

When painting distant objects, one very important rule of thumb is that cold or cool colours, such as blues, recede into the distance, whereas warm colours, such as reds, advance. This means that the colours you use for distant objects are in the blue cool range and the colours for the foreground are in the red warm range. Another important rule is that objects in the foreground are more detailed than those in the distance.

Distant village

This picture contains many optical illusions to show distance. The clouds get smaller to the horizon. The distant trees and buildings are cool blue/grey, and the warmer colours are in the foreground. The road leads you into the distance, the distant buildings are pale and not painted in any detail, and the telegraph poles become smaller as they get further away.

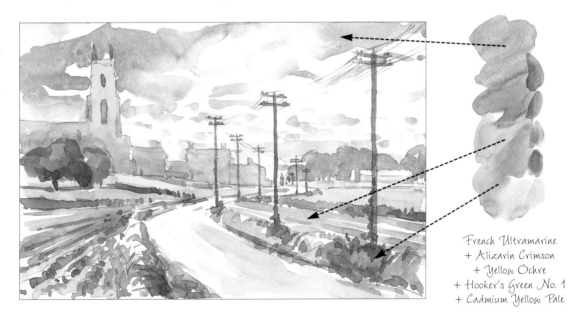

French Ultramarine
+ Alizarin Crimson
+ Yellow Ochre
+ Hooker's Green No. 1
+ Cadmium Yellow Pale

The most important thing to remember is that although I could see the village in reasonable detail, I had to simplify it in order to keep it in the distance. Notice that there is no detail, except for the church windows. The silhouette shape of the buildings is important.

Distant hills

This is a very good simplified example to show how cool colours recede. It includes another optical illusion: colours get paler as they recede into the distance. You can often see this very clearly in hilly countryside. Note the warm colour that is used for the foreground field.

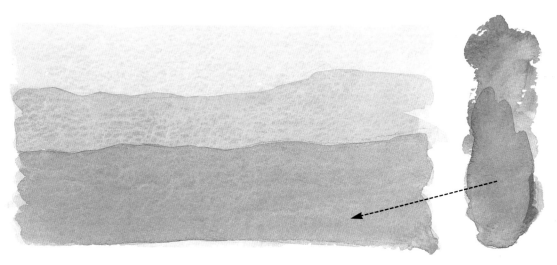

French Ultramarine
+ Alizarin Crimson
+ Yellow Ochre

1 *Paint a pale blue wash down to the field. When dry, paint over it with a darker wash. Finally, when this is dry, paint a third even darker wash over the last one.*

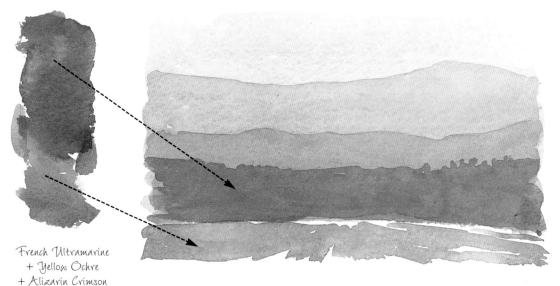

French Ultramarine
+ Yellow Ochre
+ Alizarin Crimson

2 *Paint in the last dark hill. Let the brush bounce around at the top to represent the simple silhouettes of trees. Finally, paint the warm foreground field.*

Foreground path with fence

One of the biggest problems that beginners have when painting the foreground is that they try to include too much detail. Keep the foreground simple. Look how simple mine is in the exercises on these pages, and on page 54.

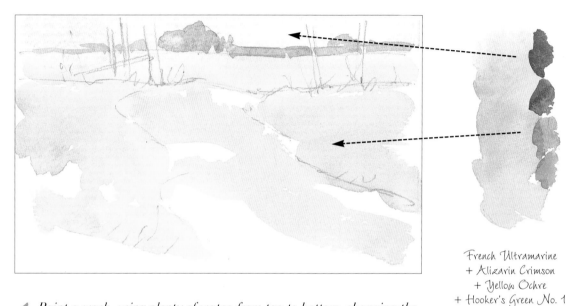

*French Ultramarine
+ Alizarin Crimson
+ Yellow Ochre
+ Hooker's Green No. 1*

1 *Paint a wash, using plenty of water, from top to bottom, changing the colour as you go. When dry, paint in the distant trees.*

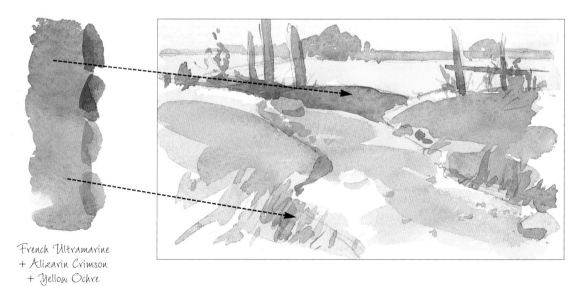

*French Ultramarine
+ Alizarin Crimson
+ Yellow Ochre
+ Hooker's Green No. 1*

2 *Paint stronger greens and browns to show simple form. When dry, paint in the fence and shadows.*

Foreground snow

Watercolour is a great medium for painting snow. Let the white paper be your lightest snow areas and add washes to show form and shape. Keep the snow simple.

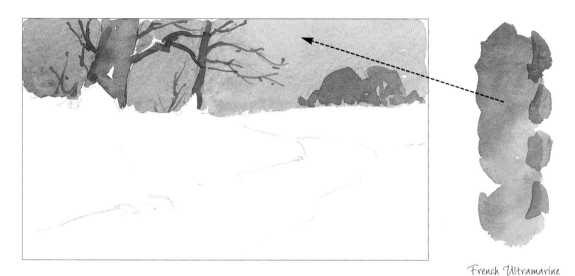

French Ultramarine
+ Alizarin Crimson
+ Yellow Ochre
+ Hooker's Green No. 1

1 *Paint in the sky, leaving the big tree trunk as white paper. When dry, paint in the trees. Leave an area of unpainted paper at the bottom of the trunks to represent snow.*

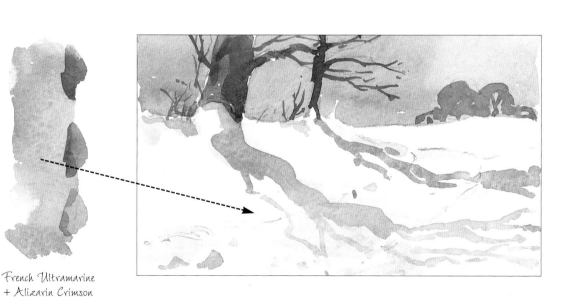

French Ultramarine
+ Alizarin Crimson
+ Yellow Ochre

2 *With free, simple brush strokes, paint washes to show the contours of the snow. When dry, paint in the tree shadows. Remember to keep it simple.*

DEMONSTRATION LANDSCAPE

 AT A GLANCE...

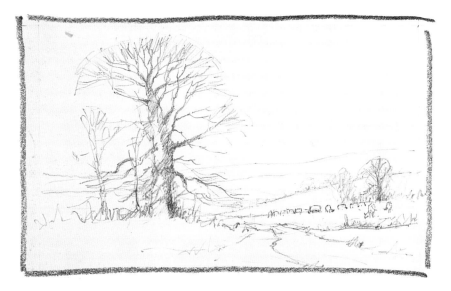

1 *Draw this landscape on cartridge paper with your 2B pencil. Shade in the shadow areas on the trees. This shading and pencil work will help to make the painting look more 'alive' and complicated when you paint it. I work a lot like this when I am painting outdoors.*

2 *Using your big brush, paint a wash for the sky, changing the colours as you get nearer the horizon. Leave some 'flecks' of white paper showing to represent distant clouds. Paint the sky over the distant hills. Use French Ultramarine, Alizarin Crimson and Yellow Ochre.*

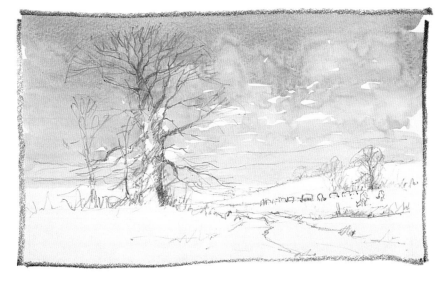

The palette

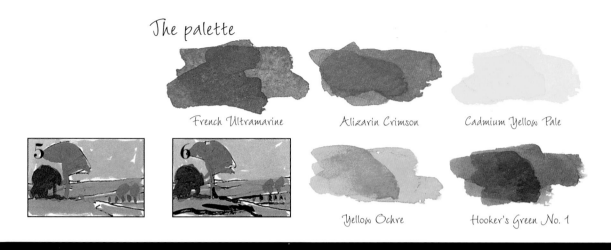

French Ultramarine

Alizarin Crimson

Cadmium Yellow Pale

Yellow Ochre

Hooker's Green No. 1

3 *Using your big brush, paint the distant hills in two washes, as you did on page 55. Don't paint over the tree trunk. Now paint the distant fields, working down to the foreground field. Leave the cows unpainted. Note how freely this was painted.*

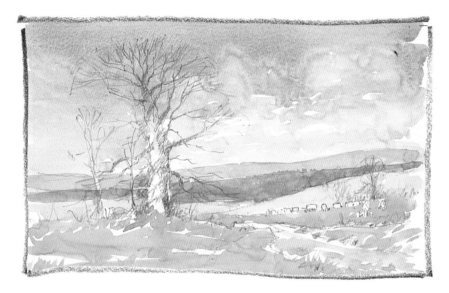

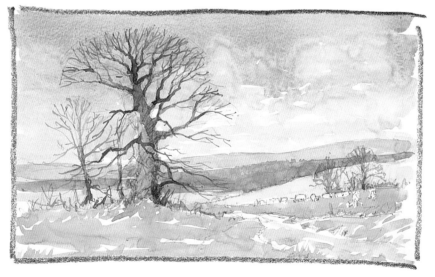

4 *Now paint in the main trees. Use your small brush for the main trunk and large branches and your rigger brush for the small branches and small trees. Notice how I have painted the left hand side of the main tree trunk paler to show the sunlight on it.*

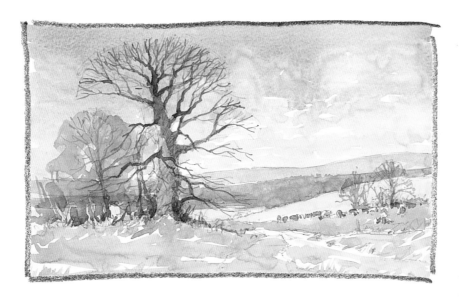

5 Now with a wash of Cadmium Yellow Pale, Alizarin Crimson and French Ultramarine, paint the autumn colour on the left-hand trees. Let the colours mix on the paper (wet-on-wet, page 16). Notice how the cool colours (hills) recede and the warm colours (trees and foreground) come forward.

Detail: Paint the autumn colours in one wash over all the branches. Look how I have left areas of background (sky and hills) to show through. Don't try to copy mine; it's impossible. Just let this happen accidentally as you paint.

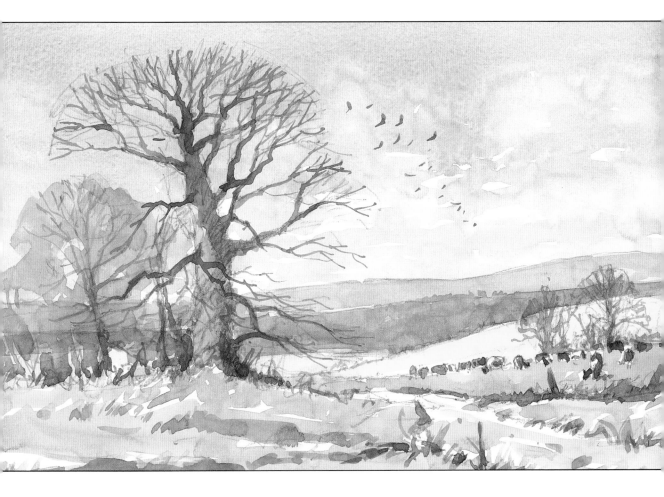

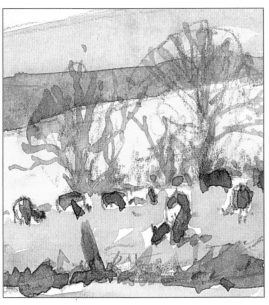

6 **Finished picture**: *cartridge paper, 19 x 30 cm (7½ x 12 in). Suggest a simple foreground with shadows. Paint the cows darker and add the birds. This painting looks complicated, but remember that it is built up using simple techniques. It is only when everything is put together that it looks complete and complicated.*

Detail: *Notice how freely the cows and trees have been painted. Look how the distant hills recede.*

SIMPLE BUILDINGS

A building without its details is just like the box you practised painting earlier, on page 24. Naturally this is over-simplifying things. But remember, if you can look at an object or scene and simplify it in your mind's eye for painting before you start, you are well on the way to becoming a good artist.

Simplify

If you stood in the high street and were asked to paint it, it would naturally be too complicated for you. Before you can paint buildings, you must learn to simplify. Here are two very different but simple ways to make a start.

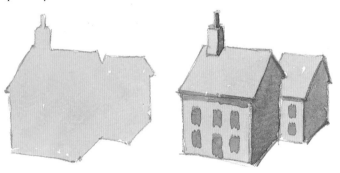

The house was a flat shape before the shadow was added. Remember, light against dark gives shape and form (page 24).

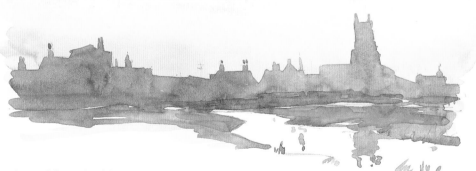

A way of simplifying buildings is to paint them in silhouette against a bright sky or sunset. It is only the outline form you need to concentrate on. I drew these then painted the

sky down and into the foreground. When dry I painted the buildings wet-on-wet, changing the colours very subtly as I worked (page 16).

Simple village

These village houses are all based on the box (page 24) and the yellow house opposite. It is light against dark that shows the form. I keep repeating this but it is most important. Look at the church tower in stage 1. It looks completely flat. Put a shadow on, stage 2, and it becomes solid.

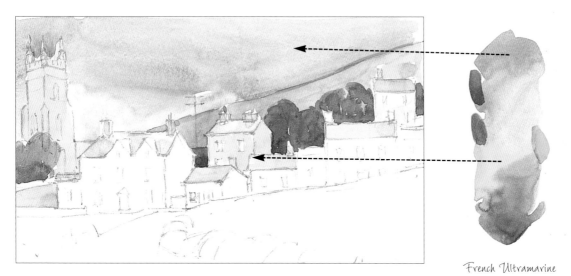

French Ultramarine
+ Alizarin Crimson
+ Yellow Ochre

1 *Draw in with your 2B pencil. Paint in the colours on this first stage. Note that the painting looks flat, but look how the yellow house stands out – light against the dark background.*

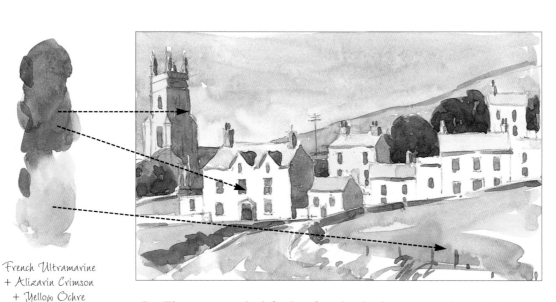

French Ultramarine
+ Alizarin Crimson
+ Yellow Ochre
+ Hooker's Green No. 1
+ Cadmium Yellow Pale

2 *The sun is on the left, therefore the shadows are on the right. Paint them in and with the same colour paint the windows. Notice they are just square blobs of paint – no detail. Now paint the simple foreground.*

EXERCISE Paint buildings

I have chosen this scene, made up from a real place with my own additions, to show how light against dark shows form and shape. Remember that to get crisp edges you must apply paint on to dry paint; if it is wet your colours will merge and you will lose the shapes of the buildings.

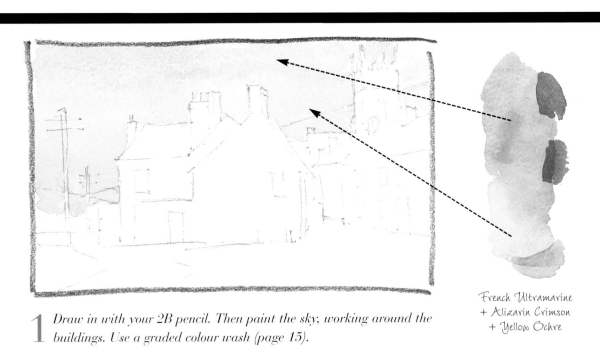

French Ultramarine
+ Alizarin Crimson
+ Yellow Ochre

1 *Draw in with your 2B pencil. Then paint the sky, working around the buildings. Use a graded colour wash (page 15).*

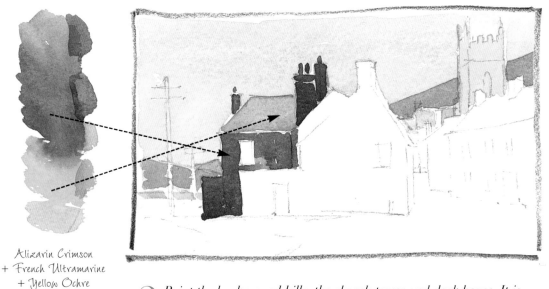

Alizarin Crimson
+ French Ultramarine
+ Yellow Ochre
+ Cadmium Red

2 *Paint the background hills, the church tower and dark house. It is important to get the silhouette shapes of the church and house correct.*

The palette

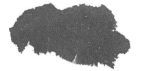

French Ultramarine

Alizarin Crimson

Yellow Ochre

Cadmium Red

French Ultramarine
+ Alizarin Crimson
+ Yellow Ochre

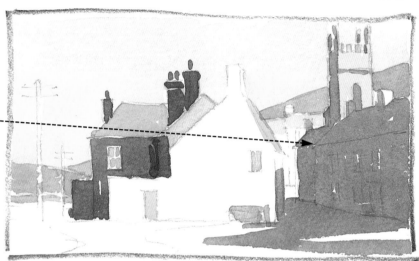

3 *With a shadow colour wash (page 24), paint down the church tower and the row of houses, on the road and up one side of the white house. Paint the windows and door.*

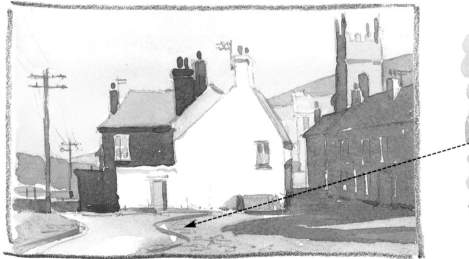

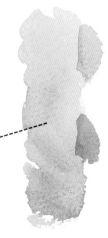

Yellow Ochre
+ Alizarin Crimson

4 *Paint the foreground with a warm wash and go over the shadow. Finally add a few dark accents where you feel they are needed.*

WATER

When water is painted well, it always looks good in a painting. The biggest trap that beginners fall into is to overwork water, making it look too complicated and unrealistic, and getting it less 'watery' with each brush stroke. The secret with water is to keep it simple; do not overwork it.

Reflections

Look how simple this water is. The water is unpainted paper. It is just the reflection that makes it appear to be water. It is important to put reflections into your water where possible.

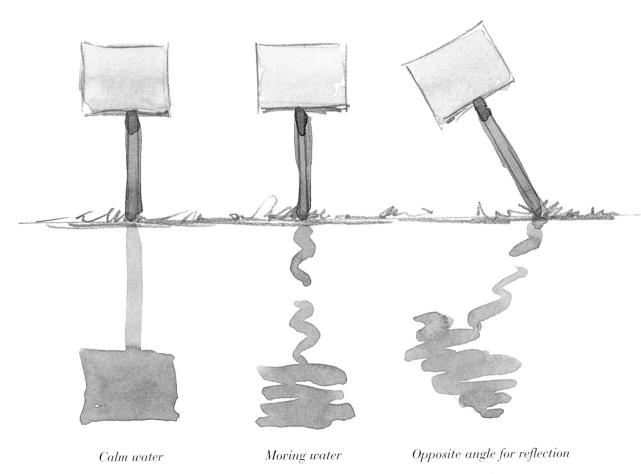

Calm water *Moving water* *Opposite angle for reflection*

Still water

If the water is without movement, the images are reflected mirror-like. But don't get too fussy about an exact image; it is a painting you are doing, not a photographic copy.

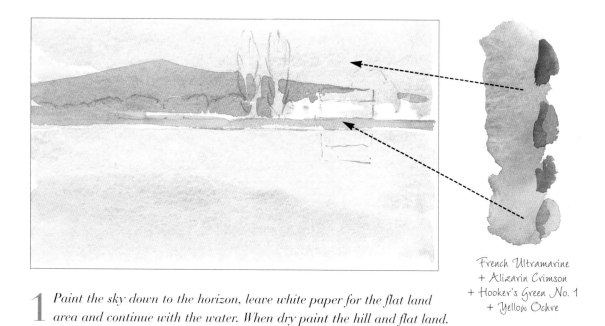

French Ultramarine
+ Alizarin Crimson
+ Hooker's Green No. 1
+ Yellow Ochre

1 *Paint the sky down to the horizon, leave white paper for the flat land area and continue with the water. When dry paint the hill and flat land.*

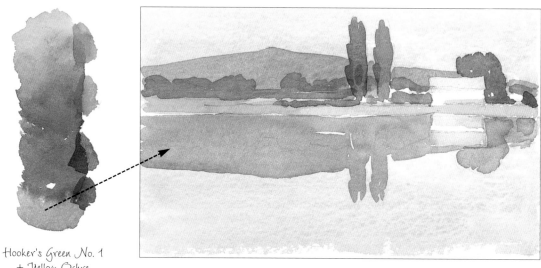

Hooker's Green No. 1
+ Yellow Ochre
+ Alizarin Crimson
+ French Ultramarine

2 *Finish the land and then paint in the reflections with one wash, starting with green and changing to grey. Remember, keep it simple, don't be tempted to keep working at it.*

Moving water

Moving water, such as a river or some water with movement on it created by the wind or boat traffic, is easy to paint in watercolour and looks very effective.

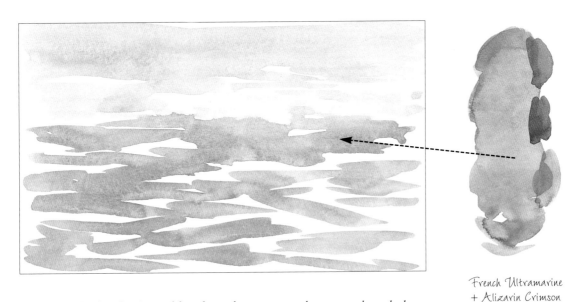

French Ultramarine
+ Alizarin Crimson
+ Yellow Ochre

1 *Using broken horizontal brush strokes, start at the top and work down. Leave areas of white paper for reflected light on the water.*

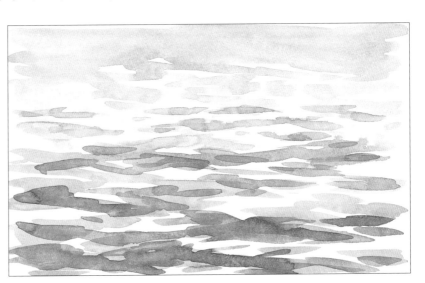

French Ultramarine
+ Alizarin Crimson
+ Yellow Ochre

2 *When the first stage is dry, paint over the top with darker colour, still using broken horizontal brush strokes.*

Estuary water

There are no reflections from the land in this water. This often happens when the water is a long way off. But if you look again, you can see reflections in the water from the sky. It is this that helps the estuary look like water. Remember that the sky is always reflected in water.

Yellow Ochre
+ Alizarin Crimson
+ French Ultramarine
+ Cadmium Yellow Pale

1 *Paint in the sky and water with the same colours. Leave some white unpainted paper in the distant water. Paint in the land.*

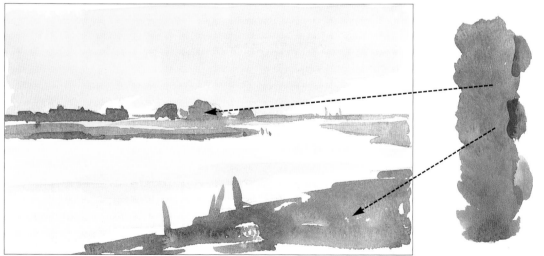

2 *Paint in the landscape. The time is evening and so it is in silhouette. Another reason the estuary appears to be water is that the land is dark against the very light water.*

French Ultramarine
+ Alizarin Crimson
+ Yellow Ochre

Boats

When you paint water you will at some time have to paint boats. You need to be reasonably good at drawing to tackle some boats, but there are ways of simplifying them. One way is to paint them in silhouette (see opposite). This takes away the need to include difficult detail.

1 *This boat has one wash painted over it. This is the same as the box on page 24.*

2 *Add the shadow with one wash and the boat becomes a solid 3D object and not a flat shape.*

1 *This small cruiser requires more drawing, but the shapes are simple – observe them carefully. Then paint the first wash. The two men give scale to the boat.*

2 *Paint the dark shadows and finally the reflection. It now looks as if it is in water.*

Yellow Ochre

Alizarin Crimson

French Ultramarine

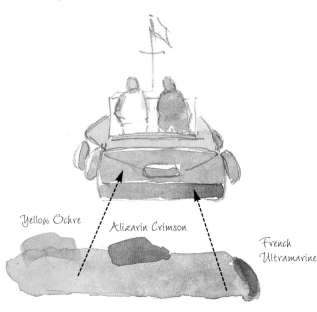

Sketching boats

Take your sketchbook out and enjoy a day sketching boats. Don't draw or paint any in the foreground. Draw them from a distance and you will lose a lot of the complicated detail. Detail will come automatically the more you practise.

Distant yacht
The white sail of the yacht is the most important part of this sketch, because it is a recognizable image.

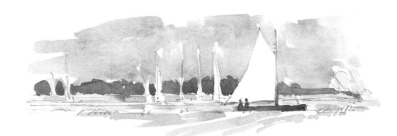

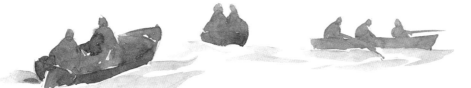

Silhouettes
Silhouettes are not an easy way to avoid learning to draw! But they are easier for a beginner to paint. Remember: a silhouette can be dark against light, or light against dark.

Fishing boat
This is the most adventurous sketch. You need to have drawing skills for this. But look how simple the painting is, using light against dark to show form. And the reflection is painted very simply.

Pebble beach

The coast is full of diverse subjects for watercolour. Because you can see the horizon you get vast, uninterrupted skies to paint. However, the most obvious subjects are the beach and sea. Below is just one way of painting a pebble beach.

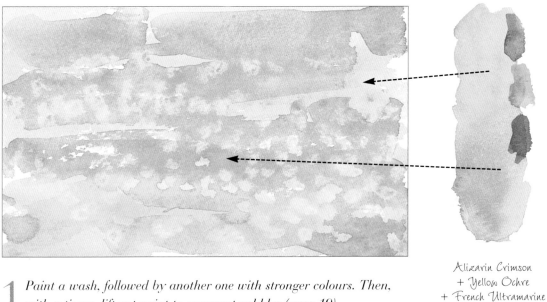

Alizarin Crimson
+ Yellow Ochre
+ French Ultramarine

1 *Paint a wash, followed by another one with stronger colours. Then, with a tissue, lift out paint to represent pebbles (page 19).*

Alizarin Crimson
+ Yellow Ochre
+ French Ultramarine
+ Pencil

2 *With stronger colour and shadow colour, suggest some of the pebbles. Finish by drawing in some pebble shapes with your 2B pencil over the dry paint.*

Waves

Waves are always moving and are therefore difficult to paint. It is helpful to sit and watch the patterns that they make until you become familiar with the shapes. You could also use photographs as a guide.

French Ultramarine
+ Alizarin Crimson
+ Hooker's Green No. 1
+ Yellow Ochre

1 *With a wet-on-wet wash (page 16), paint in the water, leaving areas of white paper for the light coloured foam.*

French Ultramarine
+ Alizarin Crimson
+ Hooker's Green No. 1
+ Yellow Ochre

2 *Using darker colours, paint under the breaking waves, and the beach. Now with a wet brush, lift out areas to represent fine spray (page 19). Then add some dark brush strokes to represent thrown pebbles.*

Sketching the coastline

Don't forget your sketchbook! There's always time and plenty of subjects to practise on, especially at the coast. Remember that sketches are not only a means of gathering information, but, more importantly for a beginner, they are also a way to enjoy practising. It isn't the end result that matters; it's the fact that you have observed and drawn, gathering experience.

Deckchairs
These are almost as difficult to sketch as to put up! This is a very well-known seaside image.

Pier
This is in silhouette, but you don't see detail if it is in the middle distance. Notice how simple the sea is.

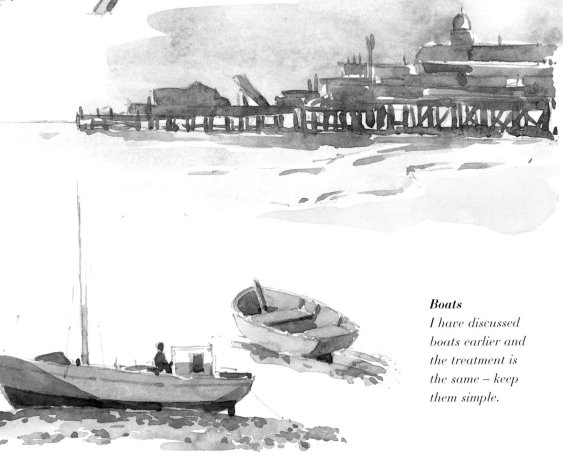

Boats
I have discussed boats earlier and the treatment is the same – keep them simple.

Cliffs

Another traditional coastline view. Cliffs are simple to sketch but very dramatic. Note how the people give scale.

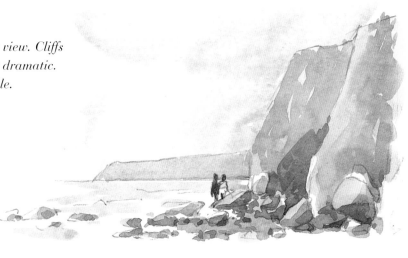

Crab

This is easy to draw but more difficult to paint. The shell and claws were done wet-on-wet (page 16). When dry, another wash was applied to give crispness to the shell.

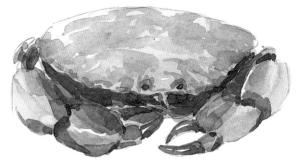

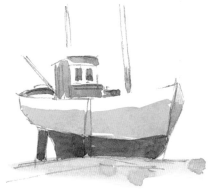

The red boat

This is painted very simply, using just two washes.

Shells

You can find these almost anywhere, and you can paint them on the beach or at home.

Windbreaks

This simple sketch works because the subject is uncomplicated and it is painted dark (posts) against light (sea). Remember, silhouette shapes are very effective in watercolour.

EXERCISE Paint a boat

If you look at stage 4, this fishing boat looks complicated to paint. However. if you follow the stages carefully and you have been practising, you won't have any problems. But first you must draw it carefully. Remember, the more you practise the better you will get.

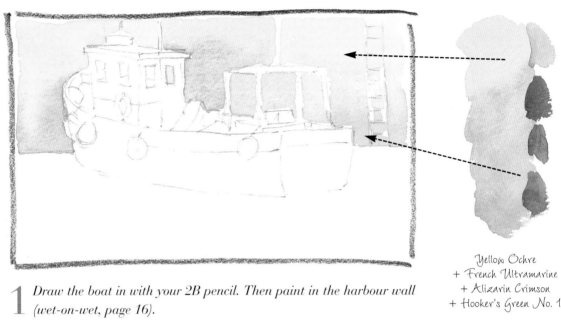

Yellow Ochre
+ French Ultramarine
+ Alizarin Crimson
+ Hooker's Green No. 1

1 *Draw the boat in with your 2B pencil. Then paint in the harbour wall (wet-on-wet, page 16).*

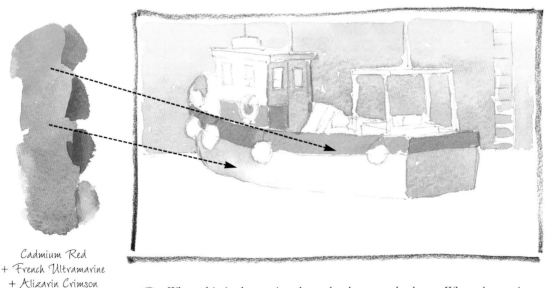

Cadmium Red
+ French Ultramarine
+ Alizarin Crimson
+ Yellow Ochre

2 *When this is dry, paint the red colour on the boat. When dry, paint the shadow areas, going over the red on the shadow sides.*

The palette

Yellow Ochre

French Ultramarine

Alizarin Crimson

Hooker's Green No. 1

Cadmium Red

Hooker's Green No. 1
+ French Ultramarine
+ Yellow Ochre

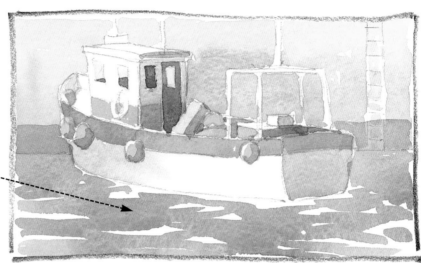

3 *Add more work to the boat and then paint in the water as you did for the exercise on page 68.*

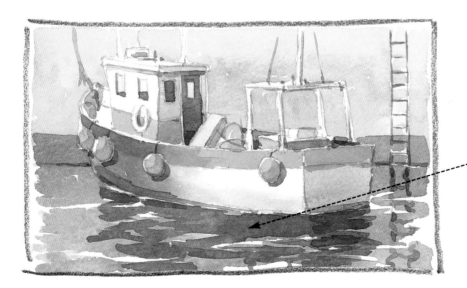

Hooker's Green No. 1
+ French Ultramarine
+ Alizarin Crimson

4 *Add some more darks and shadows to the boat. Paint in the ladder. Finally, paint in the reflections.*

PAINTING PEOPLE
Sharon Finmark

Figure work is one of the most exciting and rewarding of all painting subjects. Figures can add atmosphere to a painting and even hint at a story. Paintings of interiors and landscapes look very empty and lack ambience without the interest of people within them, and this section of the book will enable you to add convincing figures to your paintings. Most beginners find the idea of painting people a bit daunting, and mistakenly think that they need years of experience working from models and attending life classes. However, a good way to start painting people is to look at the most basic elements that make up a person.

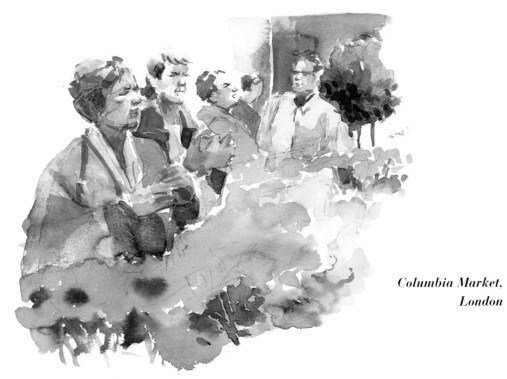

Columbia Market,
London

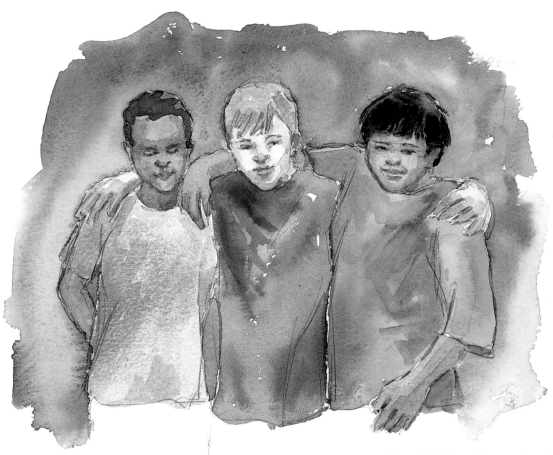

Schoolchildren, illustrating the natural way they like to pose.

These include the colour of their skin, the proportions of their bodies and the shape of their heads, hands and feet. You can then progress to painting figures in a variety of poses and in different situations.

As people, we know so much about the details of our bodies that we can make the mistake of trying to include too much detail when adding figures to our paintings. The more objective we can be in our painting the better, attempting more of an impression or a simple statement. Just as when you are painting a landscape you would not attempt to include all the leaves on a tree, so you do not need to include all the detail in people's eyebrows or hair.

Your 'models' can be your own family and friends, or may be people in photographs that you have taken or have found in magazines. Taking photos is very helpful when painting a moving subject, as the camera freezes the motion for you to paint in your own time.

Watercolour is an excellent medium for painting people as it gives swift, fluid results without the need to include too much detail. As with all painting, your confidence will gradually build with your experience. If you take time to practise the stages shown in this book it will give you the confidence to have a go at painting subjects of your own choice. I am sure that before long you will enjoy bringing your own paintings alive with convincing figures.

TECHNIQUES

Watercolours may be used on a surface that is either wet or dry, and the paint behaves differently on these different surfaces. On a wet surface it spreads and the effect is blurred, on a dry surface it retains the shape you have painted. I suggest that you practise using your watercolours by trying out some of these exercises, to get a feel for your paint and brushes.

Wet-on-wet

When wet paint is applied onto wet paper it drifts, and colours merge together to make other colours. The paper may be re-wetted once it has dried.

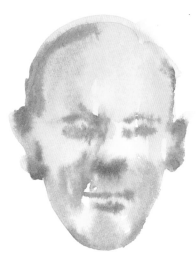

Apply two colours onto wet paper and let them drift into each other.

1 *Working quickly wet-on-wet, paint the shape of a head, using the way the colours blend to show areas of shading.*

2 *Develop the features by adding darker paint onto the now damp surface to show the ears, eyes, nose, mouth and shading on the head.*

Wet-on-dry

When paint is applied to dry paper, the edges of the shapes you paint remain sharp. The paint is allowed to dry completely before other layers of paint are added on top.

Paint a block of colour and let it dry, then add some other colours over the top. This is called glazing: you can see the colour underneath through the paint on top.

Soft edges

When painting in watercolour you often need to create a soft edge, but not one that smudges or drifts out all over the place. Soft edges are useful for painting the transition at the hairline, the planes of the face and the edge of a shadow on the body.

Alternatively, use water to wet an edge then continue with paint.

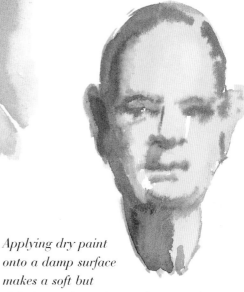

Create soft edges by running a clean damp brush (remove any excess water first) along an edge of still-wet paint.

Applying dry paint onto a damp surface makes a soft but definite mark, as distinct from an edge, and is useful for suggesting features.

Brush marks

Usually it is best to load your brush with lots of
watery paint. You can make a variety of different
marks by increasing or decreasing the pressure
you put on the brush with your hand, and by
holding the brush in different ways, either loosely
towards its end, or tightly near the bristles.

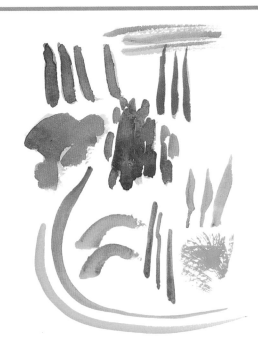

*Try painting some lines, applying
more weight at the start of the
stroke and tailing off, then paint
some curves and other marks
using the heel and point of the
brush. Get to know how the
brush feels in your hand.*

Dry brush

If you use hardly any water with your paint, the effect
is feathery broken marks. Fanning out the bristles on
the brush is excellent for showing hair strands.

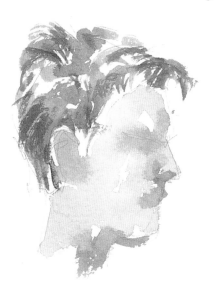

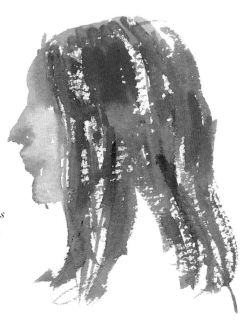

*Drag and flick
a dry brush to
reveal the surface
of the paper. This
makes good highlights
on hair, and prevents
it looking flat.*

Highlights

The use of highlights in your pictures will add depth and reality. Highlights may be created in three ways: by leaving white paper, by applying masking fluid to the areas you want to leave white at the start of your painting and rubbing it off when the paint is dry, or by scratching the paint out with a craft knife once it is dry.

The highlights around the girl are created by leaving white paper at the edges.

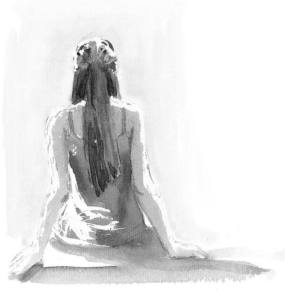

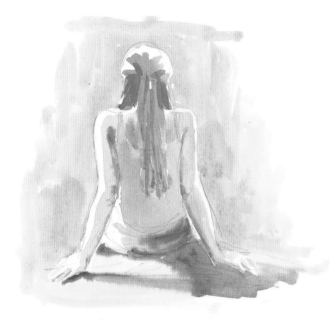

Here, masking fluid is used for the highlights before the paint is applied, and after the paint has dried the masking fluid is rubbed off to show the white paper underneath.

Scratching out areas with a craft knife once the paint is dry is excellent for showing highlights on hair.

Lifting out

While the paint is still wet, areas of light may be created by 'lifting out' the paint using kitchen roll or other soft tissue. There will usually be a slight stain, depending on the colour of the paint you have lifted out. You can also use a damp sponge to lift out paint from dry paper.

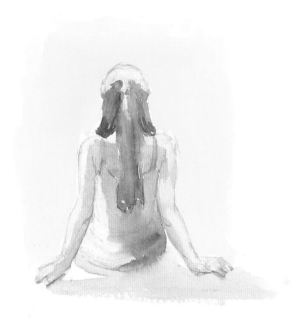

An area of paint has been lifted out on this child's face to show the light shining from the right.

The highlights around the girl have been created by lifting out an area of paint on the outsides of her arms, the tops of her shoulders and head, and the left of her body.

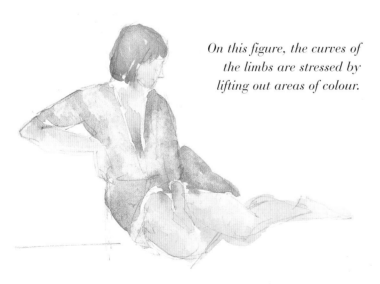

On this figure, the curves of the limbs are stressed by lifting out areas of colour.

This edge has been lifted out with a brush, leaving a more definite area that shows the shape of a face.

Working from photographs

Working from photographs is ideal when you are trying to capture swift movement in your pictures. People aren't always going to pose for you. Sometimes you may see a perfect subject and have insufficient time to make a sketch of it, so taking a photograph and painting from it at your leisure is ideal. If you take a variety of photos from different angles, you can select the one you like best from which to work.

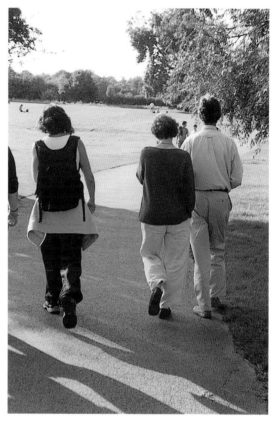

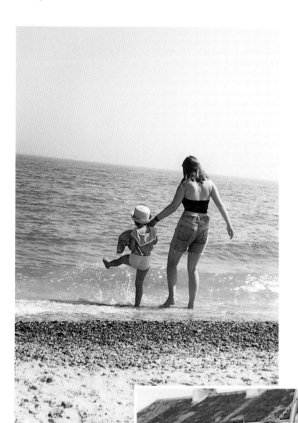

These photos have frozen fleeting moments that would be very difficult to capture in a sketch. The photos may be used to paint from at a later stage. The painting that I produced from the picture above is shown on page 131.

SKIN COLOUR

Mixing skin colours comes with practice. It is a common mistake to use a mixture that looks too flat and uniform and does not enable you to show the form of the body or face. Start with diluted paint and build up to more solid areas, leaving highlights on cheeks, noses and shoulders. Stress prominent parts of the body – knees, tips of noses and chins – with warmer colours than the basic skin colour.

Asian

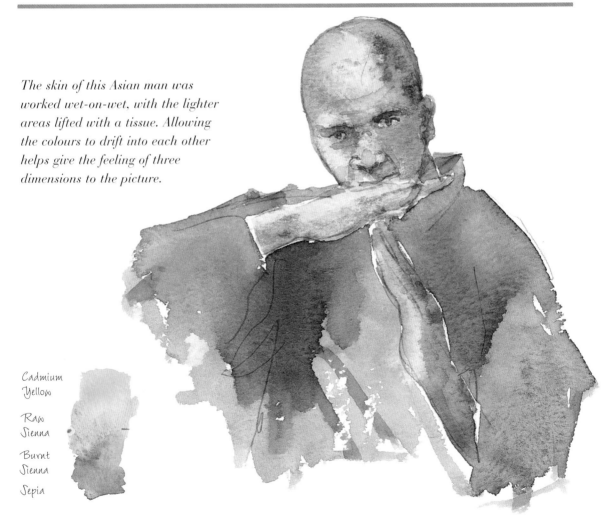

The skin of this Asian man was worked wet-on-wet, with the lighter areas lifted with a tissue. Allowing the colours to drift into each other helps give the feeling of three dimensions to the picture.

Cadmium Yellow

Raw Sienna

Burnt Sienna

Sepia

African

African skin can be dark, shiny and rich with bluish-purple shadows. The highlights are very strong in contrast to the skin colour, so leave them as white paper. Again, the colours were allowed to drift into each other, and the very deep darks were added at the end when the other paint was dry.

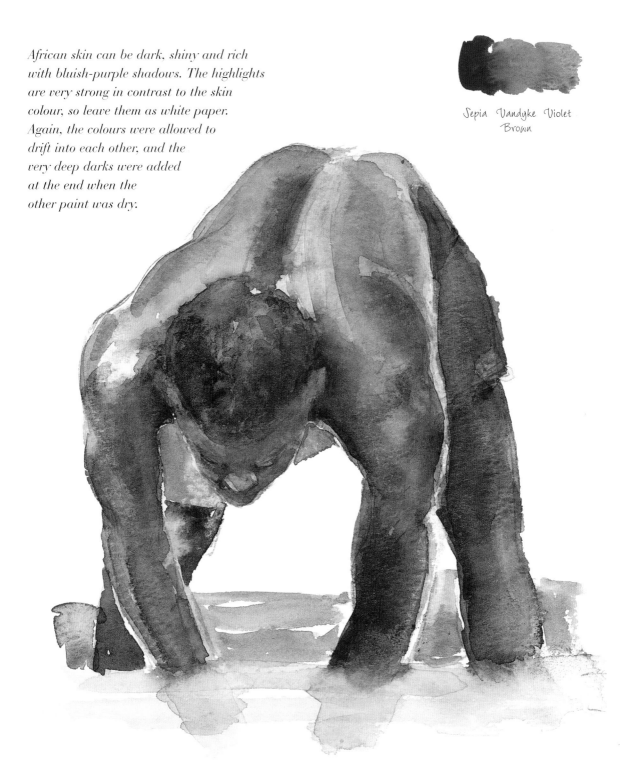

Sepia Vandyke Violet
 Brown

Arab

Arab skin is more brown than reddish. The leg on the right is further back and is slightly in shadow, so I made the skin colour less warm.

Yellow Ochre

Burnt Umber

Burnt Sienna

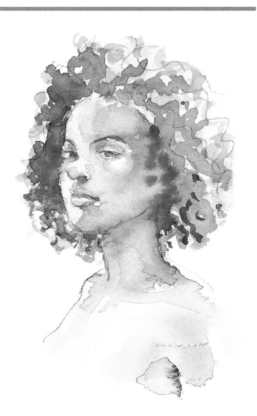

Mixed race

Mixed race skin can vary hugely in tone. Here the emphasis is yellows, and the shadows are applied with a very light touch.

Raw Sienna

Burnt Sienna

Cadmium Yellow

Sepia

White

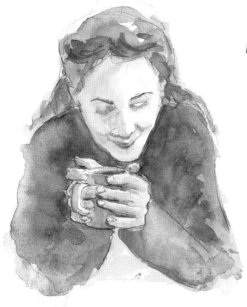

White skin has less brown in it, and the shadows tend to be more greenish-blue. This head was painted with a very light touch to keep the skin looking translucent and young. Use very diluted yellow mix as the base, then very gently add other colours to the still damp paint.

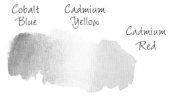

Cobalt Blue Cadmium Yellow Cadmium Red

Older skin

Older faces have more complicated planes, and the skin tone is more varied in the folds and expression lines. The light hits at different angles. Older skin tends to have warmer shadows than younger skin, and the contrasts are stronger. Older white skin is more brown and yellow.

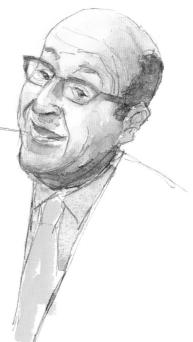

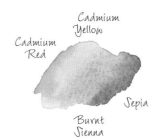

Cadmium Yellow

Cadmium Red

Sepia

Burnt Sienna

Painting people 89

SCALE AND PROPORTION

To get the proportions of your people right, think of them divided into parts. Stand someone in front of you. Hold out a long pencil with your arm straight and elbow locked. Line the top of the pencil up with the top of the person's head. Place your thumb on the pencil in line with the bottom of the chin. This pencil length, the head length, is your measuring unit.

Adults

The average adult human figure can be divided from crown to ankle into approximately eight head lengths. Some people have short waists and long legs, etc., but these are the standard proportions.

Here the body has been divided into a number of head lengths, showing the divides at the neck, chest, waist, hips, knees and ankles. There are slight differences in the proportions of men and those of women.

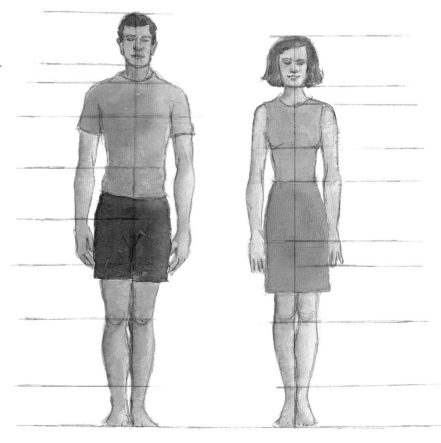

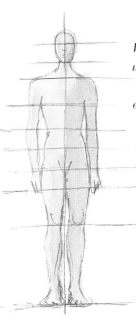

When people stand with their weight evenly distributed, the feet take the weight totally evenly. All the body parts are balanced. It is helpful when you are painting someone in this position if you put a vertical line down the middle of the figure.

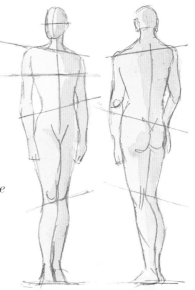

This figure has shifted its weight onto one foot by bending slightly at the knee and turning a little. The shoulders and hips tilt to compensate. People often stand with their weight unevenly distributed, particularly when they relax and bend.

Children

A child's body can also be divided into head lengths. The major difference is that the head of a child starts off big relative to the rest of his body, and grows only very gradually. As a result, a toddler has a proportionately larger head than an older child, and an older child has a proportionately larger head than an adult.

At one year (right) a child's body may be divided into only four head lengths. At about three years of age (centre) this has increased to five, and at five years (left) to about six.

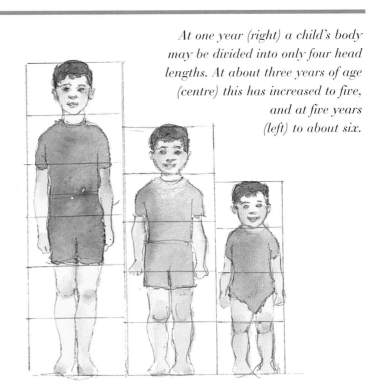

HEADS

It is essential to grasp the way heads move, tilt and turn on the neck if you are to paint people successfully. It is a challenge to place the features in a balanced way on the head when you are painting heads at different angles, looking up, down or sideways. It is also important to get the hair right, giving it a soft edge and leaving it as a subtle suggestion rather than adding too much detail.

Front view

The simplest view of a head is from the front. Full on, a head is an oval or egg shape, and can be divided up into sections that will help you to get the proportions correct.

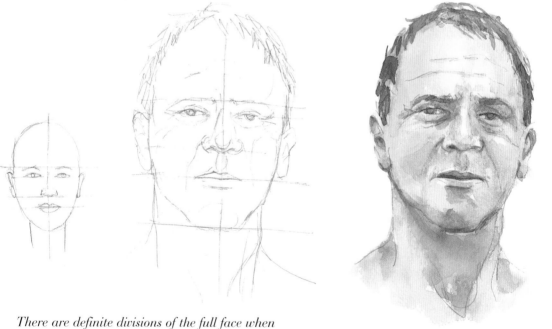

There are definite divisions of the full face when seen head on. Each face differs slightly, so there are no strict proportions. Taking a vertical line down the middle of the face and horizontals at the brows, tip of nose, mouth and chin, will help you to fill out the features correctly, and you can then go on to sculpt the head in paint. Don't forget to leave highlights on cheeks and noses, and stress the tip of the nose and chin with warmer colours than the basic skin colour.

Heads at an angle

Notice how the area of each part of the face alters, depending on the angle from which the face is viewed. A face looking up shows less forehead and more chin whereas one looking down shows more forehead and less chin. Also, look at the distances from the ear to the features. These are increased when the head is turned away.

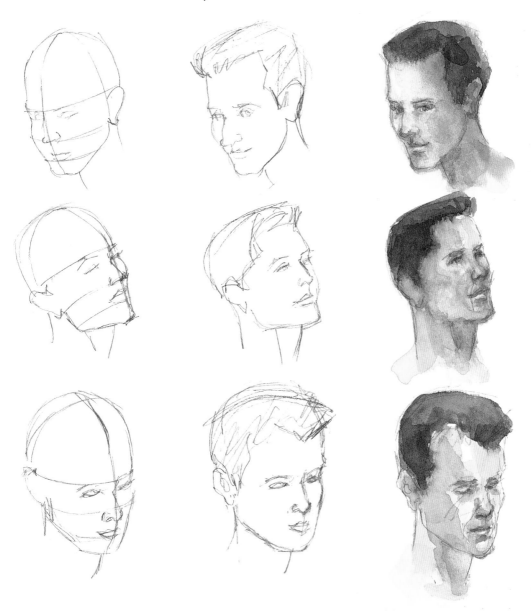

To construct the head, draw an oval and divide it into sections so that you have a middle line for the centre of the face, and draw curved lines to follow the tilt of the head on the brow line, on the nose line and on the mouth line.

Positioning the eyes

Beginners often force a partial side view of a head into almost a front view, by putting in too much of the eye that is partially hidden. There is a triangle shape formed by the eyes, nose and mouth, and it is important to keep the proportions right between these three, and to check where the tip of the nose is in relation to the cheek.

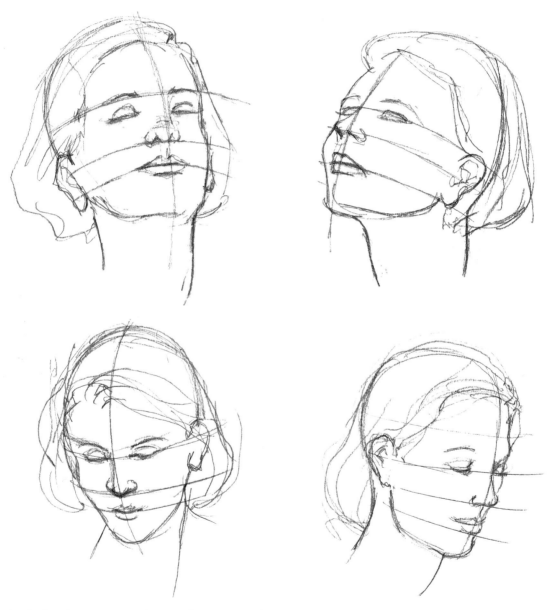

As the head turns away the eyes shorten in width but their height remains the same. The eye that is further away seems shorter than the closer one.

Man's head in profile

In profile the features are easier to locate in relation to each other. The ear is at the same level as the top of the eyebrow and the bottom of the nose. The eye is within a triangle shape.

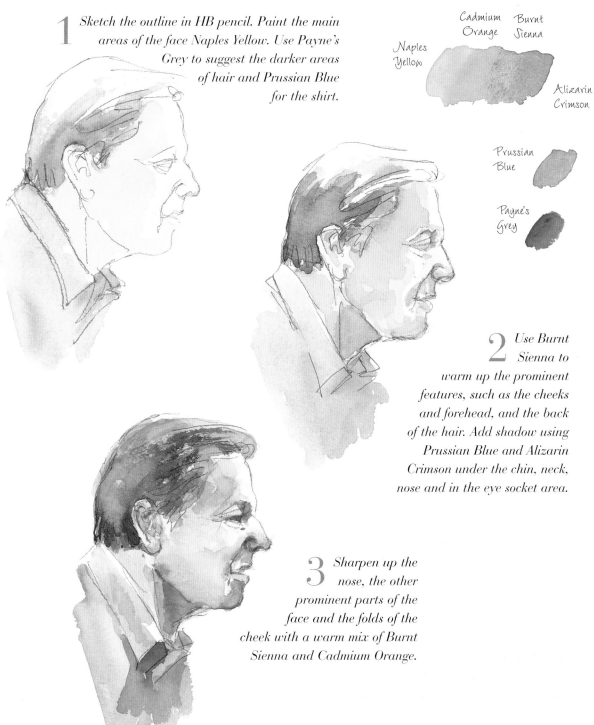

1 Sketch the outline in HB pencil. Paint the main areas of the face Naples Yellow. Use Payne's Grey to suggest the darker areas of hair and Prussian Blue for the shirt.

Naples Yellow

Cadmium Orange

Burnt Sienna

Alizarin Crimson

Prussian Blue

Payne's Grey

2 Use Burnt Sienna to warm up the prominent features, such as the cheeks and forehead, and the back of the hair. Add shadow using Prussian Blue and Alizarin Crimson under the chin, neck, nose and in the eye socket area.

3 Sharpen up the nose, the other prominent parts of the face and the folds of the cheek with a warm mix of Burnt Sienna and Cadmium Orange.

Older faces

In older faces, the features tend to drop, and there is less space between the nose and mouth. The triangle of features (eyes, nose and mouth) is longer and narrower. There are shadows where the skin is deeply textured.

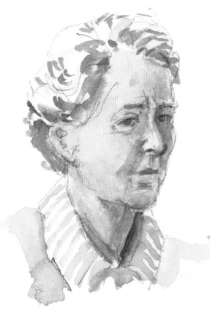

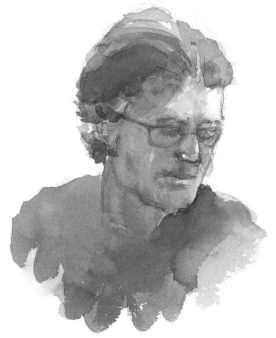

As people age, their faces become less tight, mouths are less full, noses are more prominent. Generally, there are more contrasts in the features and more drama and expression in the faces themselves.

When painting someone wearing glasses, it is important to paint the face and the glasses at the same time, rather than add the glasses when the face is finished.

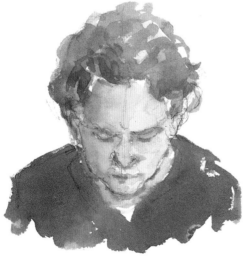

Looking down on this face, the features appear to cave in a little, the jowls are loose and the jawline slack. Some frown marks can be seen.

Younger faces

In young faces the features form a wide triangle, are set apart, and there is very little shadow. Children, especially babies, need to be painted with a very light touch, leaving plenty of highlights.

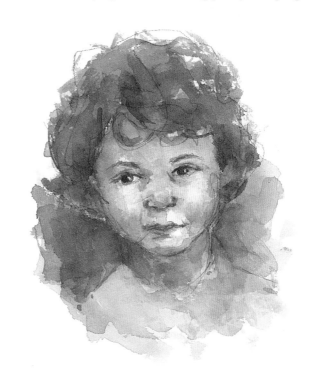

When painting children, keep the contrasts down or the children will 'age'. Warming up the end of a child's nose really helps to define the face, as there is so little definition otherwise.

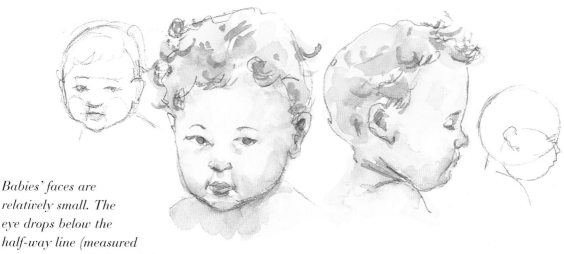

Babies' faces are relatively small. The eye drops below the half-way line (measured from crown to chin), and the forehead is very curved: this is especially clear in profile. The bridge of the nose is concave, and the eyes seem wider apart than adults' eyes.

Hair

Hair varies as much as skin, so think of it in broad categories, such as straight, curly, wavy, grey, light, dark, fair, short or long. It is best to understate hair, concentrating on overall shapes and ensuring you give the hair soft edges, as a hard edge, especially where the hair meets the face, can be too wig-like. When the area is dry you can add a few dry brushstrokes to show texture. Be aware of the nature and direction of the light falling on the hair.

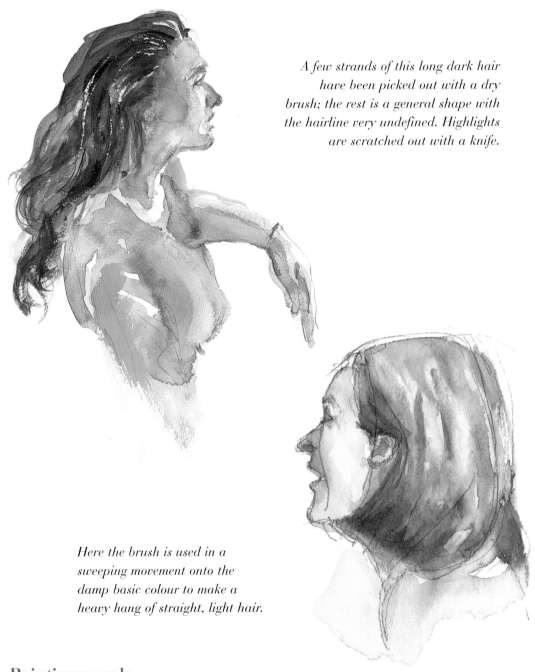

A few strands of this long dark hair have been picked out with a dry brush; the rest is a general shape with the hairline very undefined. Highlights are scratched out with a knife.

Here the brush is used in a sweeping movement onto the damp basic colour to make a heavy hang of straight, light hair.

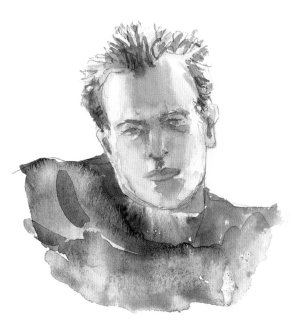

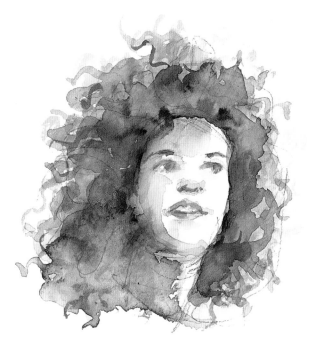

The spikiness of short hair is emphasized by the strokes of brown made while the diluted undercolour is still damp. The marks are soft and natural.

Here lots of water is worked into damp colour to give water marks which work well to show thick hair. Drier strokes pull out the curls.

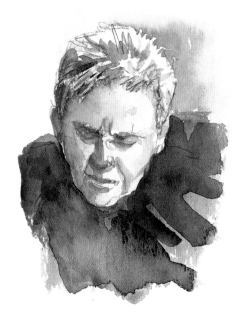

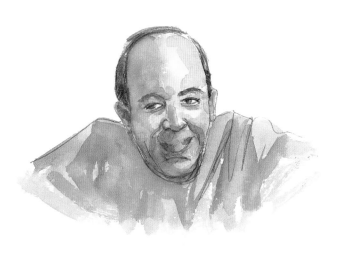

The trick with grey hair is to show its whiteness by highlighting it against the background.

Exaggerating the light reflecting on a bald head emphasizes its solidity. This can be done by lifting the paint out of an area whilst it is still wet.

EXERCISE Paint a female face

Women's heads often have soft features and the hair helps to make an interesting shape.
A three-quarters face is a very common view of a head which offers more opportunity to
express the character of the person you are painting.

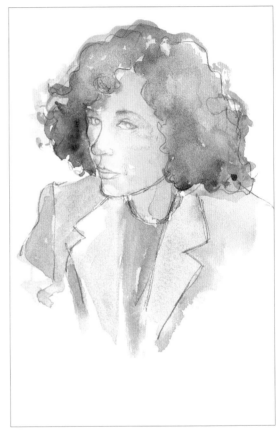

1 *Sketch the face in HB pencil. Don't make the drawing too detailed. Notice the space between the nose and cheek. The eye socket is partially hidden on the woman's right side.*

2 *Paint a wash of Naples Yellow and Vandyke Brown for the face, wet-on-wet to blur the shadow shape on the main cheek. Paint the hair wet-on-wet using Sepia, Vandyke Brown and Cadmium Orange, and pull out some edges to define the curly shapes. Start painting the clothes in Cobalt Blue, Alizarin Crimson and Payne's Grey.*

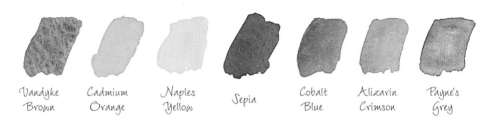

Vandyke Brown Cadmium Orange Naples Yellow Sepia Cobalt Blue Alizarin Crimson Payne's Grey

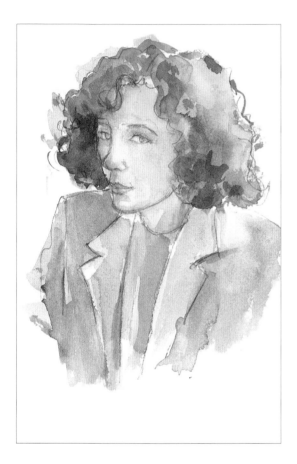

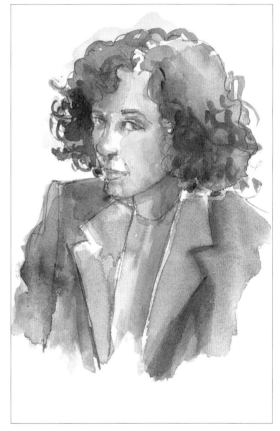

3 *Start to define the features, such as the eye socket and the shadow under the nose and mouth, using Alizarin Crimson. Use the same red for the lips, and a touch on the nose to project it forward. As the head is turned away, the hair on the left is in slight shadow, so add Sepia to show this.*

4 *Bring in Alizarin Crimson on the forehead, face and the bridge of the nose. Warm up prominent features, leaving a highlight on the nose and upper mouth to give a sculpted three-dimensional effect. Finally, add more dry detail to the hair in Sepia. Paint the eyes Cobalt Blue, and add a shadow in Payne's Grey under the collar of the jacket.*

HANDS AND ARMS

There is no mystery about painting hands; it is a matter of fitting pieces together in the correct proportions. The length of the hand is about equal to the length of the face from hairline to the bottom of the chin. The palm of a hand is concave, the back convex – hands are seldom held flat.

Basic hands

The movement of the hand starts at the wrist, which is where the bones of the fingers start, so it is best to paint a hand as one piece, the whole hand bending in line with the fingers. This series of pictures of hands shows basic positions. Note the spaces between the fingers as well as the shapes of the fingers themselves. Painted hands must look as though they could hold or cup something; they should not be flat and immobile.

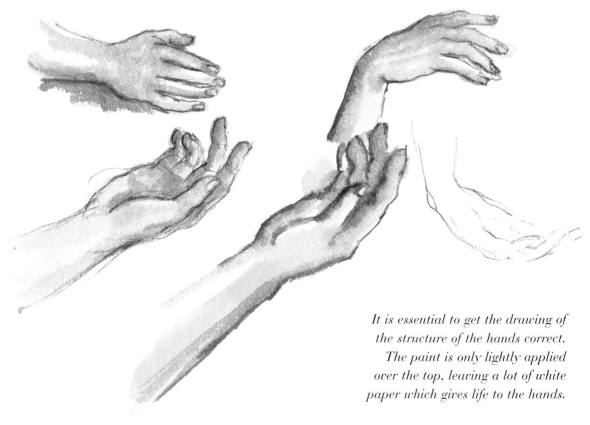

It is essential to get the drawing of the structure of the hands correct. The paint is only lightly applied over the top, leaving a lot of white paper which gives life to the hands.

Clenched hand

The overall shape of the hand is vital, and there is no need to make too much of the details, such as the nails or creases in the palms.

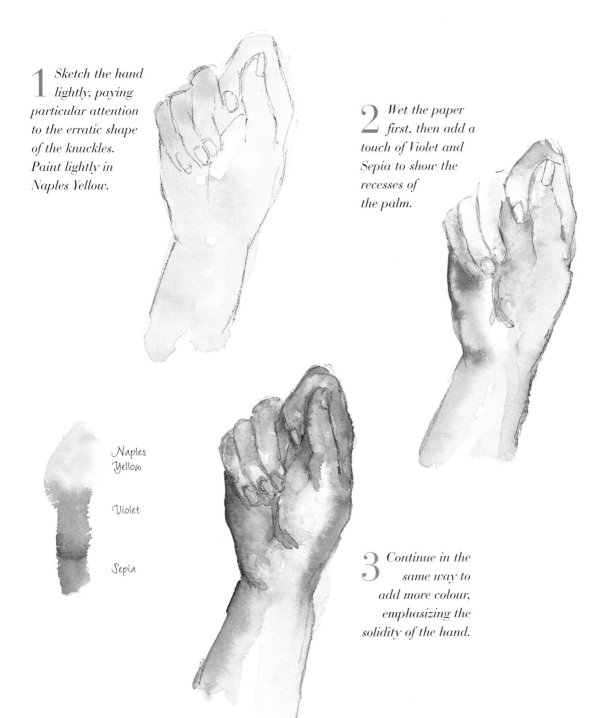

1 *Sketch the hand lightly, paying particular attention to the erratic shape of the knuckles. Paint lightly in Naples Yellow.*

2 *Wet the paper first, then add a touch of Violet and Sepia to show the recesses of the palm.*

Naples Yellow

Violet

Sepia

3 *Continue in the same way to add more colour, emphasizing the solidity of the hand.*

Relaxed hand

Here is a generous open hand, in contrast to the clenched hand on the previous page. The fingers are more outstretched and the palm is concave.

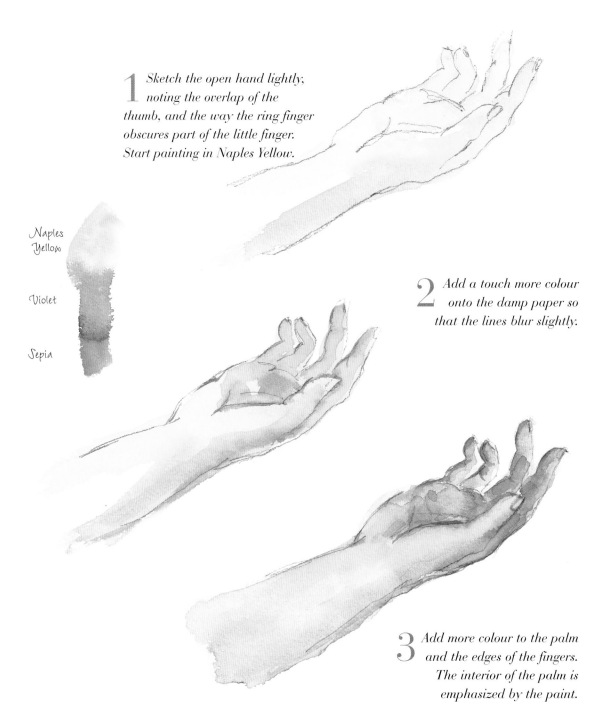

1 Sketch the open hand lightly, noting the overlap of the thumb, and the way the ring finger obscures part of the little finger. Start painting in Naples Yellow.

Naples
Yellow

Violet

Sepia

2 Add a touch more colour onto the damp paper so that the lines blur slightly.

3 Add more colour to the palm and the edges of the fingers. The interior of the palm is emphasized by the paint.

Expressive arms

People often use their arms and hands to express themselves. Watch how people fold their arms or hold their face with their hands.

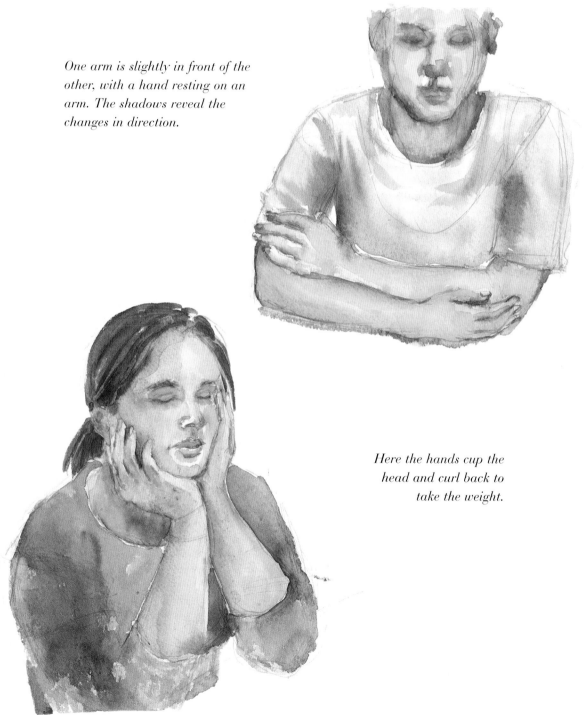

One arm is slightly in front of the other, with a hand resting on an arm. The shadows reveal the changes in direction.

Here the hands cup the head and curl back to take the weight.

FEET AND LEGS

One of the most common mistakes when drawing feet is to underestimate the size of the foot in relation to the rest of the body, and the size of the heel compared with the rest of the foot. A person's foot is at least one head in length. Feet and legs can be as expressive as hands, and the way someone places their legs and feet when sitting can reveal a great deal about them.

Basic feet

I painted these feet from different angles and viewpoints. You may like to practise by drawing your own feet in many poses by setting a mirror on the floor. Try to see the foot as a single shape, the toes only being added at the end of the painting process.

Note the length of the toes when the foot is in profile, and the foreshortening of the foot when viewed from the front: the big toe dominates, and the heel dominates the view from the back.

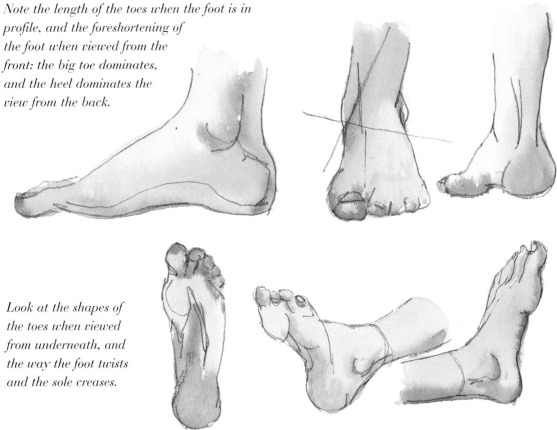

Look at the shapes of the toes when viewed from underneath, and the way the foot twists and the sole creases.

When someone is lying down, a fold appears in the sole of the foot. In movement, the toes support the weight of the feet, and the ball of the foot does the same when you are sitting.

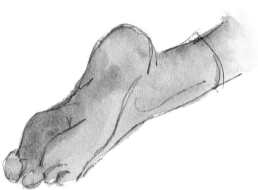
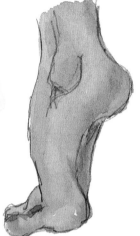
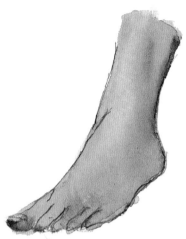

Legs

Imagine yourself sitting cross-legged in a chair: this will help you to feel where the weight is distributed. Adding trousers simplifies painting the legs.

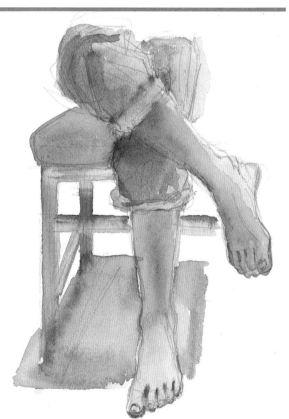

The light is hitting the boy's feet, and the legs are in purplish shadow. This helps to create the sense of the foot being placed firmly on the ground.

Shoes

There is an enormous range of shoes, and they can add character and individuality to your people. Practise painting your own feet by looking in a mirror.

Note the pinkness of the knees in these daintily crossed legs in heels, and observe the way the shadows are used to show how one limb overlaps the other.

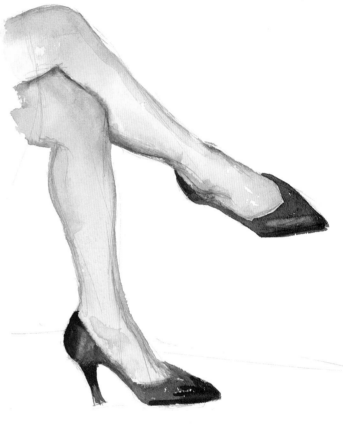

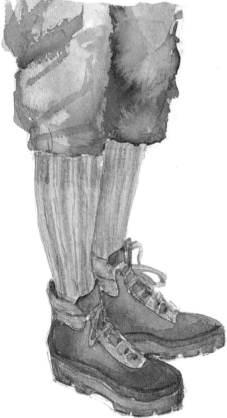

These walking boots are big and sturdy, and the feet are firmly planted on the ground. The laces add a decorative touch.

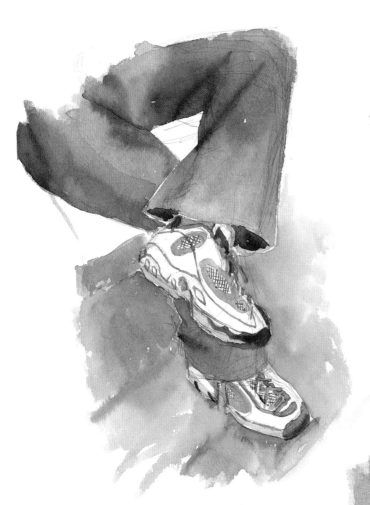

The trainers are on the legs of a young, confident man, and the way in which the feet are casually tilted gives the picture a sense of atmosphere. Notice the way the trousers fall over the ankle.

One of the legs in sandals is painted slightly bent as if anticipating a dance: here I focused on the way the strap curve alters depending on the angle of the leg.

SINGLE FIGURES

It is good practice to start by painting a friend, or yourself (using a mirror), so that you become familiar with the general proportions of the human body and know how it looks when standing and sitting. Don't be too ambitious at first, and try sketching a number of different poses before you begin to use your paints.

Nudes

Sketching nudes is a good way to begin painting people. You will gain a better idea of the form and shapes of the human body, which will help you when you are painting people fully clothed.

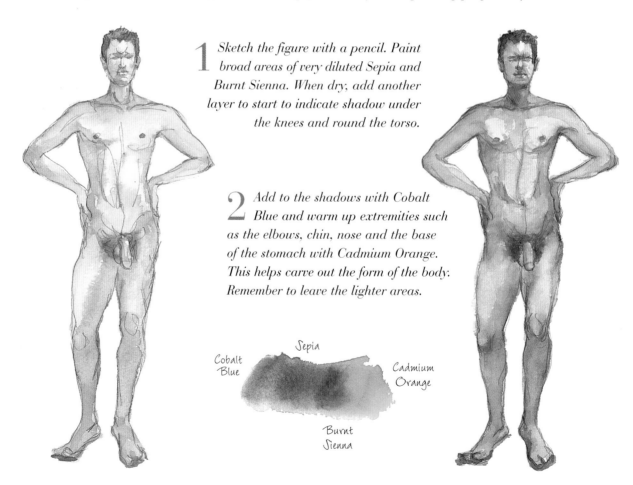

1 Sketch the figure with a pencil. Paint broad areas of very diluted Sepia and Burnt Sienna. When dry, add another layer to start to indicate shadow under the knees and round the torso.

2 Add to the shadows with Cobalt Blue and warm up extremities such as the elbows, chin, nose and the base of the stomach with Cadmium Orange. This helps carve out the form of the body. Remember to leave the lighter areas.

Cobalt Blue

Sepia

Cadmium Orange

Burnt Sienna

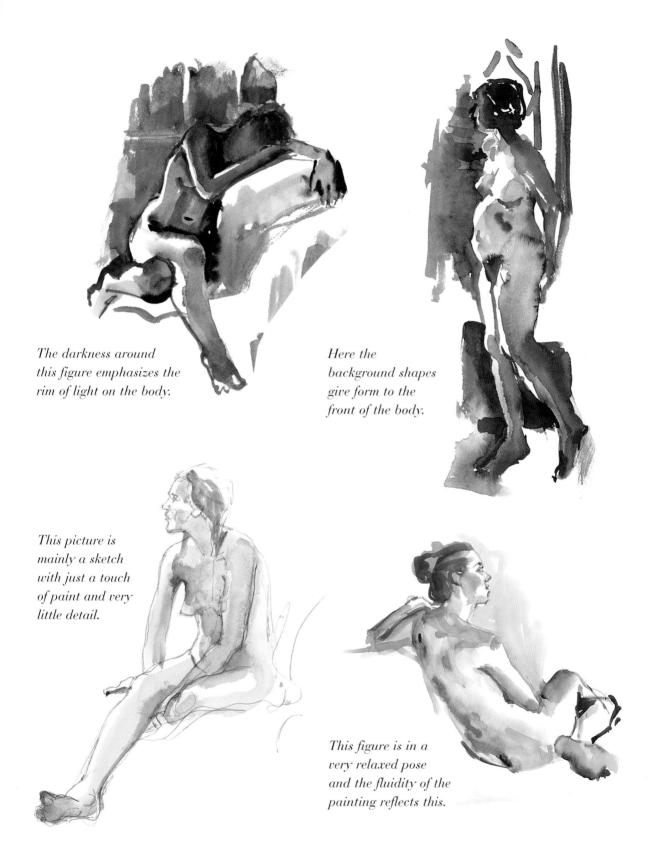

The darkness around this figure emphasizes the rim of light on the body.

Here the background shapes give form to the front of the body.

This picture is mainly a sketch with just a touch of paint and very little detail.

This figure is in a very relaxed pose and the fluidity of the painting reflects this.

Paint a single figure

This person is standing in a relaxed manner with one leg slightly bent and one hand on her hip. The body is slightly twisted, so the centre plumbline is pushed round, and as the weight is slightly unevenly distributed, one hip is tilted just above the other.

1 *Sketch the outline of the figure in HB pencil, then apply a wash of very diluted Cobalt Blue for the clothes, and Naples Yellow for the skin tone. The sandals are painted on in diluted Sepia.*

2 *Paint in the shadow on the clothes with an overwash of blue with a touch of Violet and Payne's Grey. Once dry, add the same mix on top, leaving the edges of the first shape. Burnt Sienna is used to contour the limbs.*

The palette

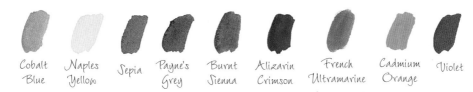

Cobalt Blue Naples Yellow Sepia Payne's Grey Burnt Sienna Alizarin Crimson French Ultramarine Cadmium Orange Violet

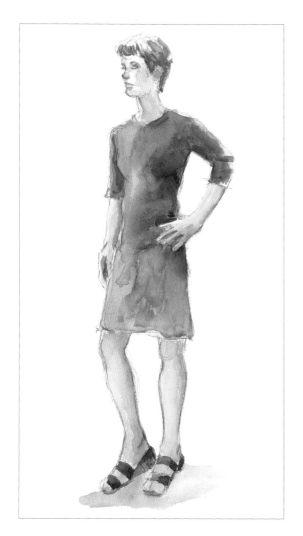

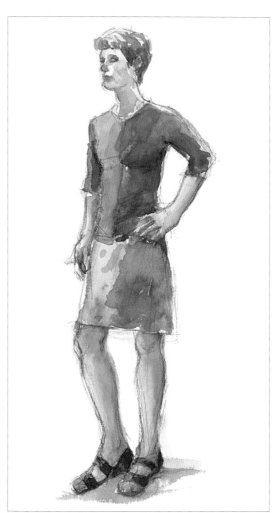

3 *Paint the hair with short strokes of Sepia and the face with Burnt Sienna, Alizarin Crimson and Cadmium Orange to sculpt the head. Wet the shapes before adding the paint to give more contour, rather than a hard line.*

4 *Increase all the tones and add the details, such as the shadows between the fingers, the shadow cast under the neck and the eye socket. Try not to cover the highlights (white paper) on the cheek and nose.*

Sitting figure

Now try painting a figure in profile sitting down. The shape is very definite. Notice the shapes that the background forms in the gaps in between the parts of the body.

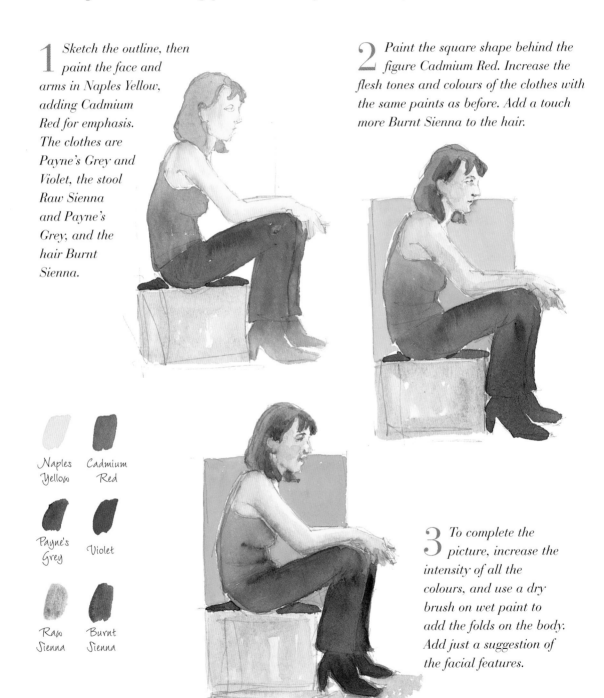

1 *Sketch the outline, then paint the face and arms in Naples Yellow, adding Cadmium Red for emphasis. The clothes are Payne's Grey and Violet, the stool Raw Sienna and Payne's Grey, and the hair Burnt Sienna.*

2 *Paint the square shape behind the figure Cadmium Red. Increase the flesh tones and colours of the clothes with the same paints as before. Add a touch more Burnt Sienna to the hair.*

Naples Yellow

Cadmium Red

Payne's Grey

Violet

Raw Sienna

Burnt Sienna

3 *To complete the picture, increase the intensity of all the colours, and use a dry brush on wet paint to add the folds on the body. Add just a suggestion of the facial features.*

Foreshortening

When someone sits hunched up, lies down or curls up, their limbs can seem to be distorted or even disappear. This effect is called foreshortening. Paint exactly what you see, however peculiar the shapes may seem: don't invent and force a limb to be more rational as your picture will not be convincing. Sometimes it is best even to exaggerate the difference in scale if a limb is near to you.

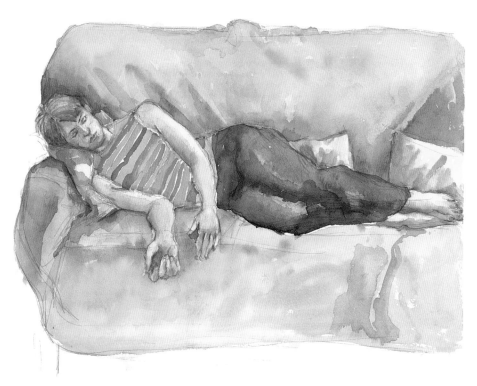

The figure is dozing, so the arms and legs are in a natural position. The legs are slightly bent and the arms have flopped. See how the arm is foreshortened and the hands seem large as they are nearer to you. I exaggerated the size of the hands slightly to emphasize this point.

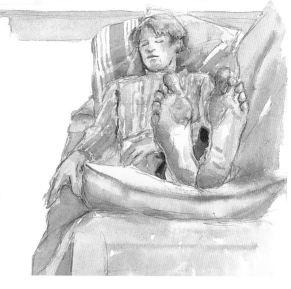

In this picture I was close to the feet, so they appear enormous. I had to check the measurements and proportions as I didn't quite believe my eyes, but they were correct! This is extreme foreshortening.

Figure on sofa

This shows how strange limbs can look when they are folded under each other and when stretched out. Using the principle of measuring limbs against the standard measure of a head length, the proportions will appear fine. The woman has crossed her legs so the lap seems to disappear and the underneath leg seems very short. The stretched out arm is as long as the knee to foot length of the top leg.

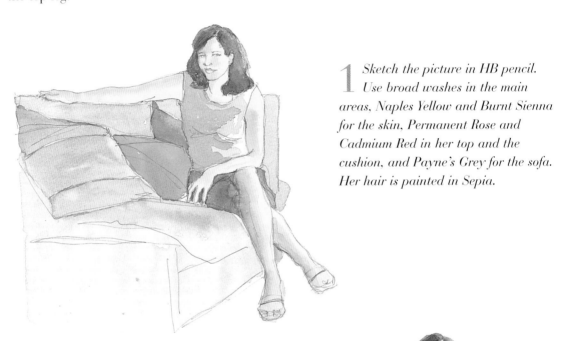

1 *Sketch the picture in HB pencil. Use broad washes in the main areas, Naples Yellow and Burnt Sienna for the skin, Permanent Rose and Cadmium Red in her top and the cushion, and Payne's Grey for the sofa. Her hair is painted in Sepia.*

2 *Emphasize the shadows on the limbs with a mixture of Burnt Sienna, Cadmium Red and Sepia, leaving the side that is lit clear. Add more grey to the sofa and Sepia to the cushion in the areas in shadow as well as wet-on-wet for the pattern on the other cushion.*

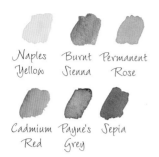

Naples Yellow Burnt Sienna Permanent Rose

Cadmium Red Payne's Grey Sepia

3 *Define the figure by using the grey more crisply round the shape of the body. Define the features with more flesh tone colours, leaving the light on the face. Add a touch of white gouache for the highlights on the nose and mouth, and lastly add Cadmium Red to the woman's top and one of the cushions.*

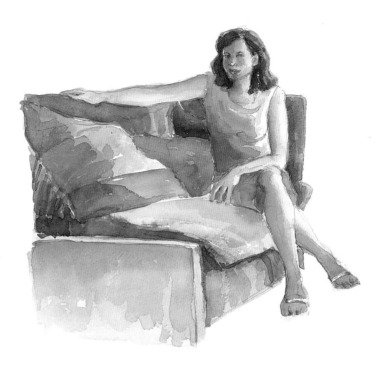

Man sitting

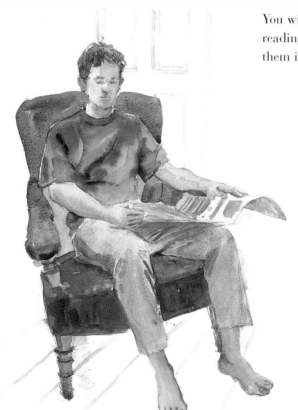

You will often find your family or friends sitting reading. and this is a good position to paint them in as they are likely to stay still for you!

Here the man is simply sitting in an armchair, so the only foreshortening is in the legs and arms. Observing the shapes in between the limbs and the legs of the chair is helpful when you are deciding where to place the figure.

Different viewpoints

Where you are in relation to the figure makes a real difference to the finished picture, so be aware of your position when you are painting. Are you looking down, or on the same level? Always check proportions, especially with complicated positions. Here I have shown two images of the same figure sitting on the ground, painted from slightly different positions. I chose to look at the figure with her head turned away, making it easier to paint her and the image more evocative.

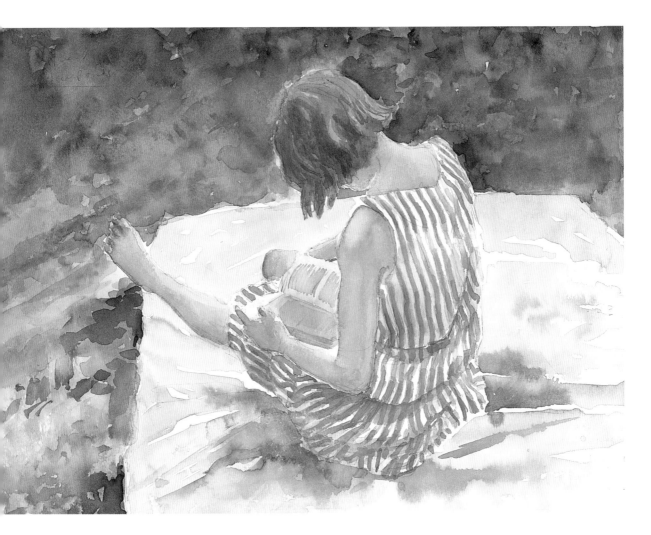

Note here the way the stripes change direction following the way the back is bent. This view from above shows a lot of grass, filling the space and balancing the rectangle of the cloth. The light is on the back of the neck: it is early evening summer light so the colours are warm.

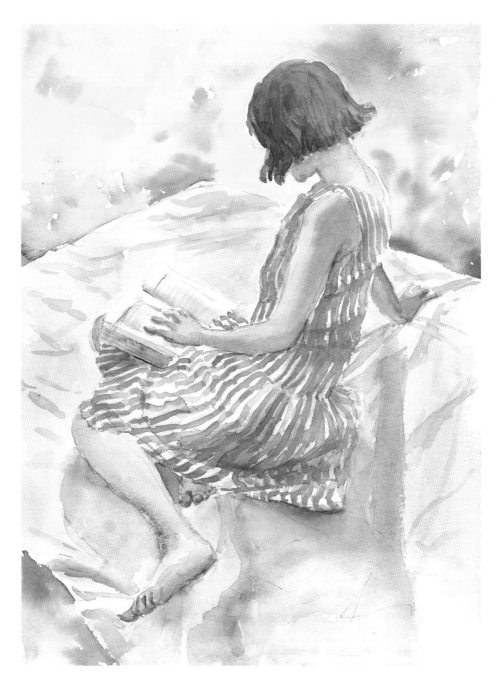

Here there is emphasis on foreshortening, as the figure is leaning on one arm and her foot is tilted upwards. The cloth is at a different angle because I altered my painting position, but it still fills the space well.

DEMONSTRATION SINGLE FIGURE

AT A GLANCE...

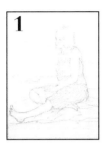
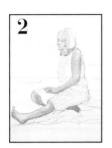
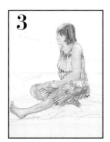
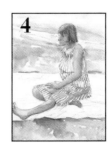
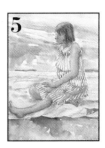

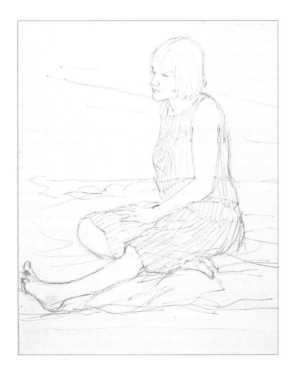

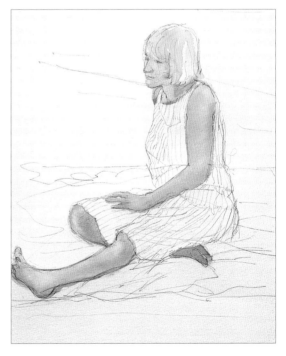

1 *Using an HB pencil, sketch the girl loosely to emphasize the direction of the stripes on the dress, which help give the impression of the figure sitting down on the ground.*

2 *Using a big brush, carefully flood the areas of the limbs and head with water. First drop in Naples Yellow and then, as the water slightly evaporates, add Burnt Sienna where the head and limbs are slightly in shadow and need to look solid.*

The palette

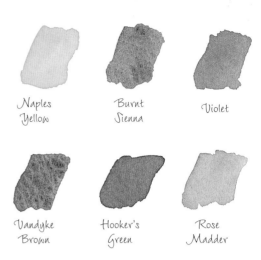

Naples Yellow

Burnt Sienna

Violet

Vandyke Brown

Hooker's Green

Rose Madder

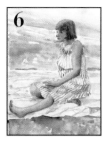

6

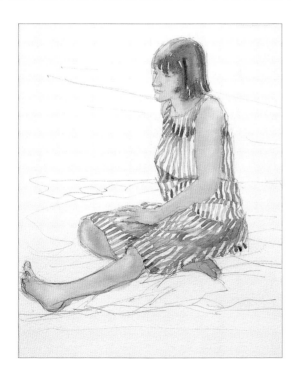

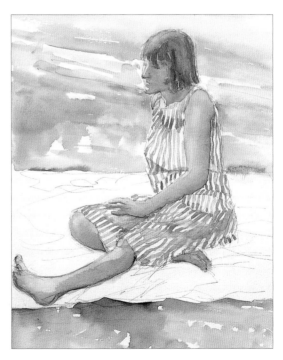

3 *Using Violet paint with a smaller brush, follow the stripes to the folds, adding slightly more paint to the wet colour where the folds create shadows and the colour appears more intense. Use Vandyke Brown for the hair, leaving a band of light on the top of the head.*

4 *Using the bigger brush, paint the grass areas with Hooker's Green and Naples Yellow wet-on-wet. Add more Burnt Sienna and Vandyke Brown, wetting the inside of the arm to give a subtle transition from light to dark. Add shadow across two-thirds of the head, leaving a sliver of light at the edge of the face.*

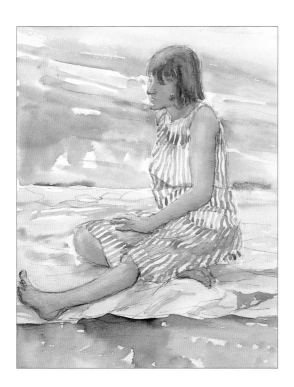

5 *Still using the bigger brush, add Rose Madder to the blanket, wetting the paper first. Emphasize the creases by leaving white paper where the light hits the top of the folds.*

Detail: *Watch how the stripes change direction, following the folds of the dress.*

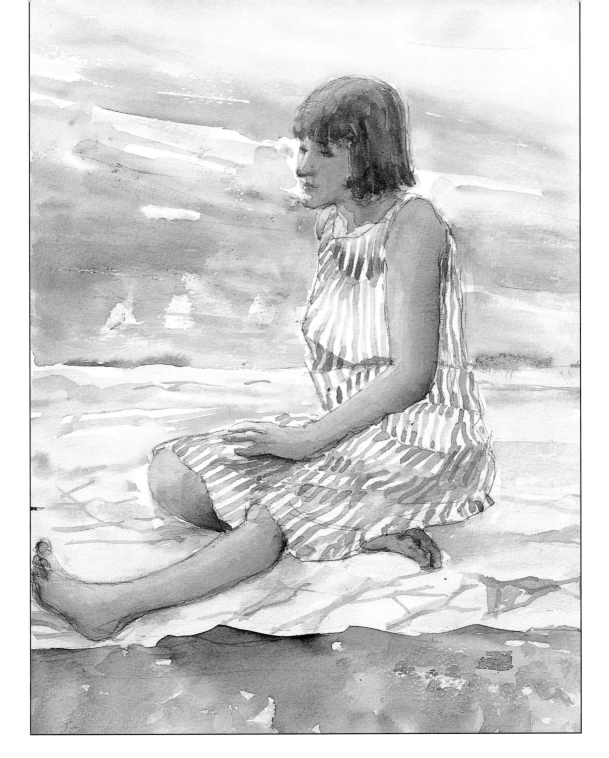

6 **Finished picture:** *Bockingford 300 gsm (140 lb) Not paper, 38 x 28 cm (15 x 11 in). Use candle wax to add texture on the grass, and paint over with more Hooker's Green. The candle wax will resist the paint. Increase the* shadow on the arm by adding a touch of Violet: this will reflect the colour of the dress and bring the picture together. Using your smaller brush, add some detail to the facial features, keeping your touch very light.

LIGHT

When painting, the source of the light is vital, whether it is natural or artificial. At first it is best to paint subjects that are lit from one side. Good contrast helps to capture form. Look for the lightest area and the darkest, then the tones in between. The most effective way to see the tones is to half shut your eyes, as this will eliminate the detail and you should be able to see in basic blocks of tone.

Contrejour

Contrejour or back lighting is when a figure is against a light source, the most common example being someone set against the light coming in from a window, without an artificial light inside the room. Most of the subject is in shadow, making details hard to see.

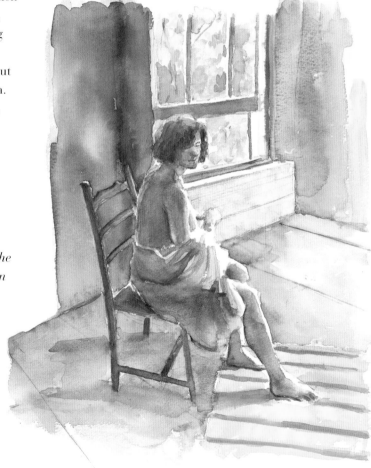

The back lighting on this figure gives a rim of light right along the edge of the body, which has been left as white paper.

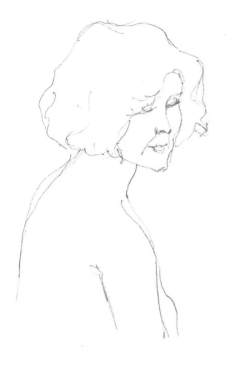

1 *Sketch the outline of the head and shoulders with an HB pencil.*

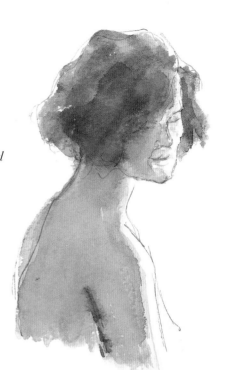

2 *Paint the hair and body in strong colour, leaving white paper to show the rim of light on the body.*

3 *To stress the rim of light and the back lighting, add a window as the source of the light, again leaving white paper to show the highlight.*

Cadmium Red, Violet and Sepia

Raw Sienna

Naples Yellow

Light from one side

The advantage of lighting from one side is that features and details tend to disappear, making the painting much easier and more effective. The examples here are practically silhouettes.

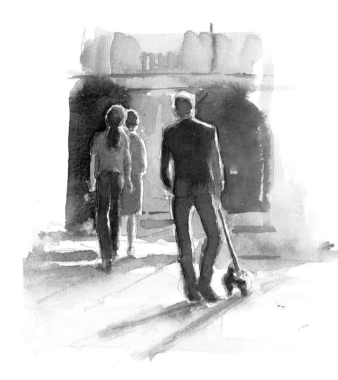

Concentrating on the backs of your subjects leaves more to the imagination and makes painting easier. Also if you are painting on the spot, by painting people from behind you will be less invasive and are less likely to be noticed, so this is a good view to start with.

This painting illustrates how much can be shown about the light on a bright beach scene by the shadows on the back of the girl. You can also see the shadow of her body falling across the towel on which she is sitting. Although the face of her companion is showing, the features are not very detailed.

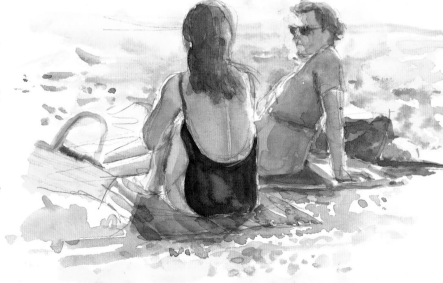

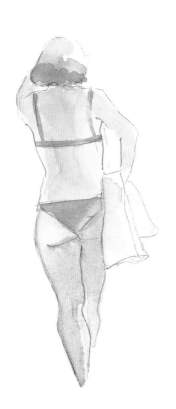

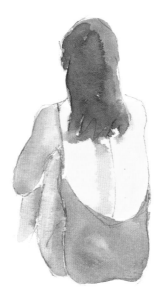

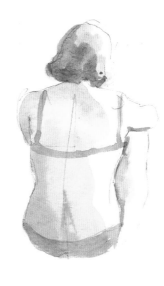

These figures have been isolated out of context to show the first stages in the layering of paint. I put in the really cooler shadows on their backs when the paint was completely dry.

Here two of the figures above can be seen in the context of the entire picture. Notice how the standing girl is emphasized by the green shapes of the trees in the background.

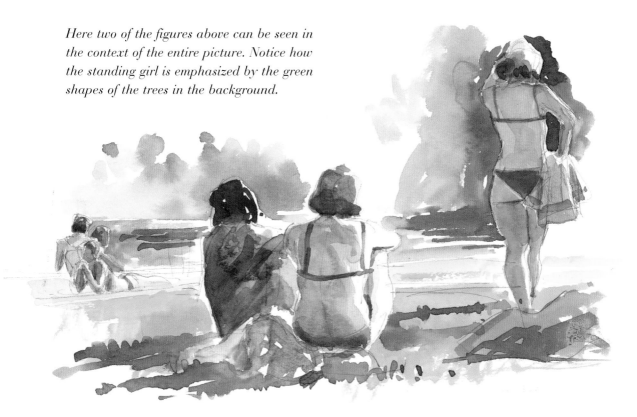

Diffused light

I painted this couple with the light from one side being filtered through the trees. Remember to hold back on the light areas, leaving the paper exposed. Only the planes of the faces were painted, not the features.

1 *Begin painting using Sepia and Prussian Blue very diluted to pick out the main shapes and the dappled shadow. The painting at this stage is very 'tonal'.*

Sepia Prussian
 Blue

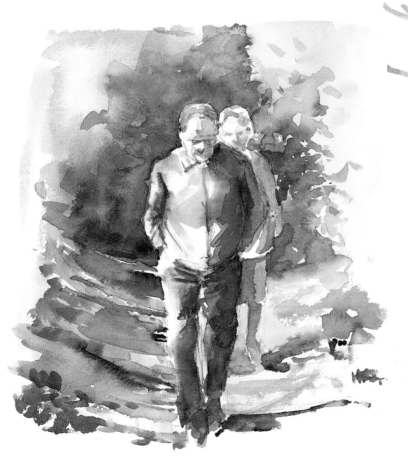

Violet Payne's
 Grey

Lemon Raw Burnt
Yellow Sienna Sienna

2 *Intensify the colours and paint the sweep of shadows from the trees along the path very boldly.*

Leaving white paper

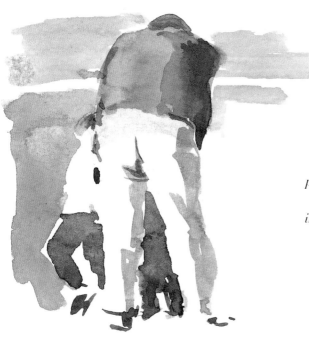

When figures are in extreme directional light it is very important to leave white paper as a contrast to the painted areas.

In this picture I have essentially painted the surrounding shapes. The children are painted in to give the impression of the adult's legs without the legs themselves being painted.

Midday sun

Midday sun, when the light is from overhead, tends to bleach colours and flatten the subject, and the shadows formed are only slight.

This was painted very quickly because the light can change rapidly at this time of day, and because the man was on a mobile phone and was unlikely to stay in this position for very long.

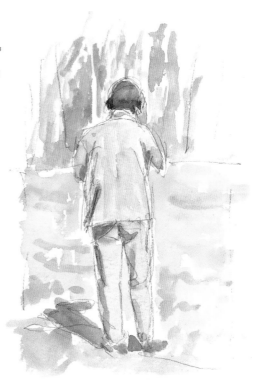

GROUPS

People are often seen in groups, so it is important to learn to put your figures together. Watch how edges overlap and look at the spaces in between and the 'negative' shapes that are formed. Watch how people interact, how their bodies lean forwards when they talk, and how people walk on a path together. Experiment with the way you place your group of figures in your rectangle of paper.

Figures with geese

The focus of this picture is on the action, so I homed in on a small section of the view, concentrating on the overlapping figures.

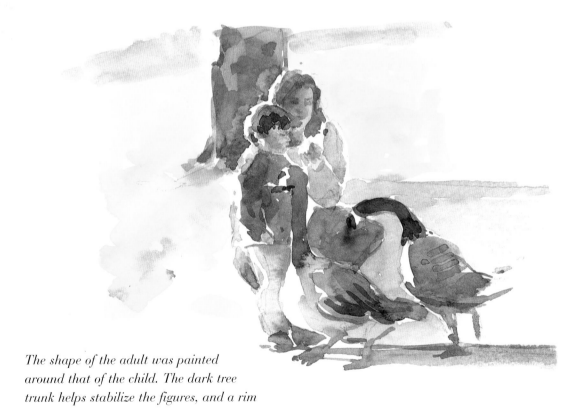

*The shape of the adult was painted
around that of the child. The dark tree
trunk helps stabilize the figures, and a rim
of light (white paper) is left on the figures' backs.*

Walking group

When drawing people walking it is important to focus on the position of the feet and legs. You will soon get familiar with how figures move and the way they slightly overlap each other. or the gaps between them.

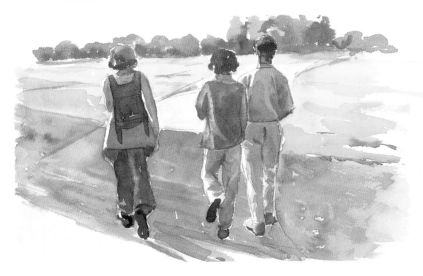

The spaces between the figures and the curves of the path make for a well-designed painting. Even simple situations can offer painting opportunities.

People in café

Another quite ordinary scene. and it is the way in which one figure obscures another that makes this so believable.

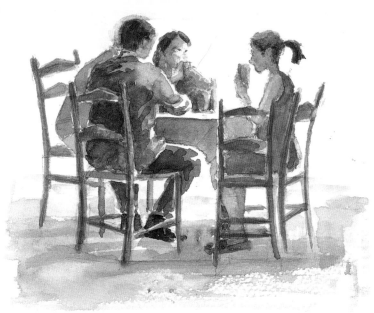

It is brighter away from the group, so they are painted quite dark, almost as silhouettes. There is light on the tablecloth. The feet are placed carefully in relation to the chair legs.

CHILDREN

Painting children is no more difficult than painting adults. The main difficulty is that they are less likely to be able to sit still for you to paint them, so unless you can work quickly it is best to work from photographs. Children can also look especially self-conscious, so they are best caught unsuspecting. Don't forget to check the scale and proportion of children's heads and bodies (page 91).

Girl

This is an eight-year-old girl painted in profile. I was very sensitive in my use of colour in her skin tones, and used a very delicate touch.

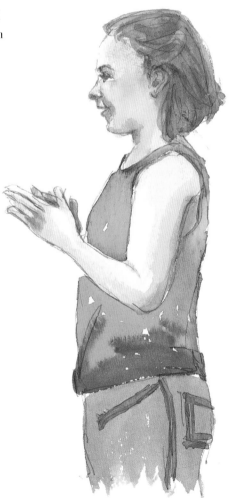

This girl is captured in animated play, and is obviously enjoying herself, so the expression on her face is vital. Notice how little definition there is in her face, with just a suggestion of features.

Boy in hat

The main difference between the profile of a child and that of an adult is how rounded and full the chin and cheeks of a child are.

1 *Make a pencil sketch of the profile.*

2 *Mix Naples Yellow, Cadmium Red and a tiny touch of Cadmium Orange for the skin tones. Paint the cap Burnt Umber, and the top diluted Black.*

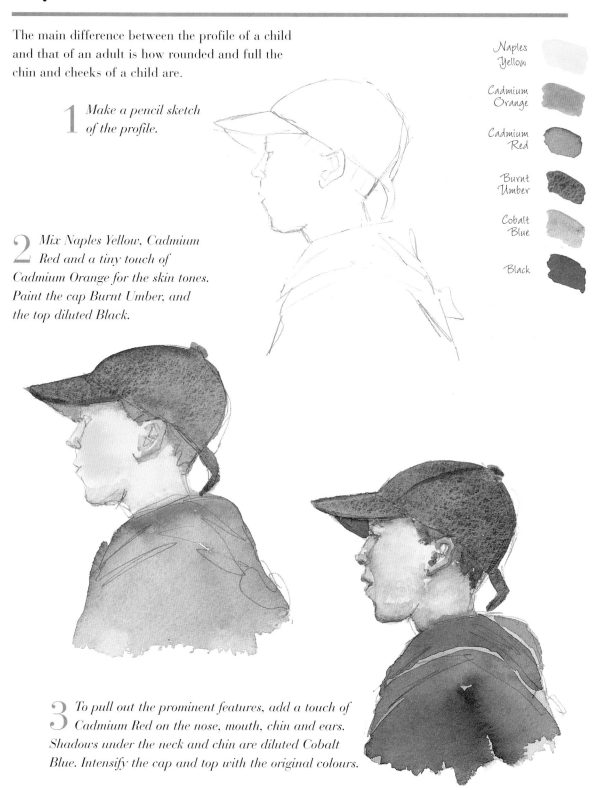

Naples Yellow

Cadmium Orange

Cadmium Red

Burnt Umber

Cobalt Blue

Black

3 *To pull out the prominent features, add a touch of Cadmium Red on the nose, mouth, chin and ears. Shadows under the neck and chin are diluted Cobalt Blue. Intensify the cap and top with the original colours.*

Girl standing

When painting children, the way they stand is enough to distinguish them from adults. This little girl stands shyly and awkwardly, a natural position for her.

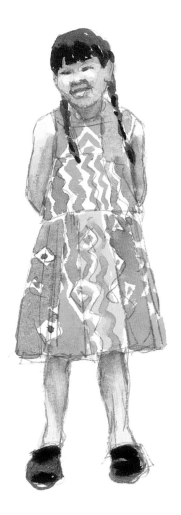

1 Sketch in the details with an HB pencil.

Raw Sienna

Burnt Umber

Black

2 Paint the skin tone in very diluted Raw Sienna, leaving the paper showing through on the cheeks as highlights. Once dry, add a touch of Black to shape the limbs. The hair and shoes are painted Black, and a light touch of Black is used for the eyes. Burnt Umber gives the shadow on the face.

3 Paint the dress very swiftly in bright colours and bold patterns.

Cadmium Orange

Cadmium Red

Cadmium Yellow

Cobalt Blue

Girl sitting

I photographed this little girl sitting naturally in a cross-legged position as I wanted to capture her wistful expression as she played.

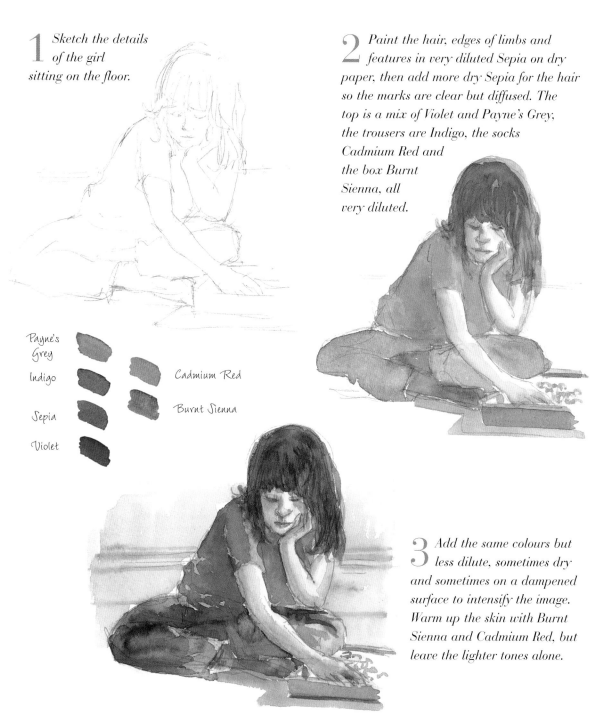

1 *Sketch the details of the girl sitting on the floor.*

2 *Paint the hair, edges of limbs and features in very diluted Sepia on dry paper, then add more dry Sepia for the hair so the marks are clear but diffused. The top is a mix of Violet and Payne's Grey, the trousers are Indigo, the socks Cadmium Red and the box Burnt Sienna, all very diluted.*

Payne's Grey

Indigo

Sepia

Violet

Cadmium Red

Burnt Sienna

3 *Add the same colours but less dilute, sometimes dry and sometimes on a dampened surface to intensify the image. Warm up the skin with Burnt Sienna and Cadmium Red, but leave the lighter tones alone.*

BACKGROUNDS

People are found in all sorts of settings such as the park, their houses, enjoying themselves eating and drinking. By now you are familiar with how people sit, stand and even dance, so we now turn to the background to all this activity. Here the emphasis shifts to integrating the figures into a setting.

Outdoors

This was painted on Hampstead Heath. I wanted the figures to disappear and become part of the background, and they really do seem to have almost vanished from the final picture. They didn't spot me as I was a long way away from them and I kept looking away in the other direction. The people require no detail at all in this setting to create the right impression.

1 Firstly, sketch the scene. The tree and foreground frame the figures.

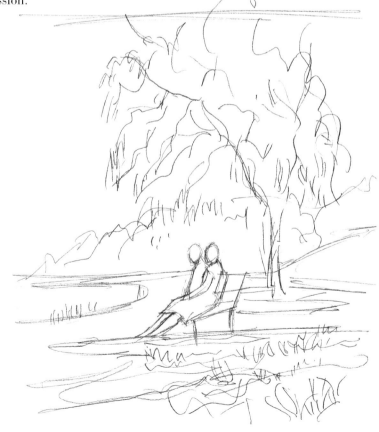

2 *Paint in the figures very roughly and the background broadly in blues, yellows and greens (blues mixed with yellows).*

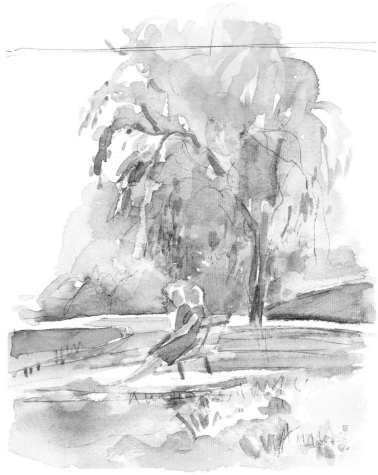

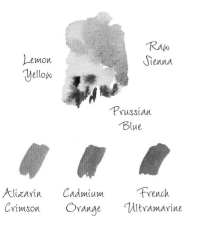

Lemon
Yellow

Raw
Sienna

Prussian
Blue

Alizarin
Crimson

Cadmium
Orange

French
Ultramarine

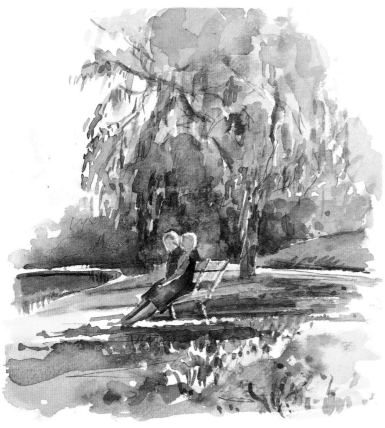

3 *Paint in the trees and foreground with stronger colours, especially the brighter more defined marks to show the grasses.*

Painting people 137

Indoors

Working indoors is very convenient, as you have a choice of different locations, control over the lighting, and can stay dry and warm! Try all sorts of unusual settings, such as the bathroom, kitchen and utility room, as well as the more public areas.

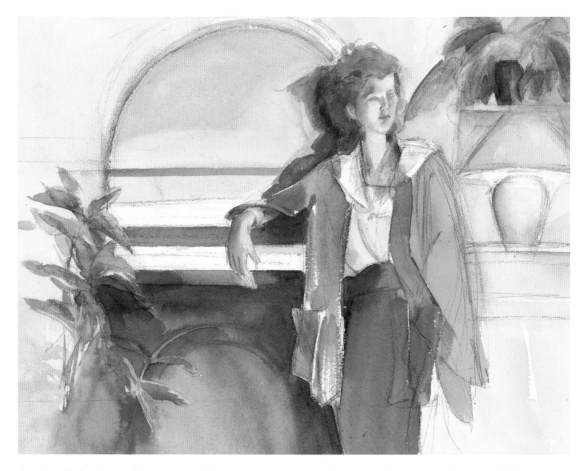

I painted this in my living room. The paper I used was a little rougher than usual so the marks on the top are more broken up as a result. The use of complementary colours is exploited in the orange shawl and blue top. The light hits the figure from one side and slightly below, so the shadows are cast slightly upwards.

In the bedroom

It was important in this picture to create a sense of atmosphere, so the main part of the figure is in semi-darkness. Again, the paper used is very rough and absorbent, so the paint creates unexpected effects and the paper texture shows through.

1 *Sketch the picture very loosely to create an impression and atmosphere rather than to give an accurate representation.*

Payne's Grey Sepia Prussian Blue Alizarin Crimson Cadmium Orange

2 *Start painting using Sepia and Payne's Grey. This is almost a tonal painting, with very few colours used in varying shades from light to dark. The paper is excellent for dry expressive marks to show the folds of the bedding.*

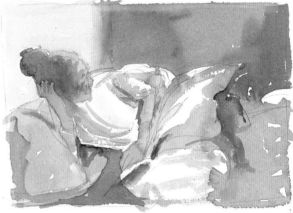

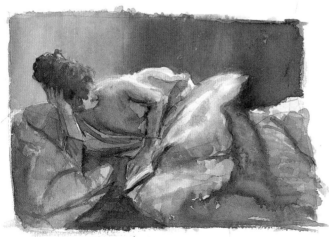

3 *Increase the depth of colour using Prussian Blue, Payne's Grey, Sepia, Cadmium Orange and Alizarin Crimson, making the bedding darker, and leaving just a little edge of light.*

MOVEMENT

People move all the time, so the next skill to acquire is capturing motion in your painting. When you start, a camera can be very useful to freeze action and help you to understand what is happening in the movement. Most movement involves repetition of the gestures made with the limbs, and in time you will learn to recognize the changes of positions in the figure.

Centre of gravity

Movement such as walking and running is a controlled loss of balance. As we step forwards, the centre of gravity of our body is moved forward, we lose our balance for a split second and our leg moves from behind to catch us.

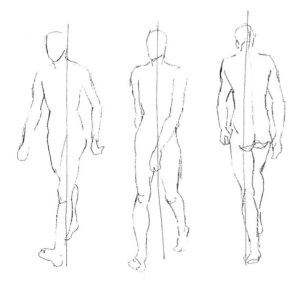

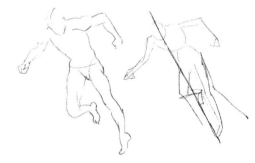

The main line of balance should lean in the direction of the movement.

If you want to draw a person in motion, place the balance point slightly ahead of the direction of the movement, so that it shows the body at that critical point when it is slightly out of balance. Then the figure will look as if it is caught in motion.

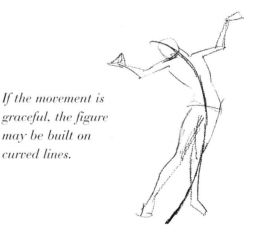

If the movement is graceful, the figure may be built on curved lines.

Conveying movement

These sketches of a figure skipping, throwing, dancing, swimming, skating and running show how little detail is needed to convey the gesture. Action is best expressed at extremes of stride, and remember always to tip the line of balance.

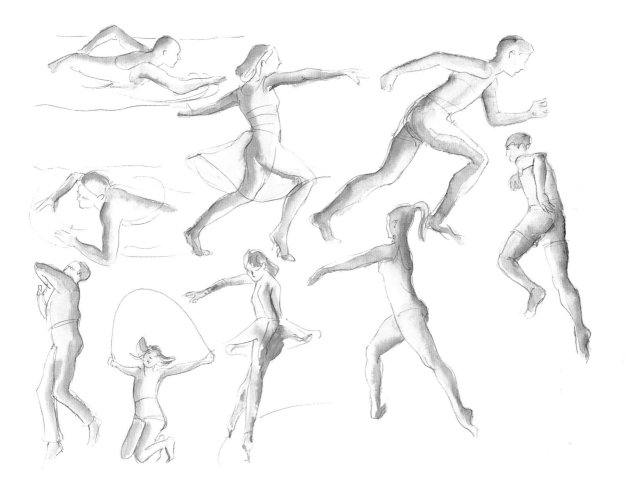

- *The arms move in the opposite direction to the legs.*

- *The back foot does not leave the ground until the front foot has been put down.*

- *The arms pass the hips at the same time as the knees pass each other.*

- *The hip is higher on the side of the foot that is carrying the weight of the body.*

Walking

Walking is a gentle movement. These figures show the walking process in profile, from the side and from the front. You can paint a person walking to add interest to a street scene.

Notice in particular the changes in the angles of the knees, the twisting of the torso and the swing of the arms. Also, when seen in profile, note the way the heel lifts as the toe goes down.

Running

Like walking, there is repetition of the stages of the movement when someone is running, but the movement is more extreme and it is important to convey the motion.

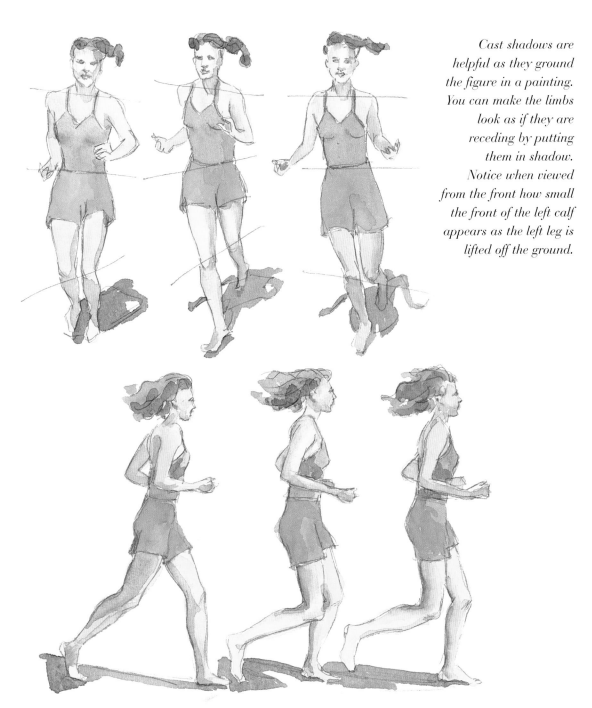

Cast shadows are helpful as they ground the figure in a painting. You can make the limbs look as if they are receding by putting them in shadow. Notice when viewed from the front how small the front of the left calf appears as the left leg is lifted off the ground.

Boys playing rugby

I sketched these boys from a photograph, so they look a little frozen and awkward, but moving figures can appear ungraceful if they are caught mid-leap.

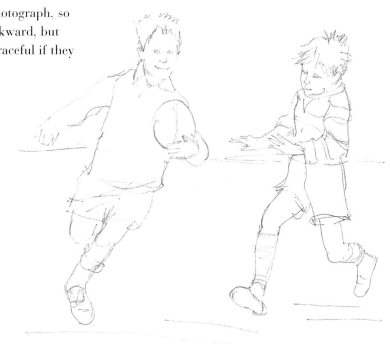

1 *Draw in the detail of the two boys using an HB pencil.*

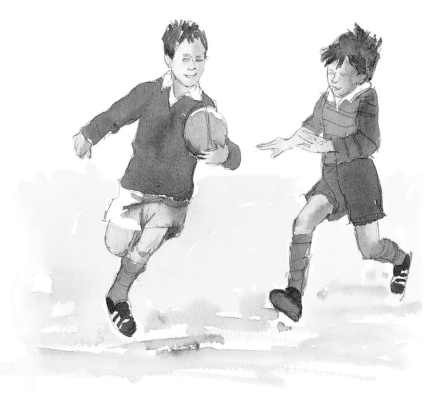

2 *Paint one shirt and a pair of shorts in Prussian Blue, the other shirt and socks in Cadmium Red, the skin in Naples Yellow, the hair in Sepia and Burnt Sienna, and the boots and shadow on the ball and shorts in Payne's Grey. The grass is painted with Gold Green.*

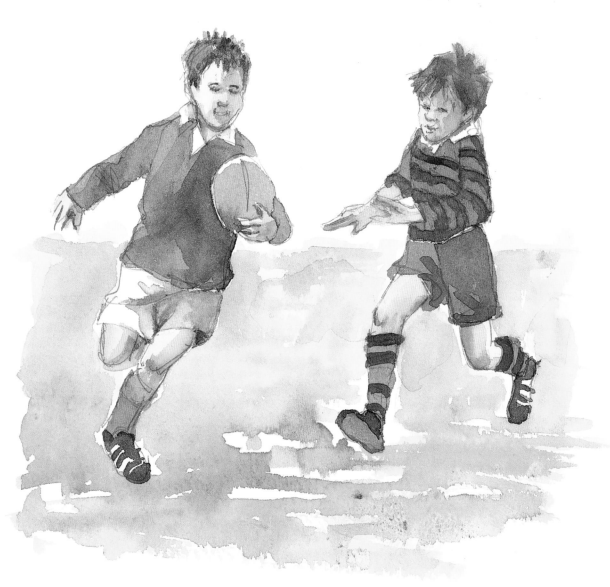

3 Add shadows on the shirts and shorts with Payne's Grey; add the stripes, and increase the form of the limbs and heads with Burnt Sienna and Cadmium Red. While the grass is still wet, add some Emerald Green.

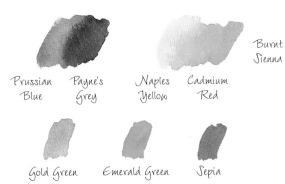

Prussian Blue Payne's Grey Naples Yellow Cadmium Red Burnt Sienna

Gold Green Emerald Green Sepia

Tango

Dance is a challenging subject to paint. I chose the tango because it has a very precise range of repeated movements so I could focus on a typical pose to paint the picture. I watched a group for some time and took photographs, as the dance is fast and furious.

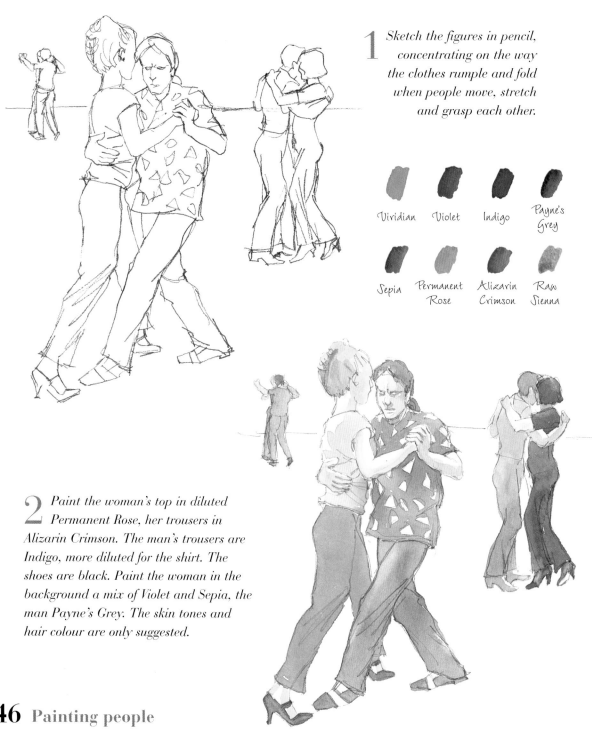

1 Sketch the figures in pencil, concentrating on the way the clothes rumple and fold when people move, stretch and grasp each other.

Viridian Violet Indigo Payne's Grey

Sepia Permanent Rose Alizarin Crimson Raw Sienna

2 Paint the woman's top in diluted Permanent Rose, her trousers in Alizarin Crimson. The man's trousers are Indigo, more diluted for the shirt. The shoes are black. Paint the woman in the background a mix of Violet and Sepia, the man Payne's Grey. The skin tones and hair colour are only suggested.

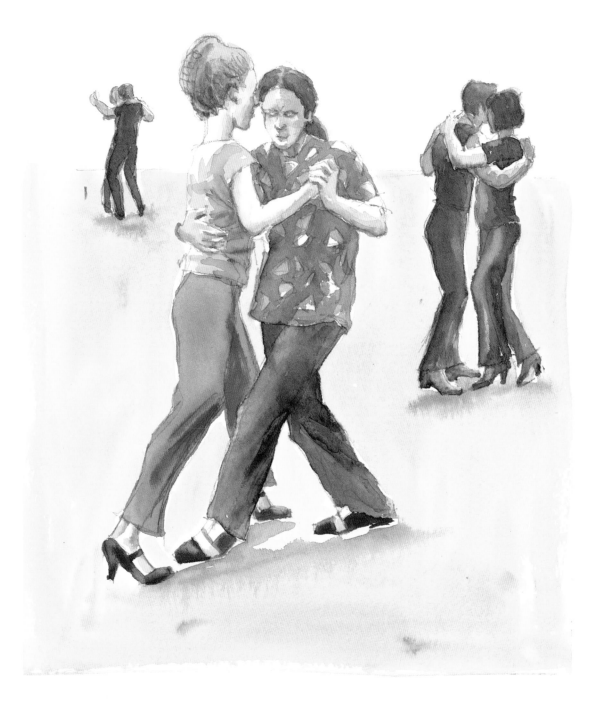

3 *Increase all the shadows, using Violet and Permanent Rose for the woman's top, leaving touches of the white paper, more Alizarin Crimson with a touch of blue for the folds in the trousers. The man's shirt and the folds of his trousers are sharpened up with Viridian and more Indigo. Paint the limbs Raw Sienna, adding form to the man's arm and face with Sepia. Add the shadow areas on the figures in the background using the same colours as before but less diluted. The floor is painted in a dilute wash of Raw Sienna.*

Painting people **147**

DEMONSTRATION FOOTBALL

AT A GLANCE...

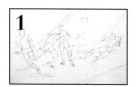
1

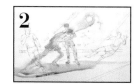
2

3

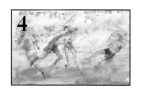
4

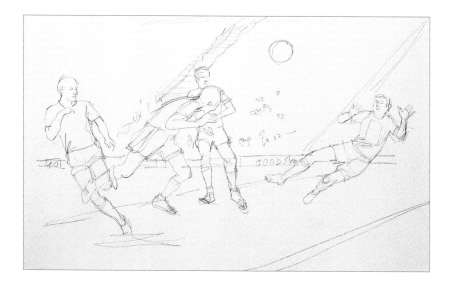

1 Sketch the figures lightly, using an HB pencil, keeping it very free. The idea is not to produce figures that look frozen, so the paint will not be kept strictly within the drawn edges of the individual figures.

2 Wet the paper thoroughly, letting the colours Cadmium Red, Hooker's Green, Payne's Grey, Gold Green and Sepia drift into each other, not keeping within the sketched lines. Leave the space clear for the ball shape, either dab it out or wet around it.

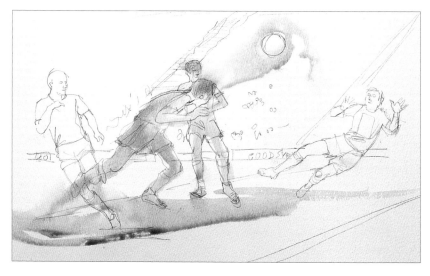

The palette

 Prussian Blue

 Payne's Grey

 Sepia

 Burnt Sienna

 Cadmium Red

 Hooker's Green

 Gold Green

5

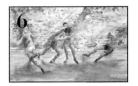

6

3 Continue adding the colours. You will see that if you flood very wet colour into a damp surface you will get 'back runs' which look like blotches but which add interesting texture and prevent the picture from looking static.

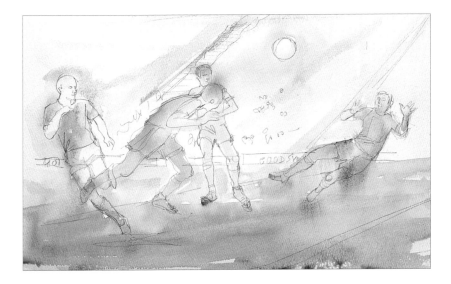

4 Here the picture begins to come together. Add Burnt Sienna on the limbs, wetting the paper first if it has dried out. Add more red to define the figures, this time on a dry surface, to sharpen up the shapes. Then start to define the terraces with greys and browns.

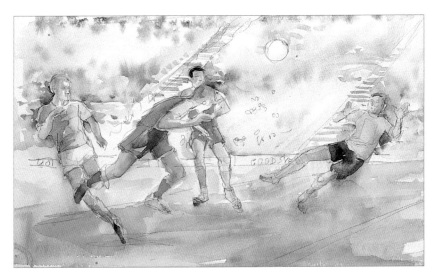

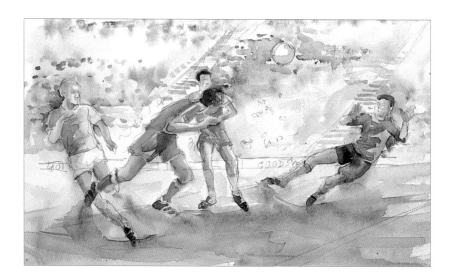

5 To increase the idea of sweeping
movement, wet an arc shape between the
legs and drop in Prussian Blue mixed with
Hooker's Green. Add detail very loosely to the
boots, heads and shirts, and add blue shadows
to the background crowd.

Detail: Notice how
the crowd is just
suggested by
applying blobs of
paint wet-into-wet
to show the faces.
The lines of the steps
are painted with a
dry brush.

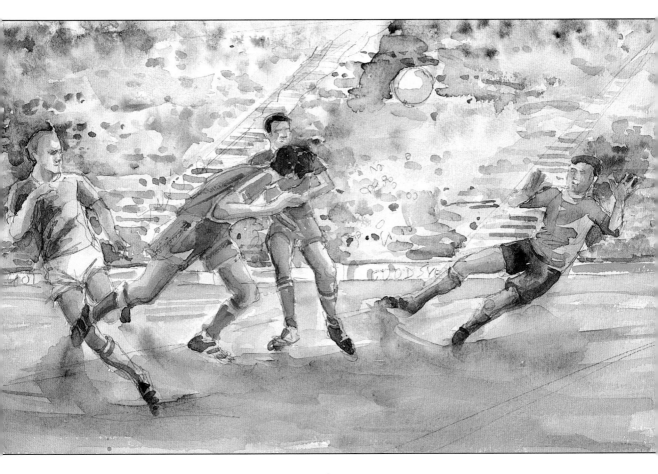

6 **Finished picture:** *Bockingford 300 gsm (140 lb) Not paper, 22 x 38 cm (8½ x 15 in). With a dry brush, work more into the background, suggesting the crowds with blobs, and using lines for the steps. Add Gold Green to bring the foreground into focus. Add some detail to the crowd in Sepia and Payne's Grey to help reveal the players' heads. The shapes emerge in part but they also melt into the picture.*

PAINTING ANIMALS

Trevor Waugh

I have frequently been asked by students over the years whether it is possible for them to start painting animals, or to improve their skills, and the answer is a resounding 'Yes!' All you need to do is to understand some basic principles, and be prepared to put some effort into your pictures, especially with regards to drawing. Animals are found in many different situations, and adding them to your pictures will add life and action.

Although painting animals is somewhat specialized, there is no reason why you cannot use what you already know to help you, provided that you start the way you mean to carry on. Learn the basics first and when you have these, progression will be much easier.

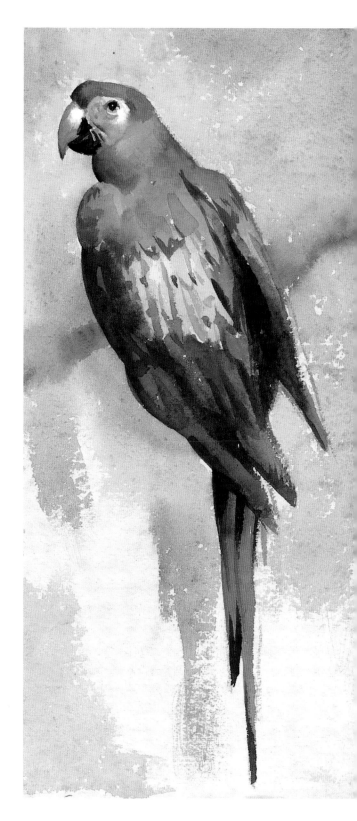

Learning
to paint
animals is
tremendous fun,
and all you really
require is an inquiring mind and a willingness
to practise with your materials until you get
the result you are looking for. The secret is to
keep your paintings simple, which sounds
easy, but can sometimes be hard to achieve.

The aim of this section of the book is to
start you working with easy-to-understand
basics and give you a platform to build upon
so that your skills become broader and your
confidence increases. Observation plays a
great part: it is useful to make sketches of
what you see as this will get you familiar with
animal shapes and behaviours. Practice is the
key issue; if you practise the exercises in this
book thoroughly, you will be well on the way
to drawing and painting animals successfully.

TECHNIQUES

You can use your brush and watercolours in various ways to create different effects. Here are a few basic techniques that will help you to interpret the animals you wish to paint and improve your skills. Practise these techniques and you will find that your abilities and confidence improve.

Brushwork and washes

The brush is a flexible tool and can be used to paint lines as well as shapes. Differently shaped brushes create different marks. You will need your No. 6 round sable brush for drawing and painting (make sure it comes to a fine tip), and your No. 20 mop and flat brush for large washes and other effects.

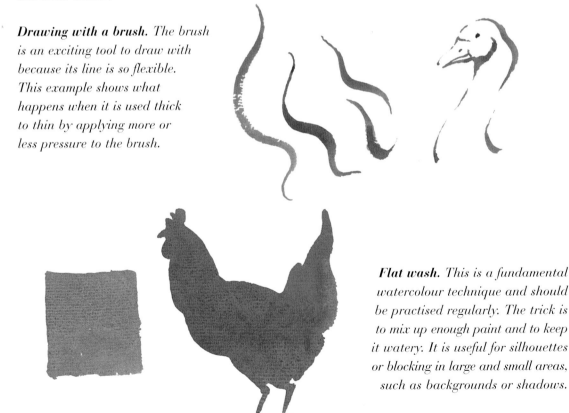

Drawing with a brush. The brush is an exciting tool to draw with because its line is so flexible. This example shows what happens when it is used thick to thin by applying more or less pressure to the brush.

Flat wash. This is a fundamental watercolour technique and should be practised regularly. The trick is to mix up enough paint and to keep it watery. It is useful for silhouettes or blocking in large and small areas, such as backgrounds or shadows.

Graded wash. Work this the same as a flat wash, except gradually add more water to your paint mix so that the colour gets paler. Move the brush from top to bottom, left to right, smoothly down the paper.

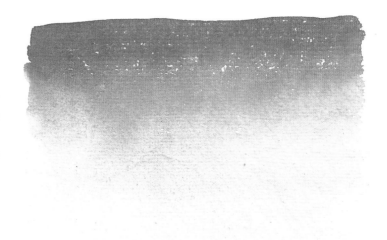

Dry brush. Using little liquid in your brush, drag it across the paper so that the pigment hits and misses the paper. This produces a sparkling effect, and is particularly useful for creating texture.

Wet-on-wet. This is one of watercolour's most thrilling techniques and can create dazzling colour mixes. Get your individual colours ready in the palette, then apply them wet into wet colour, letting them blend together freely on the paper. Although the effect may seem uncontrollable at first, with practice you will be able to place colours exactly where you want them.

Other techniques

There are many other techniques available to you, but I suggest you keep them simple. The art of watercolour is all about controlling the amount of liquid you have in the brush at any one time; this includes the level of concentration of pigment and how you apply it to the paper.

Lifting out. This is a process to remove paint that has already been laid down; it can be done with a dry brush, sponge, rag, or even a tissue. A slight trace of pigment may be left on the paper.

Glazing. Place one colour down on the paper, let it dry, then place a different one on top. This creates a third colour where the original colour shines through. The more transparent the top colour, the better this effect will be.

Dropping in colour. Very similar to wet-on-wet, but let the sheen go off the the first colour applied before dropping in another colour. Use less water and more pigment in the brush for the dropped-in colour, thereby restricting the flow, or spread, of the two colours.

Two colours on the brush. This is an exciting technique that can give tonal form and colour in one go. Load the brush with two colours, one darker than the other, then press down on the paper using one brush stroke until you can see both colours flowing out into the shape.

Soft edges. *Use water to form a shape, and then add the paint so that it flows dark into light. This can also be done in reverse, painting the colour in and then adding water to soften the edge. You will find yourself using the soft edge technique quite a lot when producing form.*

Spattering, splashing. *Load your brush with paint, then hold it and tap with your index finger on the handle of the brush onto either dry or wet areas of paper. You can use a different tool, such as an old toothbrush, and spray or flick the hairs with your finger. Spattering is very useful for all kinds of markings and textures.*

Basic Animal Shapes

This section is about using basic geometric shapes to construct your animals. Recognizing these shapes and using them in modified ways is a very important first step. Look carefully at the relative sizes of these shapes and how they join together. This is all about having fun by going back to basics.

Basic shapes

All the animals below and opposite are constructed using very simple shapes, and drawn in pencil. Don't worry if you find yourself erasing some shapes to adjust the relative sizes of them until they look correct. This process of trial and error is absolutely necessary if you are to progress.

Use your graphite pencils to sketch these basic shapes and then try to interlock them to form different animals.

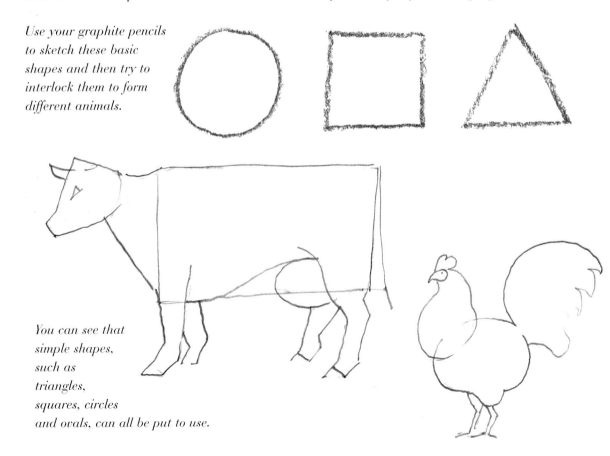

You can see that simple shapes, such as triangles, squares, circles and ovals, can all be put to use.

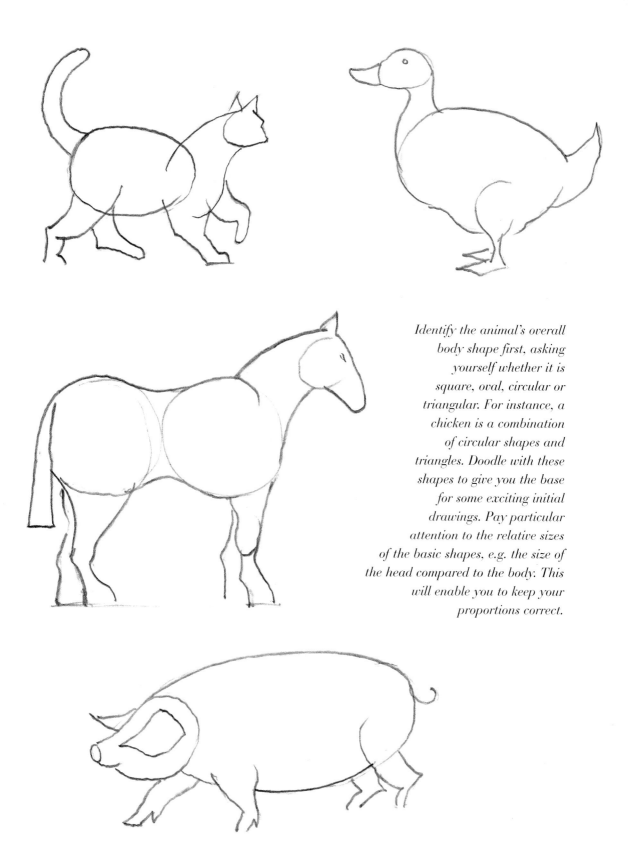

Identify the animal's overall body shape first, asking yourself whether it is square, oval, circular or triangular. For instance, a chicken is a combination of circular shapes and triangles. Doodle with these shapes to give you the base for some exciting initial drawings. Pay particular attention to the relative sizes of the basic shapes, e.g. the size of the head compared to the body. This will enable you to keep your proportions correct.

Modified shapes

Now it is time to get out your small round brush, and start to sketch with paint. It is helpful to think of your basic shapes as balloons that can be squashed to alter their shapes. When modifying your basic shapes start by noting how wings overlap the body or legs and how the legs seem to tuck into the body, etc. Try to show which leg comes in front and which one goes behind.

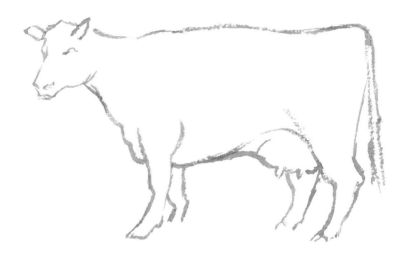

Make sure your brush comes to a fine tip when dipped in the paint. Load it with a dilution of Burnt Umber and then, before you touch the paper, make the mark you want to paint above the paper in the air several times; this will give you the confidence to make the correct mark. I call this manoeuvre 'air painting'.

A useful hint at this stage is to go faster on the curves and slower on the straight lines. Now you're really drawing.

Sometimes basic shapes can look a little flat and uninteresting, so break your lines to show plumage and interest on the outlines.

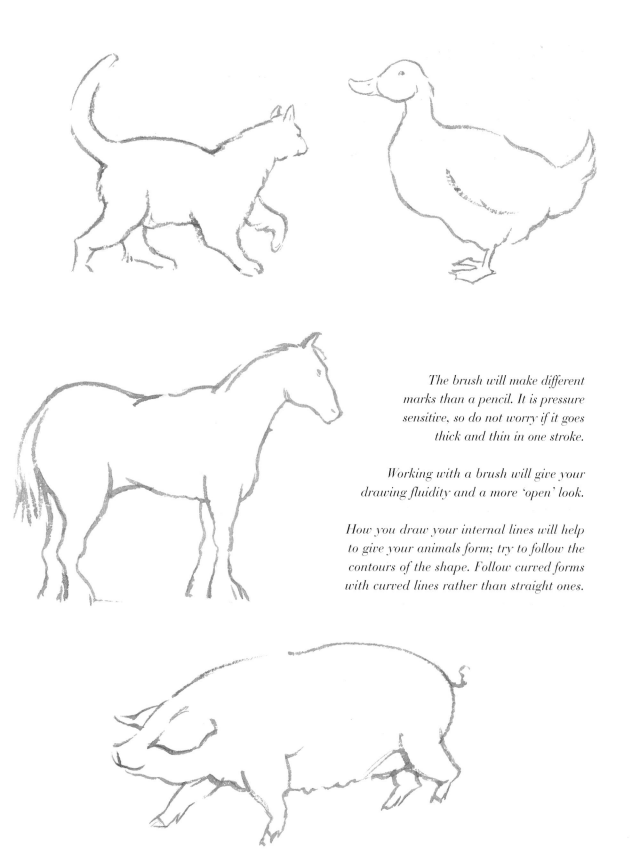

The brush will make different marks than a pencil. It is pressure sensitive, so do not worry if it goes thick and thin in one stroke.

Working with a brush will give your drawing fluidity and a more 'open' look.

How you draw your internal lines will help to give your animals form; try to follow the contours of the shape. Follow curved forms with curved lines rather than straight ones.

Three-dimensional shapes

Simply drawing an outline is not enough to give your animal form. You will want your animals to look three-dimensional, so the use of tone, or shading, is important. Shadows help to describe form when you draw and paint, so you need to learn to use shading to make your animals three dimensional. Use the soft edge technique (page 157) to help you.

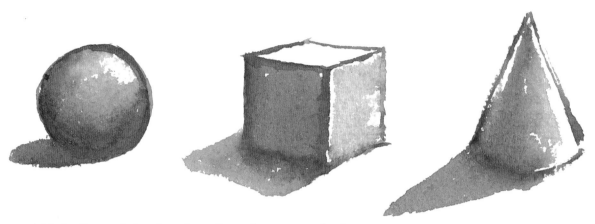

Add shading and therefore three dimensions to your basic shapes by imagining a light source to one side of the shapes and adding shading and shadows to the opposite side.

The same idea can be extended to give your simple paintings three dimensions.

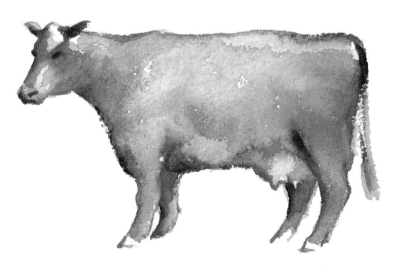

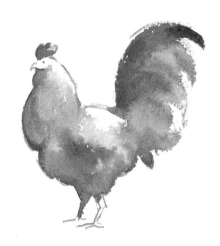

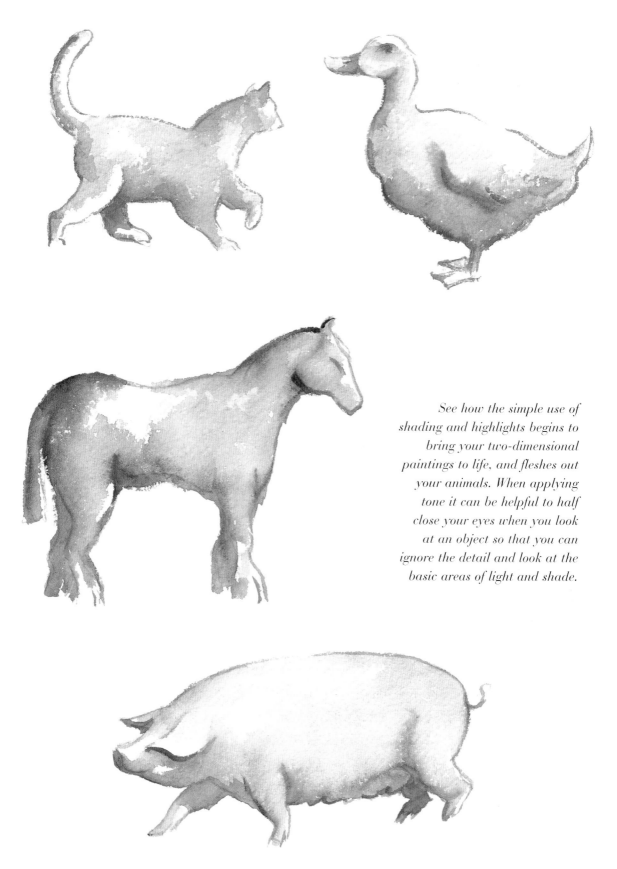

See how the simple use of shading and highlights begins to bring your two-dimensional paintings to life, and fleshes out your animals. When applying tone it can be helpful to half close your eyes when you look at an object so that you can ignore the detail and look at the basic areas of light and shade.

Cow

This Friesian cow is a good subject to begin with as it is structured around a basic box shape, and the black-and-white markings are striking.

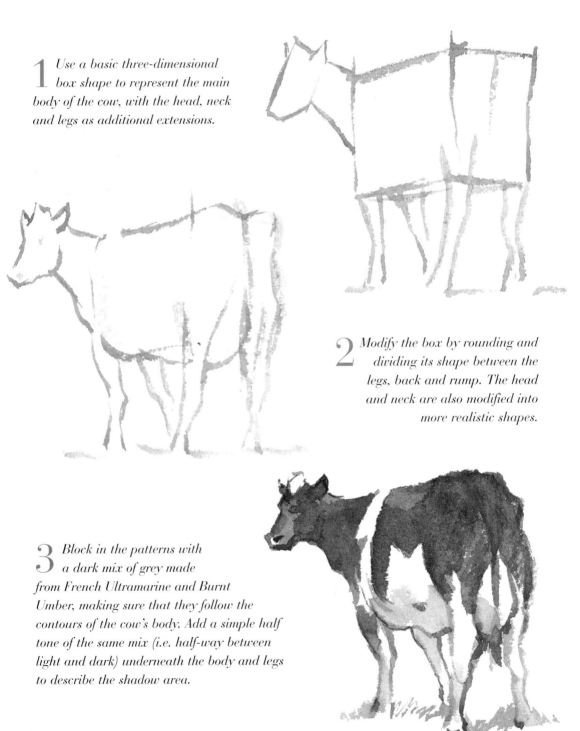

1 Use a basic three-dimensional box shape to represent the main body of the cow, with the head, neck and legs as additional extensions.

2 Modify the box by rounding and dividing its shape between the legs, back and rump. The head and neck are also modified into more realistic shapes.

3 Block in the patterns with a dark mix of grey made from French Ultramarine and Burnt Umber, making sure that they follow the contours of the cow's body. Add a simple half tone of the same mix (i.e. half-way between light and dark) underneath the body and legs to describe the shadow area.

Chicken

Here again the picture is structured around some simple basic shapes. Note the way the shadow cast by light falling on an object can be used to describe its shape and to enhance the form.

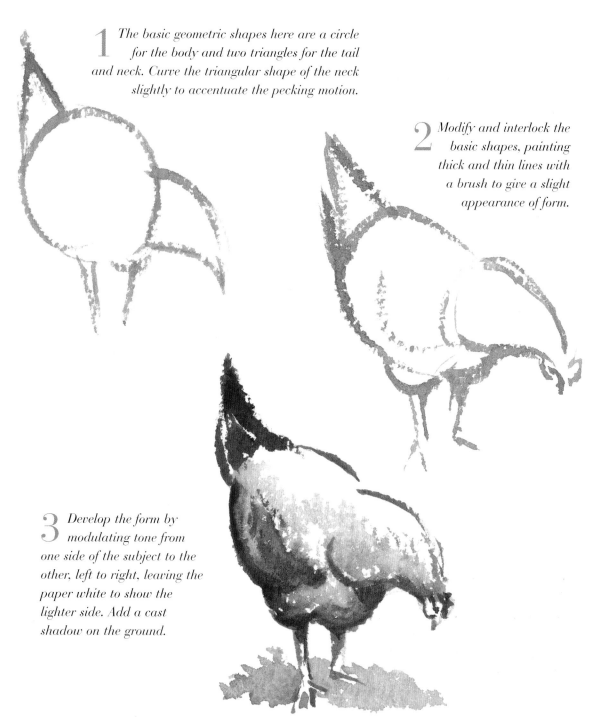

1 The basic geometric shapes here are a circle for the body and two triangles for the tail and neck. Curve the triangular shape of the neck slightly to accentuate the pecking motion.

2 Modify and interlock the basic shapes, painting thick and thin lines with a brush to give a slight appearance of form.

3 Develop the form by modulating tone from one side of the subject to the other, left to right, leaving the paper white to show the lighter side. Add a cast shadow on the ground.

UNDERSTANDING TONE

Here you will learn to apply tone to create the form and shape of your subjects. Understanding tonal values will not only bring life to your paintings, but will also give you the confidence to tackle more complex subjects. When you know how to use tone in a painting you are more than half-way to success.

Creating tone

Creating tonal values in your paintings is not just a question of making an outline drawing and then filling it in. Initially you need to consider three things: where your lights are, where your half tones are and where your darks are. Here are some examples of paintings using this method.

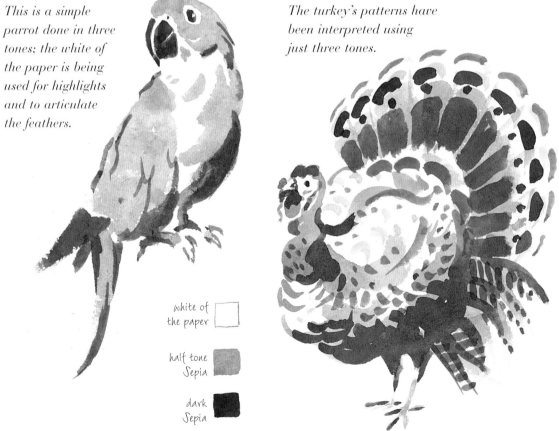

This is a simple parrot done in three tones; the white of the paper is being used for highlights and to articulate the feathers.

The turkey's patterns have been interpreted using just three tones.

white of
the paper

half tone
Sepia

dark
Sepia

Tonal studies

Tonal studies play an important role in building your confidence for painting. They can be exciting and fun pictures to paint in themselves. Keep to the three-tone method as much as you can, as it is the easiest way of stripping the image right down to the basics.

The goose was sketched in Burnt Umber using a small round brush and thick and thin lines to create form. A simple half-tone shadow was added to give more depth to that form.

In this tonal study (painted using Burnt Sienna) dark, light and half tone have been effectively employed to create a whole painting, including outlines, shadows and background. The light areas are the white of the paper.

Tonal cat

In this exercise I have worked quickly from brush line to half tone to dark without stopping in between, working whilst the watercolour is still wet, a wet-on-wet technique. This gives a softer and furrier look to the tones.

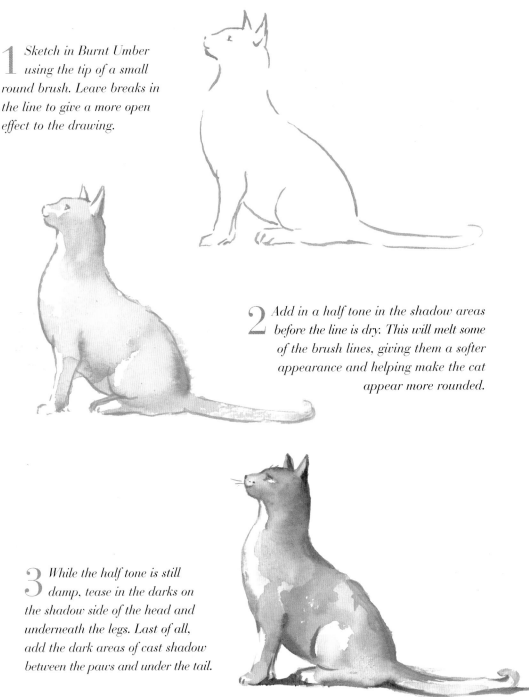

1 *Sketch in Burnt Umber using the tip of a small round brush. Leave breaks in the line to give a more open effect to the drawing.*

2 *Add in a half tone in the shadow areas before the line is dry. This will melt some of the brush lines, giving them a softer appearance and helping make the cat appear more rounded.*

3 *While the half tone is still damp, tease in the darks on the shadow side of the head and underneath the legs. Last of all, add the dark areas of cast shadow between the paws and under the tail.*

Pig

These three separate studies are of the same view. One is done in pencil with shadow areas, one in Sepia tones and the third in three colours. The use of tone is the same in all three studies.

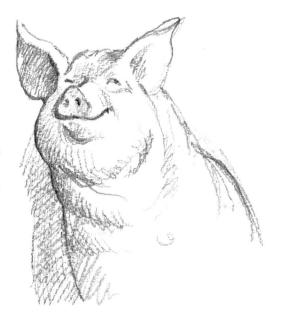

Using an HB pencil, start by drawing your simple outline, modified from basic shapes, then decide on a light side and a shadow side. Here I have scribbled and hatched my tones from left to right to bring out the features of the face.

Again, make a simple outline drawing in pencil, then with a large round brush push in the Sepia tones from left to right, making the shadows as punchy as possible.

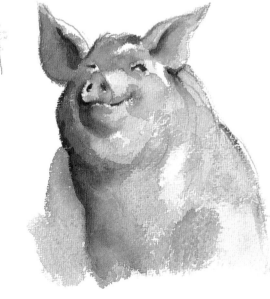

Mix up pale dilutions of French Ultramarine, Cadmium Red and Yellow Ochre in a palette. Use a pencil outline, then let pale Yellow Ochre and Cadmium Red mix on the paper leaving two or three highlights from the white paper. Gradually get darker by adding French Ultramarine and Cadmium Red in the shadow areas. Go as dark as you can in the more recessed areas of the subject.

CONFIDENCE WITH COLOUR

As soon as you are well practised in the use of tone it is a relatively easy step to replace those tones with colours. You can sketch in any single colour, or combination of colours, and the outcome will always be fresh and individual, but you must keep your tonal contrast.

Using colours for tone

Colours do not have to be literal when you paint. Here I have deliberately used unusual colour combinations to test the theory. However, the basic shapes are sound and the tonal contrast is dynamic. Try out some examples like this to build your confidence with colour.

Goose
Unusual colours have been used not only to describe the line but also the form of this goose, making a visually exciting image.

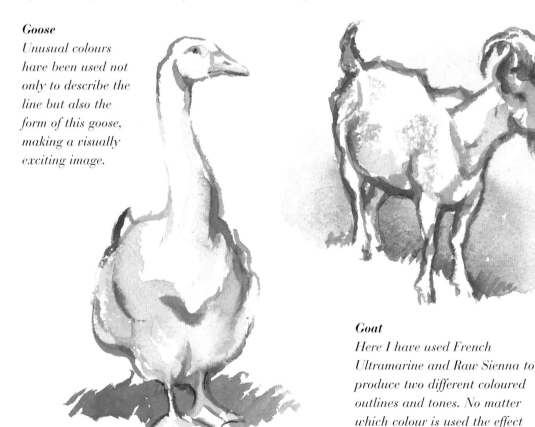

Goat
Here I have used French Ultramarine and Raw Sienna to produce two different coloured outlines and tones. No matter which colour is used the effect is always unique.

Cat

In spite of the fact that purple and pink have been used to create the form, this still appears to be a white cat. Providing the proportions are drawn correctly the colour speaks for itself.

Tortoise

Green is the main colour here, for both the drawing and the shadows. The red and yellow are put in afterwards as glazes.

Deer

Here I have used dramatic and unusual colours again, but the picture still reads true. I had a lot of fun painting it.

EXERCISE Paint a goose

Here I have been more traditional in my choice of colours, but, as you can see, they are still quite bright and are kept dynamic by the use of tone, especially in the shadow areas. White paper is left for the bright highlights in stages 2 and 3, and the really dark areas left until the last stage.

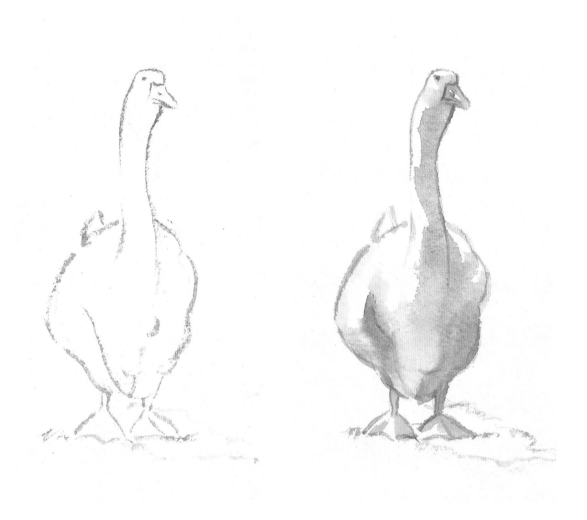

1 *Sketch in the goose with a pale Sepia outline, keeping the brush quite dry to achieve a broken line.*

2 *Put in the shadow areas of the goose first, using a purple mixed from French Ultramarine and Permanent Rose. Use Cadmium Orange for the beak and feet.*

The palette

French
Ultramarine

Coeruleum

Cadmium
Yellow

Cadmium
Orange

Permanent
Rose

Sepia

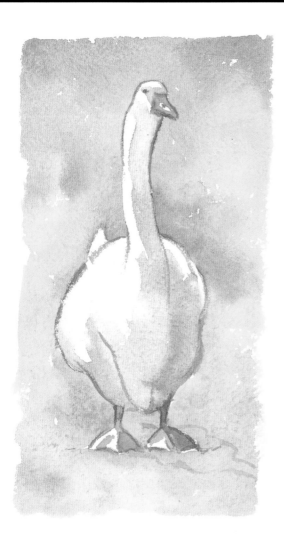

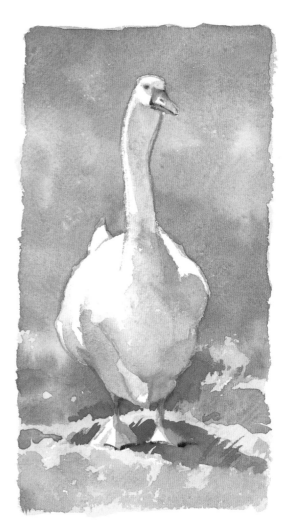

3 Paint the background around the goose wet-on-wet, using varying combinations of Coeruleum and Cadmium Yellow.

4 When thoroughly dry, repeat the process of wet-on-wet in the background using more water in the mix to create a glazing effect, then punch up the darker tones in the cast shadows using French Ultramarine.

TEXTURE AND PATTERN

All animals have some texture, markings or patterns. If these can be mimicked in some way, either by employing the surface of the paper, or by using the brush to imitate the pattern, the results can be simple and effective. After you have tried the techniques shown here, have a go at inventing some of your own.

Feathers and fur

Whether rendering feathers or fur the same method applies. Several layers of colours are needed, and the build-up of these layers creates the effect. Put the main block colour, or colours, in first, then build up the layers with finer brush strokes moving in the direction of the pelt or plumage.

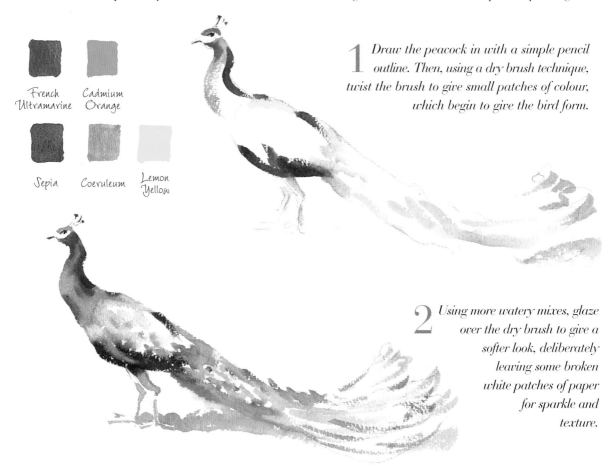

French Ultramarine

Cadmium Orange

Sepia

Coeruleum

Lemon Yellow

1 *Draw the peacock in with a simple pencil outline. Then, using a dry brush technique, twist the brush to give small patches of colour, which begin to give the bird form.*

2 *Using more watery mixes, glaze over the dry brush to give a softer look, deliberately leaving some broken white patches of paper for sparkle and texture.*

This whole painting is an exercise in textures and patterns. There are obvious black markings following the contours of the bird, but also the background has been given a different texture by the use of wet-on-wet colour patches.

Start off these badgers using a dry brush technique to establish the basic body shapes. Use a dark wash with a round brush to paint the patterns on the heads and the cast shadows.

Spiny hedgehog

This fun exercise gives you the chance to use your
dry brush technique to full effect. Build the spines
up in layers as they look more effective this way.

1 With Burnt Umber, start by
positioning the nose and eyes
correctly. Then work upwards with pale
swatches of Cadmium Red and Burnt Sienna
until the overall body shape begins to emerge.

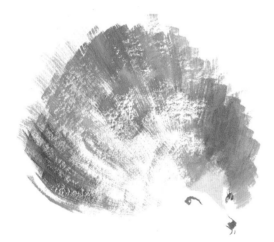

2 Now using a square brush, develop the whole
shape with drier paint so that the texture of
the spines starts to show. Pay particular attention
to the direction in which the spines fan out and
where they finish to form the edge of the animal.

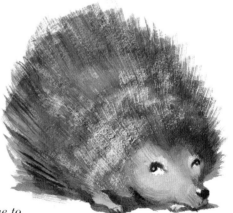

Burnt
Umber

Burnt
Sienna

Cadmium
Red

3 Continue to
develop the spines with
darker paint and a dry brush, especially in the
recessed and shadow areas, leaving a small
amount of white paper showing through. Lastly,
work on the face using a small round brush,
giving attention to highlights and cast shadows.

Patterns and markings

Patterns and markings are exciting features on animals. Observe how markings follow the contours of the animal, and make yours do the same. This will enhance the form.

Dalmation

Using a white watercolour paper, I put in the tonal sequences first to create the form. I then added the spots over the tones, slightly darkening them for the facial features.

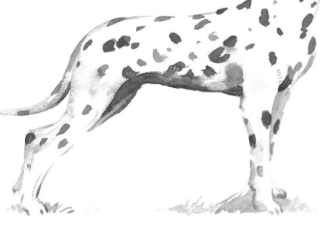

Tiger stripes

For this tiger's face, a large wash of different colours (Burnt Sienna, Yellow Ochre and French Ultramarine) was put down first and then neat Burnt Umber dropped in for the stripes. Finer directional marks were layered on top with a dry brush.

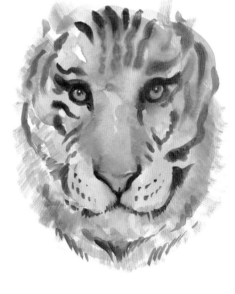

Cheetah spots

Here the body of the cheetah was painted in a wet-on-wet wash of colours first and the spots were dropped in whilst it was still wet.

ANIMAL FEATURES

When you are painting an animal close up, you need to consider details, such as the eyes, ears, nose, beak, etc., as well as textures such as fur or feathers. Although you will want to create a likeness, it need not be as precise as you might expect. Keeping detailed studies in a sketchbook is extremely helpful when you are positioning features.

Facial features

Facial features are crucial to identify a type of animal, and, in the case of an animal portrait, to capture a likeness of a specific animal. Do not try to get too involved with minute detail; instead, have fun looking at how little detail you have to paint to get a result.

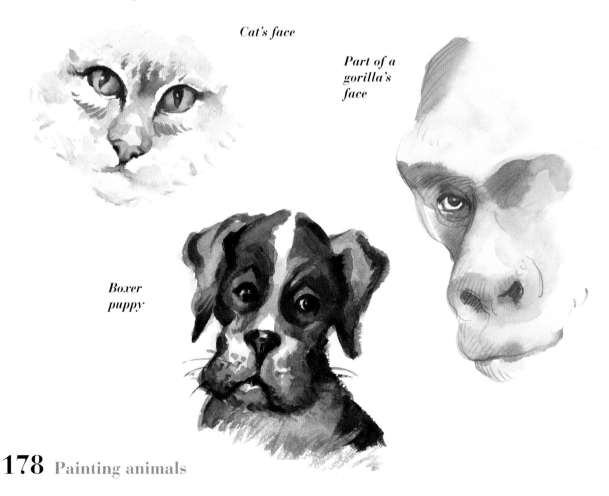

Cat's face

Part of a gorilla's face

Boxer puppy

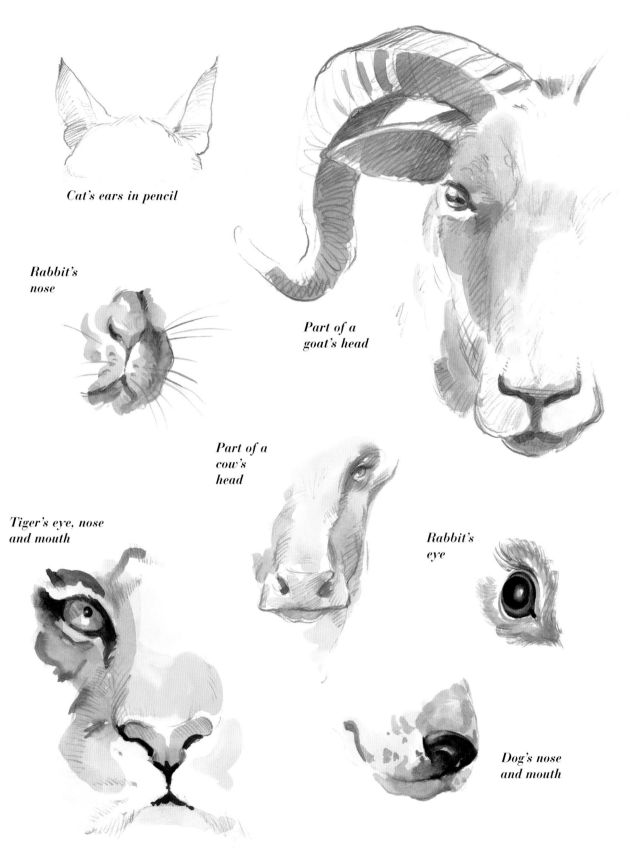

Cat's ears in pencil

Rabbit's nose

Part of a goat's head

Part of a cow's head

Tiger's eye, nose and mouth

Rabbit's eye

Dog's nose and mouth

Beaks and bills

Although their basic structure is the same, there is an amazing variety of beak and bill shapes. Here are a few examples; I am sure you will spot many more that you can record in your sketchbooks.

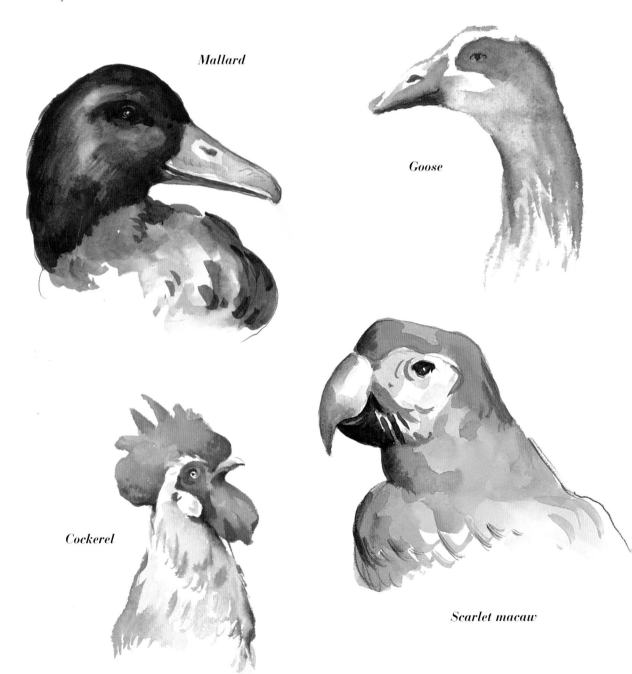

Mallard

Goose

Cockerel

Scarlet macaw

Feet and claws

Close observation of an animal's feet is not always easy; they can be hidden in grass or folded beneath them. Study the different sorts of feet, such as paws, claws and hooves. Ask yourself what kind of spaces there are between the toes and whether a hoof is cloven or round.

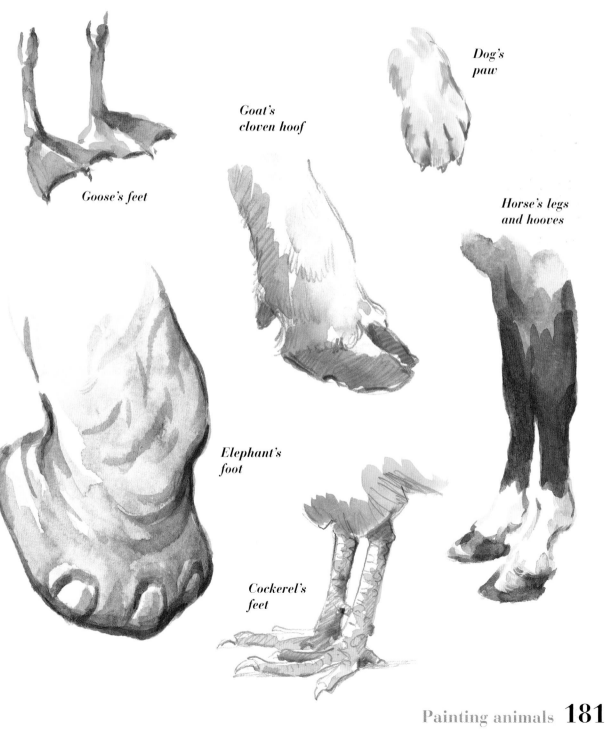

Dog's paw

Goat's cloven hoof

Goose's feet

Horse's legs and hooves

Elephant's foot

Cockerel's feet

FORESHORTENING

When an animal is coming towards or going away from you, some body parts will be distorted in size, and some may even disappear. This is called foreshortening, and it is vital to paint exactly what you see, however strange this may appear. Check your proportions thoroughly to make your painting realistic.

Lamb

The size of the head in relation to the body is critical in the majority of animal paintings and should be one of the first reference points in getting the proportions correct.

1 *The basic shape for the lamb is a box seen at an angle, with an echo of that box beneath to help the placement of the legs. Using this approach will help you to construct a foreshortened view more easily.*

2 *Modify the basic drawing with a brush line, adding facial features, legs and feet. With Raw Sienna and purple (French Ultramarine and Cadmium Red) float in the shadows on the face, down the front and across the legs. Paint the background a wash of Coeruleum and Cadmium Yellow, adding touches of the purple.*

Pig

This pig is constructed simply from four interlocking circles from nose to rump. This makes the general shape foreshorten, before the details are added.

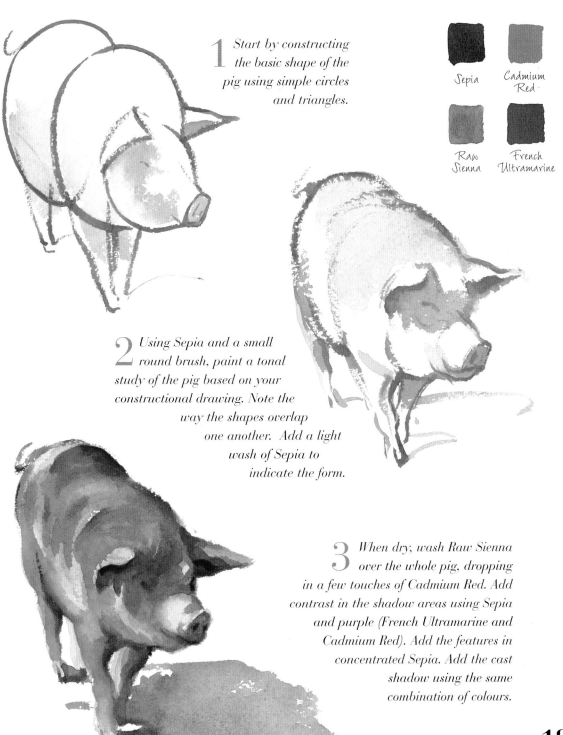

1 Start by constructing the basic shape of the pig using simple circles and triangles.

Sepia Cadmium Red

Raw Sienna French Ultramarine

2 Using Sepia and a small round brush, paint a tonal study of the pig based on your constructional drawing. Note the way the shapes overlap one another. Add a light wash of Sepia to indicate the form.

3 When dry, wash Raw Sienna over the whole pig, dropping in a few touches of Cadmium Red. Add contrast in the shadow areas using Sepia and purple (French Ultramarine and Cadmium Red). Add the features in concentrated Sepia. Add the cast shadow using the same combination of colours.

Dog

This three-quarters view of a fox hound will help you with contrast and form. I have used a No. 6 round brush for the drawing, and a flat brush to block in the colours diagonally, which helps to accentuate the form.

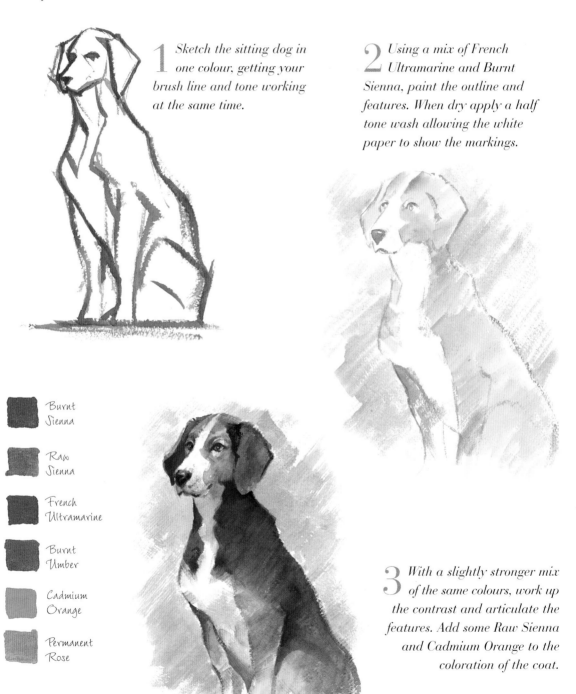

1 Sketch the sitting dog in one colour, getting your brush line and tone working at the same time.

2 Using a mix of French Ultramarine and Burnt Sienna, paint the outline and features. When dry apply a half tone wash allowing the white paper to show the markings.

Burnt Sienna

Raw Sienna

French Ultramarine

Burnt Umber

Cadmium Orange

Permanent Rose

3 With a slightly stronger mix of the same colours, work up the contrast and articulate the features. Add some Raw Sienna and Cadmium Orange to the coloration of the coat.

Fox

This is an extremely foreshortened view of a fox, based on three interlocking circles forming the head and body.

1 *Paint a brush line constructional drawing of a fox coming towards you. Note how the circle for the back of the body is almost completely overlapped by the one in front.*

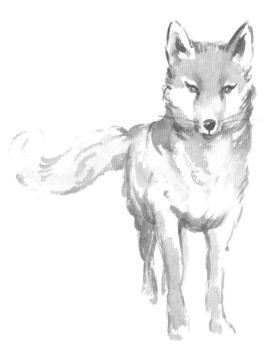

2 *Develop the tonal values using a warm grey (French Ultramarine and Burnt Umber). Indicate the tail. Work up the features with a slightly stronger mix of the same colours.*

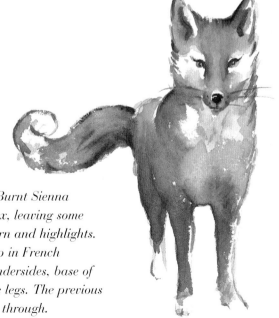

Burnt Umber

Burnt Sienna

French Ultramarine

3 *Once dry, wash Burnt Sienna over the whole fox, leaving some white paper for pattern and highlights. Whilst still damp drop in French Ultramarine to the undersides, base of the tail and down the legs. The previous tonal wash will show through.*

FARMYARD ANIMALS

Farmyard animals are one of my favourite subjects to paint in watercolour. They are easy to locate, so you can work from life and spend more time studying them. There is an enormous variety of different breeds as well as endless colours and markings. Remember to start by drawing basic shapes, and keep your sketchbook with you whenever you are outside to record your observations.

Brown cow

When you are observing basic shapes in an animal it is helpful to half close your eyes, see the animal as a simple shape and then imagine yourself putting a line around it.

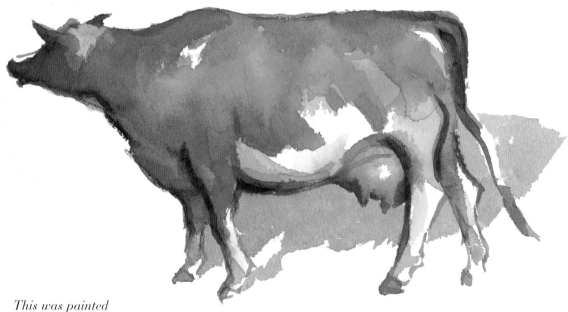

This was painted
boldly in my sketchbook
from life in just a few minutes, using a small
round brush for the drawing and a big round
brush to block in the colours and shadows.

Friesian

Friesian cows are wonderful to paint, largely because of the contrast between their almost white and almost black markings. A variety of colour mixes can be used to create this.

1 *Develop an accurate line drawing from your basic shapes. Keep the pencil outline light and simple. Do not develop the tones, or erase your markings.*

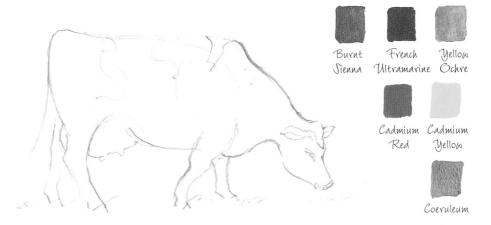

Burnt Sienna French Ultramarine Yellow Ochre

Cadmium Red Cadmium Yellow

Coeruleum

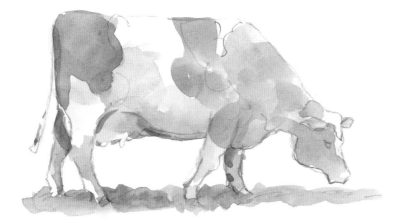

2 *Apply light washes of Yellow Ochre, light purple (French Ultramarine and Cadmium Red) and Burnt Sienna to the shadows on the underside and legs. Let the washes flow into one another. When dry, apply a light grey wash (French Ultramarine and Burnt Sienna) for the patterns.*

3 *Apply a darker mix of French Ultramarine and Burnt Sienna (almost black). Develop the patterns by leaving some of the light grey to represent the highlights on the dark areas.*

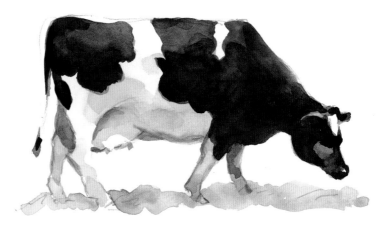

Painting animals 187

Sheep

In this exercise, the sheep is painted predominantly monochromatic, i.e. with one colour. I have used just a hint of a second colour. Notice how the more neutral colours stand out against the bright background.

1 Do a simple outline, drawing in Burnt Umber with a small round brush, indicating the main shapes.

Burnt Umber | French Ultramarine | Cadmium Yellow | Yellow Ochre

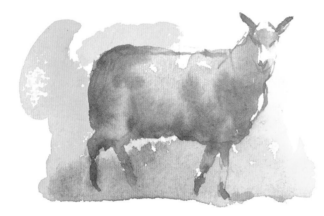

2 Using more Burnt Umber with a touch of Yellow Ochre, work wet-on-wet, varying the tones to help convey form and the texture of the wool. When dry, put in some background using Cadmium Yellow with French Ultramarine dropped in to create green.

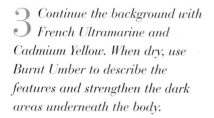

3 Continue the background with French Ultramarine and Cadmium Yellow. When dry, use Burnt Umber to describe the features and strengthen the dark areas underneath the body.

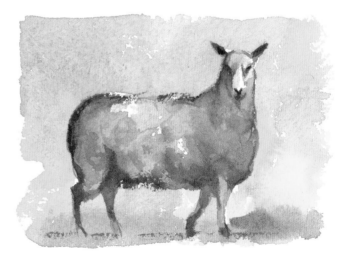

Goat

This exercise incorporates some movement in the animal, which gives it a bit more life. Gestures like this will give your paintings charm. This painting has been done on rough watercolour paper, which adds more texture to the finished picture.

1 Start with a basic outline drawing using the tip of a small round brush. Try to give your line some movement by working quickly and not going back over mistakes.

Burnt Sienna

Burnt Umber

Yellow Ochre

French Ultramarine

Cadmium Yellow

2 Block in some Burnt Sienna to form patches over the whole body making sure that they all join together. Leave some white patches from the paper on the head, back and legs to show through. Keep the painting simple.

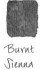

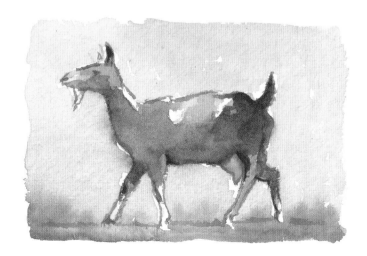

3 Work in some darks with Burnt Umber and French Ultramarine to give some variation in the tone and colour. Then paint the whole background in one wash of Yellow Ochre, dropping in a green (mixed from French Ultramarine and Cadmium Yellow) at the base whilst the wash is still wet.

EXERCISE Paint hens

In order to create a sense of space between two animals in a picture, it is important to allow one to overlap the other. The hen in the background is somewhat smaller than the one in front, giving the picture a sense of depth.

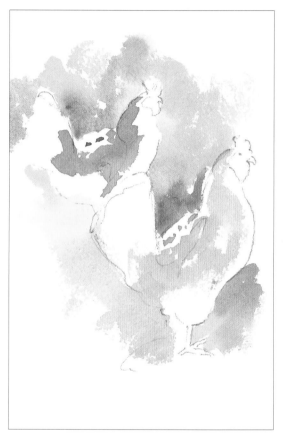

1 *Use a pencil to outline the two hens. Although these two are the same basic shape it is important to vary them slightly to avoid repetition, so I have given them different tails, and slightly different heads.*

2 *With a large round brush, block in the pale colours with patches of Cadmium Yellow, adding French Ultramarine behind the foremost hen and Coeruleum behind the one in the rear. Then, using Burnt Sienna, put in the paler patches to represent the sunlit areas on their backs. Leave some white paper as highlights.*

The palette

Cadmium
Yellow

French
Ultramarine

Coeruleum

Cadmium
Red

Burnt
Sienna

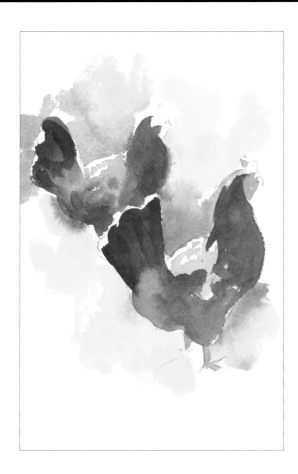

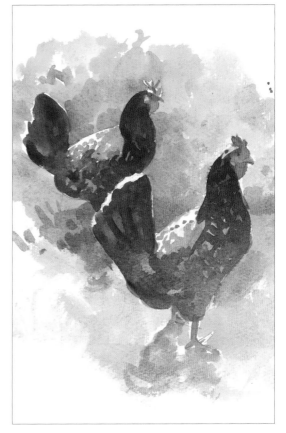

3 Whilst still damp, push in the darks with a mix of French Ultramarine and Cadmium Red. Make sure you leave some of the paler areas showing through to capture the effect of sunlight, particularly between the two birds (on the edge of the foreground hen's tail). When this has dried, add a pale wash of Cadmium Red on the wattle, crest and legs.

4 Strengthen the dark areas with another wash of French Ultramarine and Cadmium Red, using a more concentrated mix to develop the speckled markings. Finish the head with a more concentrated wash of Cadmium Red. Apply a wash of cool green (Coeruleum and Cadmium Yellow) to the background. Once dry, paint in the cast shadows with a glaze of French Ultramarine and Cadmium Red.

Mallard

Side views of animals are much easier to do than you might imagine. They can look very effective. Remember to keep each stage simple.

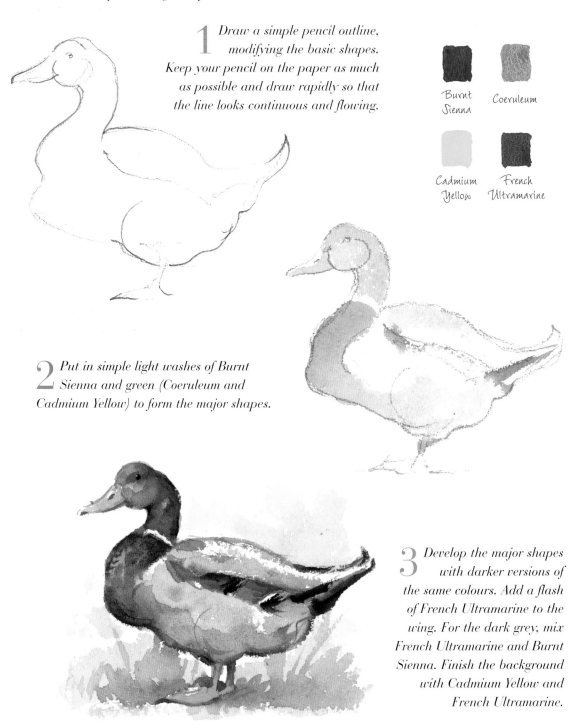

1 Draw a simple pencil outline, modifying the basic shapes. Keep your pencil on the paper as much as possible and draw rapidly so that the line looks continuous and flowing.

Burnt Sienna Coeruleum

Cadmium Yellow French Ultramarine

2 Put in simple light washes of Burnt Sienna and green (Coeruleum and Cadmium Yellow) to form the major shapes.

3 Develop the major shapes with darker versions of the same colours. Add a flash of French Ultramarine to the wing. For the dark grey, mix French Ultramarine and Burnt Sienna. Finish the background with Cadmium Yellow and French Ultramarine.

Pig

This exercise has been done with a looser style, utilizing only the brush and very little outline. Your eye is still able to perceive the overall shape of the animal.

Permanent Rose Raw Sienna French Ultramarine Burnt Umber

1 Use pale washes of Permanent Rose and Raw Sienna to give shape to the front and back of the pig. This gives the impression of the overall length of the animal.

2 Build on this simple beginning by adding more patches of the same colours, as well as a few spots of French Ultramarine.

3 Use the darks to develop the form of the animal, especially in the recessed and shadow areas. Add more patches of French Ultramarine for the spots. Finish off with a cast shadow made from French Ultramarine and Burnt Umber.

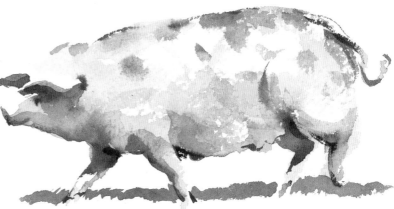

Painting horses

Horses are more complex animals to draw and paint, but there are a few basic principles to follow that will make the task easier for you.

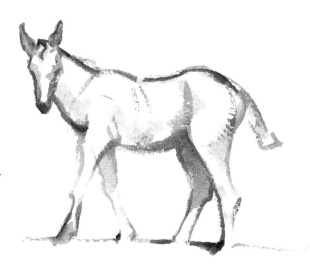

The basic shape of a horse's body is not a box, as you might expect, but two interlocking circles which form a kidney bean shape. Proportions are critical, so spend some time observing the basic geometric shapes and their relative sizes and lengths.

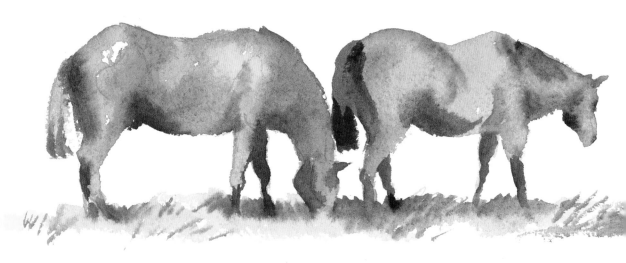

This study of two horses was painted using Burnt Sienna and Burnt Umber. I started with a loose pale wash of both colours, and a large brush, leaving a highlight on the left hand horse's rump. I let the two colours blend wet-on-wet to form the shapes, applying concentrated Burnt Umber for the dark areas, such as the mane, tail and shadows.

Grazing horse

The emphasis here is on the construction of the horse. Do not be tempted to overcomplicate it: keep your washes simple and accentuate the shadows in order to describe the form.

Burnt Sienna

Cadmium Orange

Burnt Umber

Cadmium Yellow

French Ultramarine

1 Outline the horse in Burnt Sienna using a small round brush. Keep the basic shapes very simple.

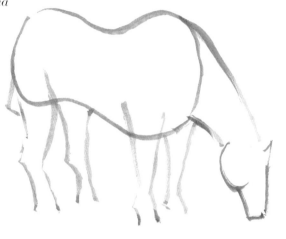

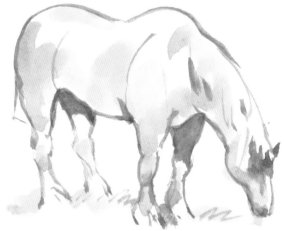

2 Modify the basic shapes with strokes of the brush to indicate the musculature, and add tone to create form until the horse takes on a more solid appearance. Briefly indicate the cast shadows on the head, the underside and across the ground.

3 Use Burnt Umber for the mane and tail, and to strengthen some of the darker tones on the body and legs. A few patches of Cadmium Orange help enhance the appearance of the muscles on the back and rump. Lastly, paint the background very simply using a pale wash of French Ultramarine and Cadmium Yellow dropped into the foreground. Use a mix of these two colours to paint the grass.

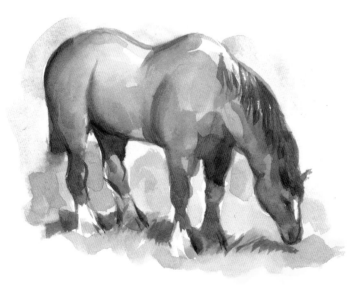

Painting donkeys

When I am painting an animal for the first time I often do a small silhouette sketch to check the overall shape. For donkeys, the basic shape is box-like and they have remarkably stick-like legs. The head is triangular with a curve at the nose end, and the ears seem excessively long.

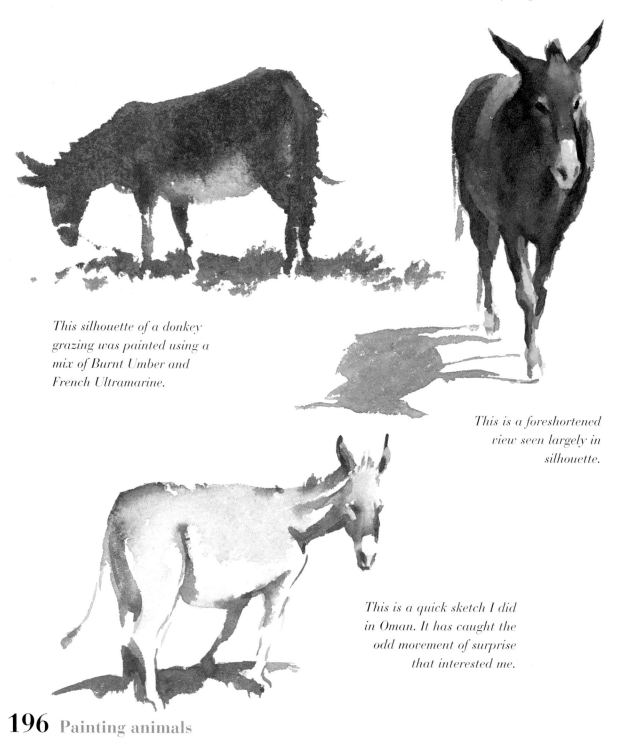

This silhouette of a donkey grazing was painted using a mix of Burnt Umber and French Ultramarine.

This is a foreshortened view seen largely in silhouette.

This is a quick sketch I did in Oman. It has caught the odd movement of surprise that interested me.

Donkey's head

When you are doing this exercise it is important to note the strong light source shining from left to right. Notice the halo effect around the ears and neck.

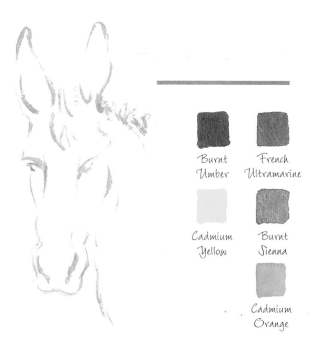

Burnt Umber

French Ultramarine

Cadmium Yellow

Burnt Sienna

Cadmium Orange

1 *Use a small round brush to outline the head with a pale mix of Burnt Umber and French Ultramarine.*

2 *With a large round brush, work a stronger mix of the grey from the ears to the nose. Use Cadmium Orange for the face, then a pale wash of French Ultramarine for the nose and underside of the neck, leaving some white paper highlights. Start the background in Cadmium Yellow.*

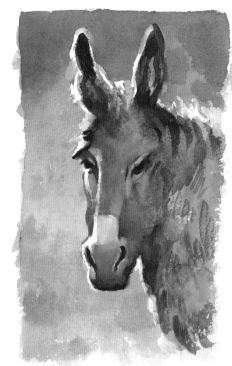

3 *Work up the dark areas with strong mixes of Burnt Sienna and French Ultramarine, and just Burnt Sienna over the face. Turning the painting upside down, apply a graded wash from the mouth towards the bridge of the nose using the brown/blue mix. Mix French Ultramarine and Cadmium Yellow for the background, then with a small brush add eyes and nostrils. A dry brush dragged across the body gives the furry texture.*

Painting animals **197**

DEMONSTRATION FARMYARD

AT A GLANCE...

 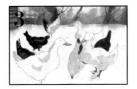 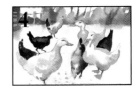

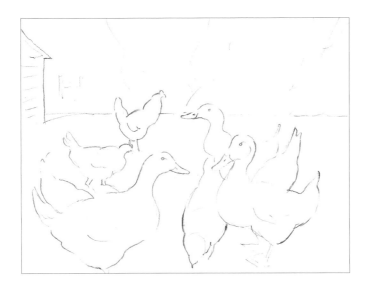

1 Start with a light HB pencil outline. Map out the scene, with the animals in the foregound and a suggestion of the setting in the background. Do not press too hard with the pencil as this will damage the paper surface, and makes it impossible to erase any unwanted marks.

2 With the large round brush, lay in a graded wash of Coeruleum and Raw Sienna over the whole surface of the paper. Make sure that the blue is darker at the top, fading to just Raw Sienna at the horizon. Whilst this is still damp put in washes of grey (Coeruleum and Cadmium Red) to indicate the buildings and fencing and yellow-green for the background trees.

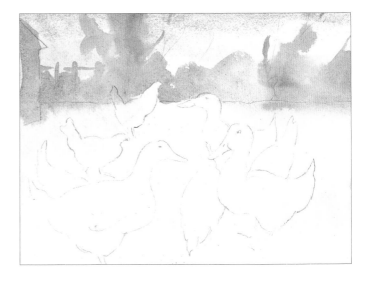

The palette

French
Ultramarine

Cadmium
Red

Cadmium
Orange

Cadmium
Yellow

Burnt
Umber

Raw
Sienna

Coeruleum

Permanent
Rose

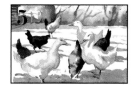

3 Use Raw Sienna to paint in some of the form of the ducks and chickens. Use a little Cadmium Orange for the foreground duck and to paint their bills. Whilst still damp, float in the dark colours wet-on-wet, using Burnt Umber and French Ultramarine. Add a touch of Cadmium Red for the combs on the chickens. Once the background is dry, you can develop the greys and greens of the trees and buildings.

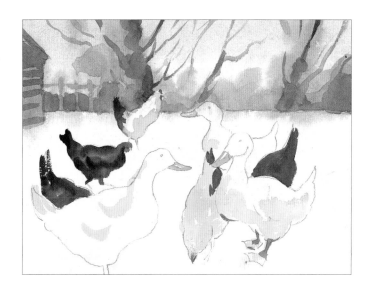

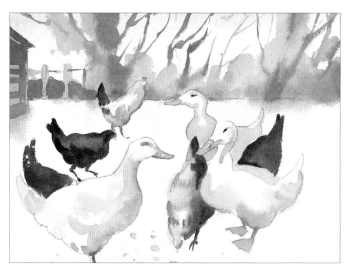

4 Concentrate on the shadow areas on the animals, using French Ultramarine and a touch of Permanent Rose to make purple. Brush the wash in loosely under the neck and body of the ducks to create form. Drop in a little Cadmium Orange just to vary the wash. Use the tip of a small round brush to put in the darks of the eyes. A little spattering in the foreground is used to indicate the birds' grain.

Painting animals 199

5 **Finished picture:** *Handmade Indian paper, approx. 300 gsm (140 lb), 23 x 29 cm (9 x 11 ½ in). This stage mainly concentrates on the cast shadows, some of which come from the objects that you can see in the painting, and some from things that are outside the picture. Use a large brush to paint the shadows, with Coeruleum for those in the background and adding French Ultramarine to the foreground shadows. When this is dry, add texture to the trees using a dry brush technique. Finally, develop the markings on the chickens by adding darker washes of Burnt Umber and French Ultramarine.*

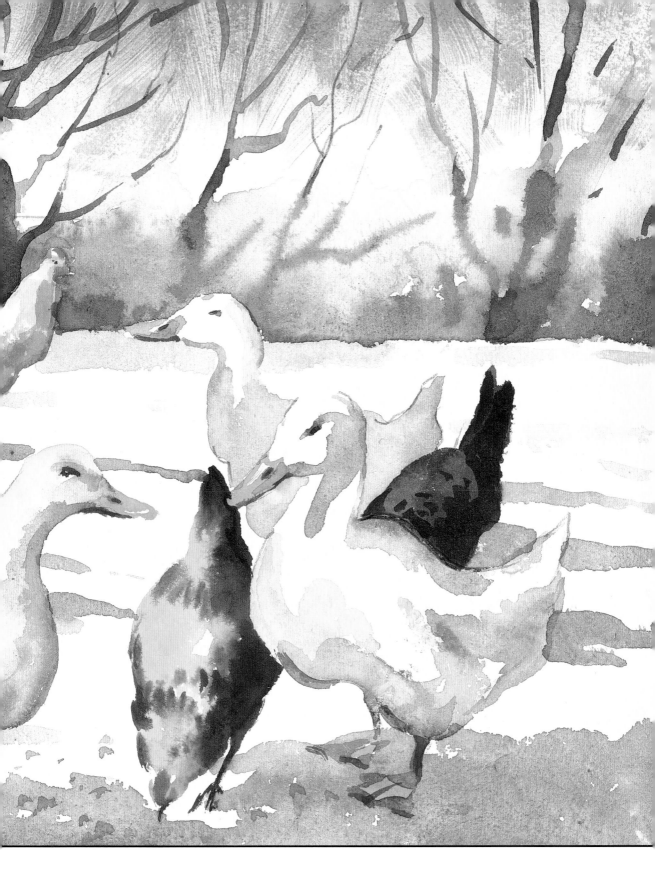

PETS

The wonderful thing about painting your pet is that your model is always available for sittings. Over a period of time you can observe them, their habits and their individual personalities, and make many preparatory sketches in pencil and watercolour.

Tabby kitten

The particular thing to note in this painting was that I used a square brush to soften the edges and paint the background which helped to accentuate the texture of the fur. Remember that fur always takes on a more realistic appearance when painted in layers. Also note that the proportions are different for a kitten than for a full-grown cat: the head and its features are slightly larger.

The colours in a tabby cat are difficult to reproduce. Here I used French Ultramarine and Burnt Umber for the greys and Burnt Sienna for the warmer, light areas, painting them in layers. The eyes are painted leaving a white rim from the paper at the initial stages. I added the dark areas last of all to heighten the contrast, or tonal values. I didn't want the outline to look too hard, so I kept the edges soft by dampening them with the brush using clean water (page 157).

Black-and-white cat

The view of this cat coming straight towards you shows extreme foreshortening, and the back legs are almost invisible. Including a glimpse of a back paw will help to give the picture more of a three-dimensional appearance.

1 With a small round brush sketch the head, making the features symmetrical, then sketch the front legs at different levels to suggest movement. Outline the body and tail.

2 With your large round brush and a mix of French Ultramarine and Burnt Umber, brush in a flat wash of half tone, leaving the markings white. Put a pale bright wash of Cadmium Yellow into the eyes.

French Ultramarine

Burnt Umber

Cadmium Yellow

Cadmium Orange

Permanent Rose

Cadmium Red

3 Paint cast shadows around the paws, under the chin and the tail tip with Cadmium Orange and purple (French Ultramarine and Permanent Rose). When dry use black (Burnt Umber and French Ultramarine) to paint the dark areas including the eyes. Add a touch of Cadmium Red to the inside of the ears and mouth.

Painting animals **203**

The colour of this cat makes him a sheer joy to paint. Do not forget the markings on the body. This is a chance to use your wet-on-wet technique to help create the texture of the fur. I chose a blue background to complement the orange coloration of the cat.

1 *This is the important stage: getting the cat's proportions right. The cat is longer than you think: four to four-and-a-half heads in length. You can sketch it out in pencil, or a light Sepia wash, but do not develop this stage too far.*

2 *Lay in pale washes on the body with Raw Sienna, Cadmium Orange and Cobalt Blue. Follow the contours of the form with your brush strokes. Put some background in, using Cobalt Blue and Raw Sienna.*

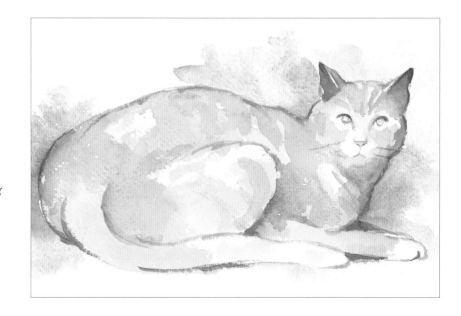

The palette

Sepia Raw Cadmium Cobalt Burnt Permanent
 Sienna Orange Blue Sienna Rose

3 Work on the details, such as the eyes, nose and ears. Work up the dark areas, especially in the shadows, with Sepia and Cobalt Blue mixes. Establish the markings, but do not make them too detailed. Remember to leave white paper to show highlights in the eyes.

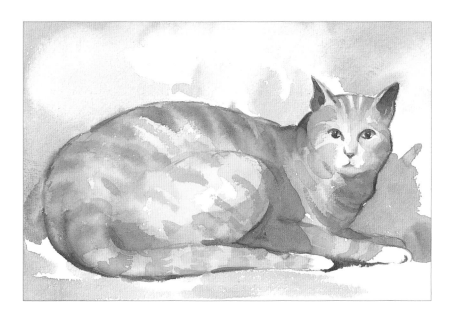

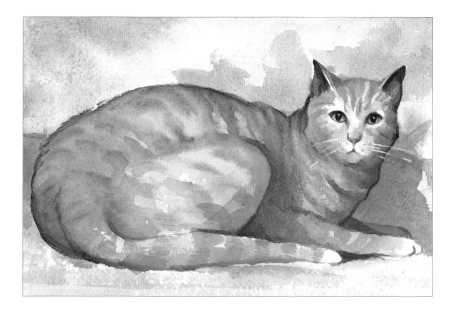

4 Finish the background wash with more Cobalt Blue. Put in the whiskers with fine strokes of white.

Painting dogs

There are many different breeds of domestic dog, both large and small, from Labradors to terriers, also including mongrel mixes. They are fun to observe. Try to catch them in their most natural poses: sitting, standing and with their tongues hanging out!

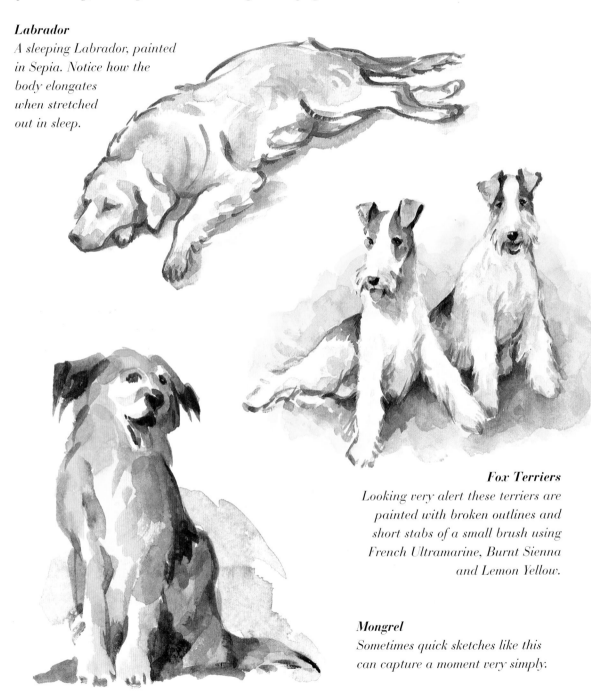

Labrador
A sleeping Labrador, painted in Sepia. Notice how the body elongates when stretched out in sleep.

Fox Terriers
Looking very alert these terriers are painted with broken outlines and short stabs of a small brush using French Ultramarine, Burnt Sienna and Lemon Yellow.

Mongrel
Sometimes quick sketches like this can capture a moment very simply.

West Highland Terrier

It is interesting to vary the papers you use for your animal paintings. On a white paper you can add tones leaving the white of the paper as highlights. On a dark paper you can add white, leaving the colour of the paper showing as tone. Here I used a brown handmade pastel paper.

1 *Paint a brush line using a dilute mix of warm grey (Burnt Umber and French Ultramarine). Keep the line as open as possible; this helps to suggest the dog's coat.*

2 *Using a more concentrated mix of warm grey add the nose and eye. Paint the head, back and tail in white. Indicate the ground with warm grey. Put in a dot of white on the nose.*

Burnt Umber

French Ultramarine

Cadmium Yellow

Permanent White

3 *Develop the coat with white and with finer brush strokes of warm grey using the tip of a small brush. With a large brush put in a pale wash of Cadmium Yellow around the dog, and add a green (French Ultramarine and Cadmium Yellow).*

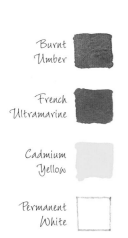

Paint a Basset Hound

This dog is painted from a slightly more complicated angle. In effect you have a profile of the head, a front view of the chest and a side view of the body. The trick to remember here is to keep your brushstrokes very simple for the outline, and to keep a vigilant eye on the proportions.

1 Paint the simple outline on coloured paper with a small brush. The colour of the paper provides a ground on which your white can stand out. Start putting some of the white in straight away, painting patches on the nose, neck and chest with a large brush. Also indicate the white patches on the forelegs and back.

2 Continuing with your large brush, block in the brown patterns using a pale wash of Burnt Sienna. Drop in a mix of Burnt Umber and French Ultramarine whilst it is still damp to the shadow areas under the ear and chin, also behind the front and back legs, and on the back. With the same wash indicate the nose and mouth. Apply a pale wash of Permanent Rose to the front paws and the stomach.

The palette

Permanent
White

Coeruleum

Cadmium
Yellow

Burnt
Umber

Permanent
Rose

Cadmium
Orange

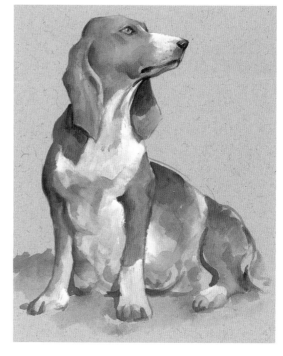
French
Ultramarine

Burnt
Sienna

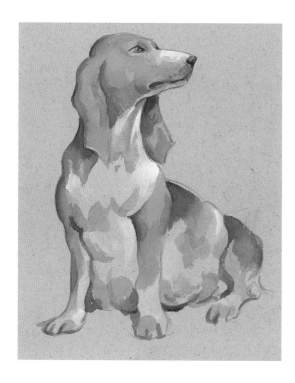

3 This stage is largely about developing the
darker areas and the details. Continue
with your previous colours using more Burnt
Umber under the ears and around the body to
create definition and depth. Add a few strokes
of Burnt Sienna in places to vary the brown
patches.

4 With a small brush, use a pale wash of
Cadmium Orange for the eyes and Burnt
Umber to delineate the dark details. Strengthen
the nose and mouth with a warm dark grey
(French Ultramarine and Burnt Umber). Lastly,
apply a wash of Coeruleum and Cadmium
Yellow for the grass.

Rabbit

A delicate touch with the brush is required to accentuate the softness of the rabbit's fur. Your wet-on-wet and soft edge techniques will work wonders in the rendering of this subject. Pay attention to the highlights, particularly the facial features. Try not to overwork them.

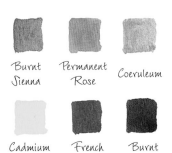

Burnt Permanent Coeruleum
Sienna Rose

Cadmium French Burnt
Yellow Ultramarine Umber

1 Paint a simple drawing on white, rough paper with a small round brush using Burnt Umber.

2 With a large brush put a wash of Burnt Sienna over the rabbit leaving some white paper; drop in some Permanent Rose over the ears. Put in washes of Coeruleum, Cadmium Yellow and French Ultramarine wet-on-wet in the background. Let them mix freely.

3 Build up the tones over the rabbit using Burnt Umber, especially in the shadow areas. Strengthen the dark in the eye with a small brush and leave a highlight showing. Add some Permanent Rose to the nose and mouth, and a touch of pale French Ultramarine to the mouth. Paint the whiskers Burnt Umber. Paint the dark background a wash of French Ultramarine with a hint of Burnt Sienna.

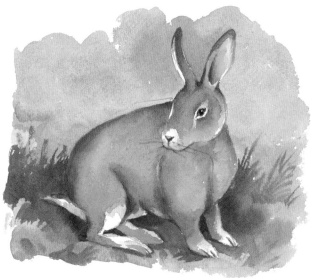

Tortoise

This tortoise is moving, albeit slowly and ponderously, through the garden. One leg raised and the angles of the others helps to show this. Articulating the facets of the shell helps to create the sense of it being a hard object. Let each stage dry before going on to the next.

1 *Paint a simple outline to start with, using a warm grey (French Ultramarine and Cadmium Red).*

French Ultramarine Cadmium Red Cadmium Yellow

Burnt Sienna Coeruleum

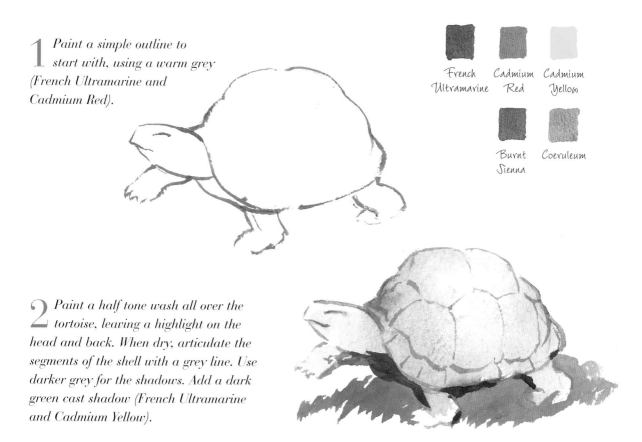

2 *Paint a half tone wash all over the tortoise, leaving a highlight on the head and back. When dry, articulate the segments of the shell with a grey line. Use darker grey for the shadows. Add a dark green cast shadow (French Ultramarine and Cadmium Yellow).*

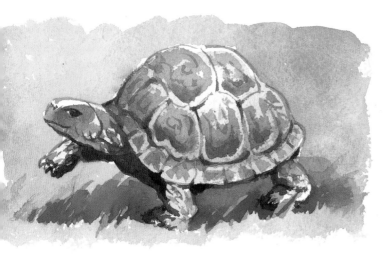

3 *Apply small patches of Burnt Sienna all over the tortoise to create the patterns and markings, allowing the grey to show through in places. Add in all the details as you go along. Finish off the background with a strong wash of Cadmium Yellow; whilst still damp, drop in Coeruleum on the right-hand side and some Burnt Sienna on the left.*

DEMONSTRATION PETS

AT A GLANCE...

 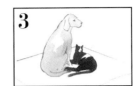 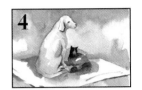

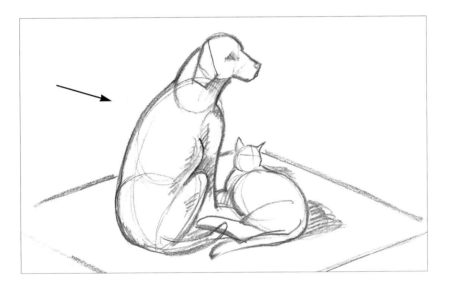

1 When doing the constructional drawing, ensure that the proportions of the geometric shapes are right: the size of one animal to another is critical. Then decide on a light source, indicated here with an arrow. Finally, scribble in some shadows to show tone and form.

2 Once you are happy that your constructional drawing looks correct move on to a simple outline drawing using either a pencil or brush. By now you should be confident with either.

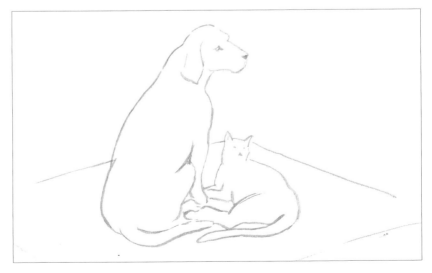

The palette

Raw
Sienna

French
Ultramarine

Burnt
Umber

Cadmium
Red

Permanent
Rose

5

3 Start with a pale wash of Raw Sienna over the dog to establish its general colour, remembering to leave some of the paper showing as highlights. Paint the cat in French Ultramarine with a hint of Burnt Umber, again leaving some white areas.

4 Accentuate the form of both animals with darker washes, softening the highlight areas with water. For the background, start with a purple wash (French Ultramarine and Cadmium Red), adding more red for the rug. Paint a wash of Raw Sienna in the foreground.

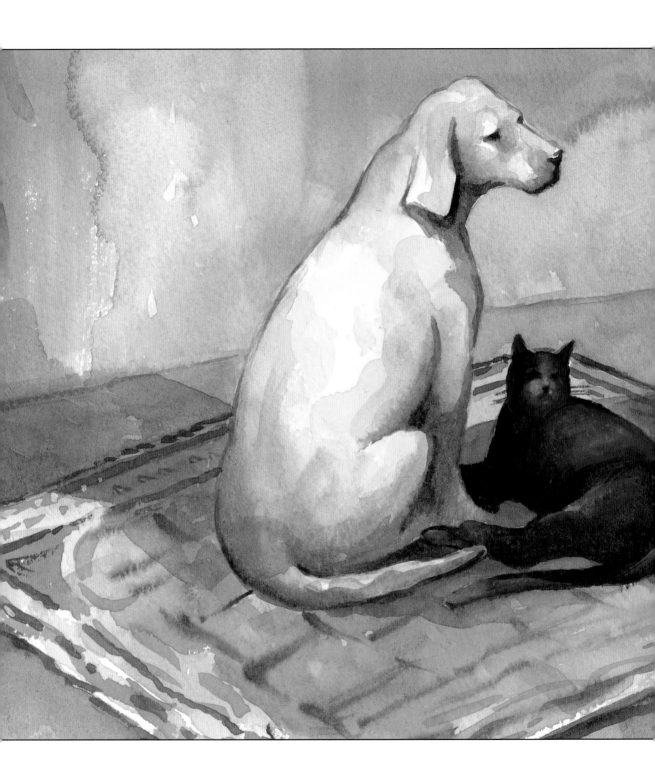

5 *Finished picture*: Bockingford 300 gsm (140 lb) Not paper, 23 x 31 cm (9 x 12 in). Add the features of the dog using Burnt Umber under the ear and neck, and on the legs and tail. Then, with an almost black mix of French Ultramarine and Burnt Umber, apply the shadows to the cat and articulate the facial features by dropping the dark paint into the area whilst it is still damp. If it has already dried by the time you come to do this you can dampen it with a touch of clear water. Tie the whole painting together by using a cast shadow of warm grey, working from left to right. When dry, suggest the patterns on the rug with a few strokes of Cadmium Red mixed with Burnt Umber. Finish off with a wash of Raw Sienna across the floor.

MOVEMENT

Observation is the key to creating a sense of life and movement in your animal paintings. Quick sketching by its very nature helps to convey movement. Try to spend as much time as you can observing any animal you would like to paint, paying particular attention to their gestures and behaviours. A camera may be useful as it captures a specific moment in time for you to sketch at your leisure.

Running

When you would like to convey an animal running, ask yourself what is happening to the legs, what happens to the overall shape, and how the facial features are affected.

In this painting the line of movement is diagonal; it is stressed by the acute angles. I have emphasized the speed by using diagonal movements of the brush in the background.

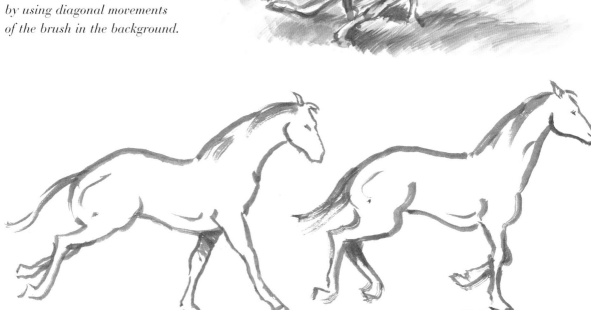

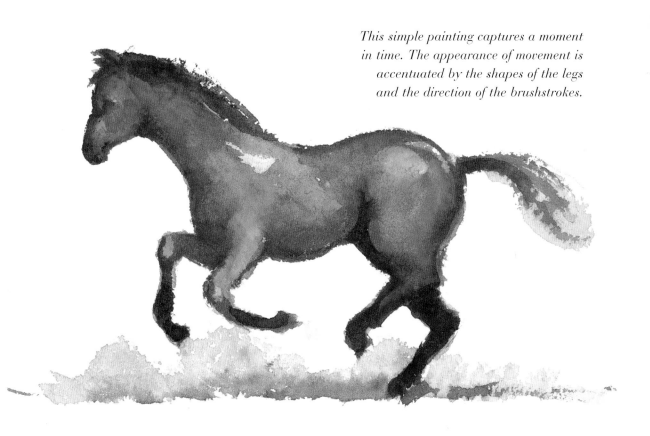

This simple painting captures a moment in time. The appearance of movement is accentuated by the shapes of the legs and the direction of the brushstrokes.

These quick brush line sketches show some of the different movements in a galloping horse. As you can see, the general body shape does not vary much, but the motion of the legs alters tremendously. Pay attention to which legs are in contact with the ground and which ones are raised. Even altering the tilt of the head slightly can create subtleties of gesture.

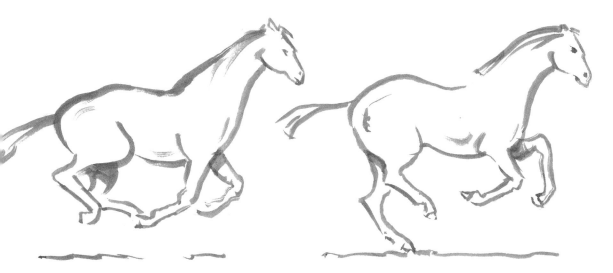

Flying mallard

Silhouettes are a quick and convenient way of exploring movement. I did these sketches onto paper with no preliminary drawing. Each one conveys a different action, or anticipation of movement.

The brushstrokes in themselves can convey a sense of movement; swift spontaneous strokes can sometimes exaggerate the action. I have tried to convey this in the wings of a mallard rising. The splashes of blue help to indicate movement in the water.

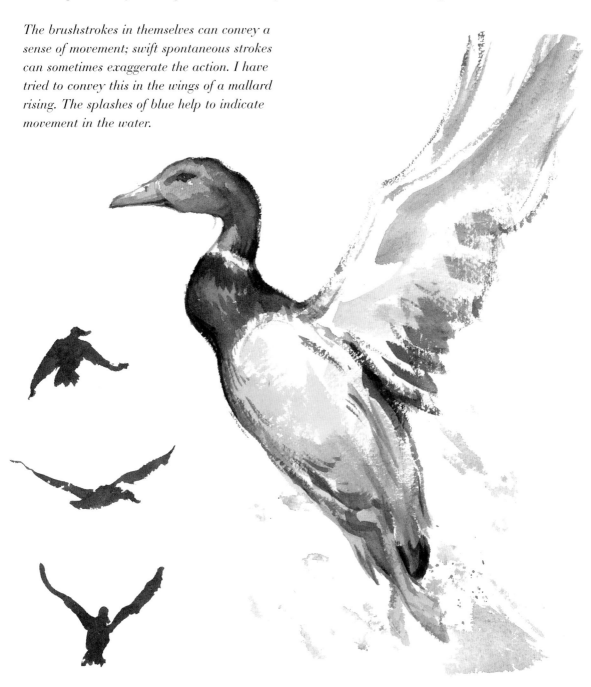

Slinking fox

Here again you can see how effective silhouttes are for conveying an overall sense of the shape of the animal, in this case a fox.

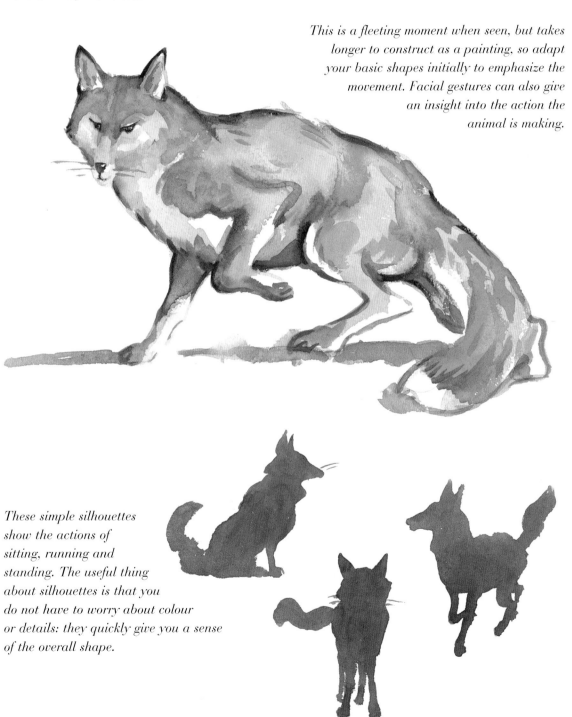

This is a fleeting moment when seen, but takes longer to construct as a painting, so adapt your basic shapes initially to emphasize the movement. Facial gestures can also give an insight into the action the animal is making.

These simple silhouettes show the actions of sitting, running and standing. The useful thing about silhouettes is that you do not have to worry about colour or details: they quickly give you a sense of the overall shape.

WILD ANIMALS

It is best to see wild animals in their natural settings, although this is not always possible. A trip to your local zoo or wildlife park is always a source of inspiration. There is also an almost unlimited supply of reference material in photographic form and on television. I cannot stress enough the importance of keeping a sketchbook for recording your observations and improving your skills.

Sketching wild animals

Sketching can be great fun, so work rapidly and do not be afraid to make mistakes. These errors are a necessary part of the learning process. I made these pencil and brush line sketches on a day visit to a wildlife park.

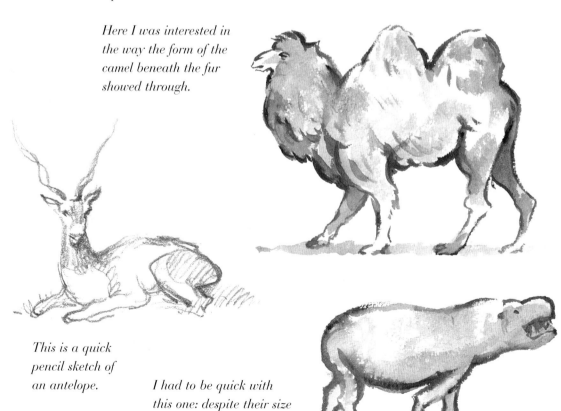

Here I was interested in the way the form of the camel beneath the fur showed through.

This is a quick pencil sketch of an antelope.

I had to be quick with this one: despite their size hippos can move fast.

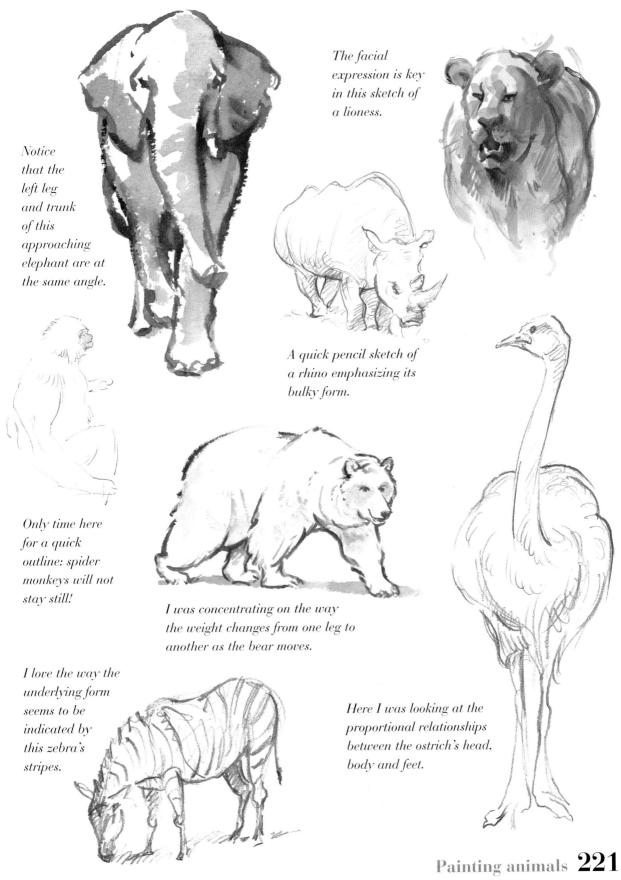

The facial expression is key in this sketch of a lioness.

Notice that the left leg and trunk of this approaching elephant are at the same angle.

A quick pencil sketch of a rhino emphasizing its bulky form.

Only time here for a quick outline: spider monkeys will not stay still!

I was concentrating on the way the weight changes from one leg to another as the bear moves.

I love the way the underlying form seems to be indicated by this zebra's stripes.

Here I was looking at the proportional relationships between the ostrich's head, body and feet.

Painting animals 221

Giraffes

Giraffes are one of my favourite animals; they are so tall when you see them up close. For such large and awkward creatures they are surprisingly gentle and elegant. The shapes of the patterns are like jigsaw pieces and translate well into blobs of paint.

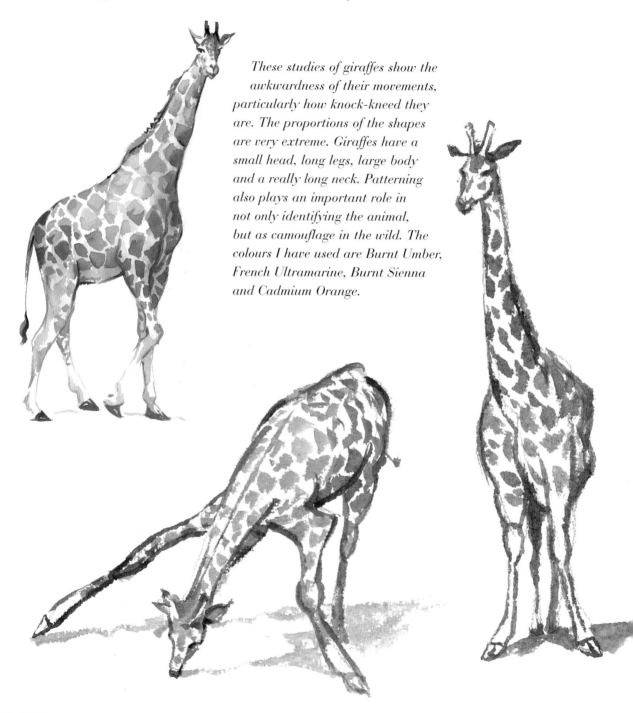

These studies of giraffes show the awkwardness of their movements, particularly how knock-kneed they are. The proportions of the shapes are very extreme. Giraffes have a small head, long legs, large body and a really long neck. Patterning also plays an important role in not only identifying the animal, but as camouflage in the wild. The colours I have used are Burnt Umber, French Ultramarine, Burnt Sienna and Cadmium Orange.

Elephant

This painting was done after spending a day studying elephants at the wildlife park. The mountains in the background were a product of previous experience and my imagination!

French
Ultramarine

Burnt
Sienna

Cadmium
Yellow

Burnt
Umber

1 *Use a blue line wash (French Ultramarine and Burnt Umber) and some simple tone to create the form. This is a slightly foreshortened view seen from the rear, which includes some movement.*

2 *Use separate pale washes of French Ultramarine and Burnt Sienna to paint the whole body, wet-on-wet. Leave white paper to show the tusk. Move the blue wash into the background and add Burnt Sienna under the elephant. When dry use a mix of French Ultramarine and Cadmium Yellow to paint the grass in the foreground.*

3 *Strengthen the dark areas, especially in the cast shadows on the animal, using Burnt Sienna and French Ultramarine. Add a wash of Burnt Sienna across the back, leaving the highlight from the wash beneath. Lastly indicate a line of mountains with French Ultramarine and suggest a sky with a hint of Cadmium Yellow wet-on-wet.*

Index